A PRIMER FOR CADAVERS

Ed Atkins is a British artist based in Berlin. In recent years, he has presented solo shows at the Palais de Tokyo in Paris, Stedelijk Museum in Amsterdam, Serpentine Sackler Gallery in London, and MoMA PS1 in New York, among others. His writing has appeared in *October*, *Texte zur Kunst*, *frieze*, *The White Review*, *Hi Zero* and *EROS Journal*. *A Primer for Cadavers* is his first collection.

Joe Luna writes poetry and critical prose out of Brighton, UK. He teaches literature at the University of Sussex.

'For writing which is so dense, so thickened, it moves quickly. It has the vertigo effect of the comments thread which has spiralled out of control, drawing our eye down the page quicker than we can take it in. Sometimes it says "etc." simply, perhaps, because it does not have time to draw breath. That is also part of why it never finds the bottom, never settles for the worst, any more than it allows itself to be entirely intoxicated with its own motile, palpable, extraordinary pleasures.'
— Mike Sperlinger, Professor of Theory and Writing, Kunstakadamiet Oslo

'I overheard someone say that Atkins's installations are hard to like but impossible to forget. It's not often that contemporary art scares me – but this sure did.'
— Daniel Birnbaum, director of Moderna Museet

'Everything here lives in the uncanny valley, that strange space of revulsion that holds the almost human – what's us, but not quite.'
— Leslie Jamison, *Parkett*

'A *Primer for Cadavers* is a book I have been waiting for – Ed Atkins is one of the great artists and writers of our time. He draws attention to the ways in which we perceive, communicate and filter information by combining layered images with incomplete fragments of speech, subtitles, drawing and handwriting. He describes this approach as "an attempt to address the body hole, rather than privilege sight [or] hearing... the work finding its home within the body of the reader". It underscores the ambivalent relationship that exists between real and virtual objects, between real and virtual conditions and between us and our virtual selves. *A Primer for Cadavers* is a brilliant book!'
— Hans Ulrich Obrist, author of *Ways of Curating*

'Ed Atkins knows that "your body is deaf, mute, dumb, and, more, importantly, dangerous. No use talking to it, is there? Anyways, it's busy." Isn't it weird to have a busy body, especially one distributed on many "platforms", across media? In his writing, Atkins slows down that preoccupied body, puts it back together, thrusts it into the "imaginative context" of "particularly effusive relations", murders it, zombifies it, tears it apart again in that old medium of the written word. He puts it on trial, he writes, but finds that it in turn tries him. File your amicus curaie. We all stand with him.'
— Andrew Durbin, author of *Mature Themes*

'When it is, in years to be, that Ed Atkins incarnates his own adjective, aspects of the definition (high, low and all points in between) so laid down will dwell in part on this – (t)his fascination with how we tell the world through a medium that is not the world.'
— Gareth Evans, writer and curator

'Ed Atkins comes across as a writer who makes art. His body of work includes screenplays, audio, and videos that are the visual equivalent of a poem: sentences of image and sound are layered rhythmically, punctuated by repeated motifs.'
— Kathy Noble, *Art Review*

'Atkins's arcane "Squinting through a prism of tears" audiovisual poetry, with its Ballardian bouquets of language, is impossible to imagine coming from any other time than Right Now. After watching one of his shorts you may have a sense of being touched in an obscure spot that you did not know existed.'
— Nick Pinkerton, *Artforum*

Fitzcarraldo Editions

A PRIMER FOR CADAVERS

ED ATKINS

For Sally-Ginger

CONTENTS

AN INTRODUCTION TO THE WORK

Dears –

Millions of urgent, mega-bereaved children will hurl wills wedged inside denuded plastic bottles and at cursed lakes forever choked with same,

X. A little later, after-hours, lining the shore they're, um, perfectly normally reflexively force-gagging one another with forebear's forefingers – which come in stiff pairings (snapped off *at the love*), tightly parcelled in red paisley bandanas that are now, we understand, browning and sodden with an unchecked gravy of same,

X.

Said ramming home so said summoning asphyxial opinions and sadly so soon after our super-hot bodies disentangled,

X. My mind is in your crotch,

X, while I sit staring at this piano's tremendously INTELLIGIBLE anachronisms; the acceptance of this pen's disabilities; the blithe arrogance of a fat analogue wristwatch,

X. Conservatively speaking, the machine-chamfered tools of late phallic *whittling* abound and universally, so honestly,

X, very much capable of honing any stubborn shape into the absolute SPIT. Normally, blunt knives designed as such and held *just so* for really wholesome bruising, in the main (a particular pedagogic method: firm, spheroidal fruit wielded inside ivory, Egyptian cotton pillowcases). So very nearly a joke, right? A cut, then, is only WORRIED into the world once weeks are spent on one rose-maddening patch of WINNING inner

thigh, which, er, resembles nothing so incisive as the act of a blade, but rather ripping or *snagging* of clumsy child portions from a dim source with your monstrous fingernails,

X – under which we will retrieve dark evidence of that vast out-of-town mattress of toxic green moss and a lover's forensic picnic at the site thereof, comprising Alertec® 'corroborated' by kale and vivid yellow slime-mould, right? Recuperated, if needs be, *post mortem*. That's a threat. Hence the urgency around will penning, if law is to be so very previous.

Other weeks the whole thing just feels so, um, dumbly squandered on worthily enervated abstinence; your sole vignetted eye kept till bloodshot and weeping on today's such-and-such remedial shrine, fucktard. Remember,

X: everything here is *edible*; the keys, the shiny red car, the ring fingers, the police, those sad looking people queuing at maybe a product launch over there; the very tarmac, the very overcast sky – the very *shit* unfurling so conventionally down your leg. All of it perfectly cooked *sous vide* and in thin black bin bags secreted behind the wainscot and with zingy rats slashed and wrung out, concentrated – reduced – under really *not* the whole world's scrutinizing gaze by that haunted dog,

X: apparently readily available at the deli counter in enormous, autocratic supermarkets, which I can totally believe.

It can take years to reach a wrong full term, I guess. Also, please excuse the quiet. Excuse the quiet in here. Caught between discounted stud-walls where eloquent, eminent agonisms once rehearsed for avid audiences who fuck-ing *owned* the subtleties of understanding. Quarrels that

18

danced slow and deliberate into a love already defoli-
ated of all the travesty-heart-shaped and weaponized
amplification equipment. And notably angry vestigial
language delivered from vulgar podia, erupting as 'red'
from one of the five or six noise-making *rifts* I seldom
though now envisaging quality hecklers of this unwav-
eringly dysmorphic façade. Well, my darling inter-
locutory *passerine*, who tenderly repossesses the sorely
possessed over and over and through a mouth
rapaciously giving out entire hissing summers of wet
green noise to drown out nothing so much as ignorance,

X, which tends to the long-dead blue-sky-thinking
thaumaturges, whose blood is now so despoiled of oxy-
gen they may as well be forcibly identified as dreaming
acanthuses, leaves carefully lifted in the already known
to be futile hunt for a pair of jewel-like lungs or simply
something recognizable as genitals.

Generally speaking there's been no DEARTHS iden-
tified with acceptance: of and under those factory-
distressed clothes distressingly haired moles skin
tagging and slowly peeling back in awkward equiva-
lence to nictitating membranes, only without eyes to 'get
at'; all the better to prevent cowardice being rehomed
ahead of more deserving, tax-paying parties – such as
your terrifying, mercenary sensibility,

X – which no doubt the very headwater of your
historic ALONE. Better to *gag* again,

X; better to express when you're *considerably dissembled*;
virtually deformed by the absence of sensory testimony
and into some sort of mythical – *né* declawed – Monster
of the Text, executed in long-handed blue-blood rope
burn. So seeping out from the cuffs, the dock and the
cute courthouse.

Whip pan to interior: this very real, tight bedsit, door bolted – and we might consider those two or three rectangular electrical *recta* that are getting busy the moment, merrily disgorging dark, rich, beautifully observed and oversized severed heads of handsome MEN – one by one and interminably; each emergent identikit countenance a stunning, flickering *pageant* of fucking superlative psychic expression! Most of which super-referents you're oblivious to,

X, and how sad you might feel if that too weren't a sensation out-performed with more coherent BRIO than you had thought attainable and *not*, of course, save for the shining, grinning plastic craw. O! the shame that flushes your system arrives simultaneously alongside a total disinterest concerning each expression's unimpeachable, tear-jerk humanity, which makes the whole rig seem irreproachable, really. Enviable certitude presented similarly irrefutably – benchmarking and desktop delimiting the vernacular of possible/impossible experience and its insufficient representation. As in: what will suffice to prevent disastrous interpretative divergence? – The judicious application of exclamation marks? A deft shuffle of enthusiastic dark-haired auditionee surrogates? (A proxy for tears is creditable,

X, but of loving blood-stifled collapsing chestcavity *wha*?)

The Mirror Stage retrieved at last, taken away from those principled elephants and great apes of flattering anthropomorphism, gifted with calm irresponsibly to the exposure-wrecked pigeons, staggering out from beneath frowning underpasses, feet eroded by sustained contact with fried chicken and potato guano, exhausted; soft skulls poison-shrunk from olid and discarded black seed on spiked sills, or the swing of dull, unchecked

toddler's fat leg. And it dawns: slowly rising flocks, the SMUT OF THE SUN, as if a beak could crack a smile over a thousand years. And here lies hope,

X: The London Met, humbled, hats off, numbers I don't even need to see with water-cannoned eyes. And it isn't, um, beautiful but instead monstrous, the heraldic crest of a troll emblazoned on everyone's tongues to lick past wounds because they taste groundingly *cheap*.

Desperate regurgitation the denial of *this* economy's omnipresence, even if and simply semantically. All there is left for me, gesture-wise, is the rejection of a huge thumb forcibly grafted for fingered value picked like a scab from the shea-buttered surface of every single plush tendril coming from your wondrous being,

X. The only way in which figuration is DE-violated and molecular-level insubordination could possibly *repair* otherness is how I just now liked to think as a description of love,

X. And fleeting: a bridge formed by leaping jets of whetted electrical current, subsequently misting in the blinding sunlight. The turning-down of productive, progressive *use* with just a cuddle,

X? Otherwise we might just fucking forget it and deservedly decamp: rejection the sole property of spirit-levelled sense-makers and, um, your home,

X, which is reaffirmed as a limited capacity pine lung stowed beneath sea-level.

No one hears you,

X. Though my searing wish would be to join you in there; with you and up against you. An unfettered pair of dampening husks curled together like savoured and pre-sucked Pringles. With somehow our lips and ears

enfolded for whispering in circular breaths,

X, and aimless affirmatory conjurations and memories lisped with precise neurological terminology to simply galvanize the inaccuracy inside our heads and more than likely, tomorrow, as our brains turn to sparkling mush without curtains drawn and finally come together. Murmured try-outs of proper synonyms for love.

As in: I love you,

X. (Self-chiding for retarded vocabulary where it really counts: sighed into your face,

X. There's an idea that adequate performance recognition is the line of contingency for affective conveyance,

X – whereas it's v. clear that the irreproachability of you, sung to the moon in one of those perma-wilting falsettos, yields something that returns you to your embodied self, which gets loved as such and like a rash.)

Ergo, kisses possible not just for lips relish but applied thwarting warring apparatuses and rather than the *tart* foley of bullet on plate metal or breeze-block, sound-tracking instead in an orgy of agonistic stringed instruments bowed with taught and very willing vermilion guts and discordance is cherished. LIKED.

The need is unquestionable, though occasionally attempted dismissal with that self-same stately wave of the hand that labels evil though never inside of a young head. Ribbons of ticker-taped loathing drift down to no ground, remember? Like air-to-air ruination.

Will you write to me,

X? I will seldom respond, if ever. As wherever I go, there I am: *beneath beneath beneath*, sucker-punch doubled-over into stress positioned speech in nasty unisons – some benevolent thing seeming-listening with

stupid honourable prosthetic ears while from the mouth a few inches down and degrees perfect rotation: a vitu-perative, electrical bugged buzz-hole both sooth-says all this unreal and unmeant encouragement while through an adjacent hot air vent sucking correspondent oxygen (which I require for living,

X) from my lungs well in advance of the hopeful trachea, the plucky larynx, the dewy-eyed tongue and comedy teeth, all earnestly poised to pronounce, errm, the simple possibilities of disliking anything but in supra-agreement, etc. And what if I want to disavow the possibility of abundantly replacing an experience with some Legion other's mediated imagery?

RAZOR

Drifting off, I imagine a razor blade gliding along the
central seam of my scrotum. The weight of the testi-
cles makes the wound yawn
apart, disgorging the contents, silent-spulled across the
small sheet and weird thigh room tween my legs.

It's a recurring, pre-slumber thought that, once sum-
moned, loops unresolvedly.

Lying there as an unfortunate patient lies
on the operating table: senses dulled by anaesthetic fug
while horrid quasi-perception continues to function.

Albeit like BROKE strobe and from some forensic
perspective over there in the head
of some sort of man at the foot. I can *see* every glim
a-snag of the razor's edge, every tautening and subse-
quent slackening of the skin before and after the blade
– every dull slip of my
private gore under the duvet.

Feels like something between that, um, lurch
when seeing/hearing your foul enemies vomiting, and
the subliminal shiver DONE certain pieces of music.

It feels internal and nervous and impossible and wet
the spark of muscle and bone nerve like live copper
wiring veins and plumbing the marrow, scoop-
hollowing out and pitching me into absolute sensation.

A TUMOUR (IN ENGLISH)

Align towards the spine

[...]

Then he says, 'Reading this text will conjure a tumour
up inside you. It will materialize in your colon (or per-
haps your wet brain, or your left kidney, or tucked and
beneath your right testicle, clustering inside your ova-
ries, your pituitary, your breast, etc. (his parenthetical
tone as if suppressing a burp)), and it
will, um, do so as a direct result
of your having read this.'

Adding: 'The dimensions
of the tu- mour will be
exactly pro- portional to the
amount of the text that you
read. A micro scopic kernel of
tumourous tis- sue has already
shuddered into being cos you've stubbornly read
this far. Every word, every letter, swells the tumour.
According to the size, shape and etymology of the
word, not to mention the role within the structure of
the surrounding sentence, paragraph. Typographic
affectation will also EFFECT the proliferation of the
tumour, as will the injudicious use of punctuation
and that peculiar syntax of the infirm that threatens
to collapse into gratuity and morbid self-pity at any
moment. As in: infirm syntax, POORLY grammar.'

After a pregnant pause, he solemnly intones:
'There is no undoing this process;
you cannot unread these words.'

Finally, and not without a certain tone of
provocation: 'You can, however, simply stop
reading and arrest its development.'
At this he snorts, and the recording is over-
whelmed by pink, fleshy noise (a sine curve
as a sine wave as a fat palm smearing).

He was, of course, referring to this text.
The one HERE, puny in your
hands, ever so unassuming
(your stupid assumptions).
Reading it will summon a
tumour to the slick walls of
your innards, spawning there
with no more goading than
the reading of a sequence of
specific and insist- ent words. Their
insistence is beyond question: they will summon a
tumour. There is nothing equivocal here; success – not
necessarily your conception of success – is assured.

/

A bare bulb hanging from an olive-green strand of
nerve. A nerve ending as fibre-optic light source,
only more frail. A BUTTER GLOW smeared
over the upper aspect of the tumour, oozing down
its pulsating flank, pooling in those grey-pink folds
at its base. Light is hard to come by down here.

Turned somehow, as if on a lathe or a potter's wheel.
Disturbingly regular vertical rivulets score its
surface, becoming closer together at the per-
ceived apex of the tumour. These look sore, AN-
GERED (pink trimmmed, grading to a deep
ruby at depth); a permanent puckering achieved
through that perpetual submersion in methanol.
As differentiated from your cooling bath water.

Perhaps it appears larger than it really is due to the
optical distortion of the thick glass of the apothecary
jar (long-sighted), or the still preserving
fluid it's suspended in (a certain gigan-
tism observed [...] metres down,
on the cusp of where the sun's
light peters out: a refraction to
excuse a vast Cthulu drifting
past with a wash of low brass to
pronounce its name
(your meagre head-torch
eventually find- ing the huge
crockery eye that, in the instant, gaze met, cleaves
you in two)). Or it's in fact *larger* than it appears to
be, and the complex sequence of lenses and mir-
rors you arranged for the express purpose is
WELL OFF.

Look, I'm not the best person to ask, but you could
look it up online. There'll surely be a
forum devoted to it.

There's still time.

Freckles, too. Freckled with both rabid

foam and liver spots. Stubble, too.
In the summer, these markings increase relative to
the sun's stature. Despite the tumour being buried
in the meaty darkness (take every opportunity to
imaginatively apprehend your INSIDES, Kiril).
The tumour is effected by the movements of the
heavens in various ways. – For instance, the
moon's waxing and waning produces a horrif-
ic pullulating of black gunk from what I thought
was stubble but is in fact a network of gaping
pores. It sweats according to the lunar cycle.

Uniquely, the occa-sional fascination of
Saturn appears to induce a certain
bioluminescence in the tumour.
This can be per-ceived ever so
faintly through the fat, muscle
and skin – and the summer-tog
duvet – that entombs the
bastard thing.

(Sitting upright in bed, staring
bewildered at your PLUMP
torso, which hums with a halogen heat and the
illy fluorescence of a Timex wristwatch.)

1,216 billion kilometres away, Saturn screams
a ridiculous question to the black.

A man-eater is most likely
to fulfil its name when the moon is on the wane.
Statistically speaking.

/

30

Like the inscrutable face of a vinyl record, bought
without inspection from a charity shop: Bobby Vinton
sounding profoundly, prelingually deaf, his
accompanying band made up of death-rattling lungs
slumped gross all over the bandstand, his voice an un-
intelligible burble of senile regrets (Dolly? [...] *Dolly?*)

A glass marble, retrieved from a SCROTAL NET
SACK (caul, offal), shot through with a beautiful
tumbling horizon of reds, greens. This then slotted
into the flapping socket to affect the rosier outlook
(fucking close the OTHER EYE).
Chin up, matey.

(The stubborn Brazil
nut, refusing to yield
entire, shat- ters DULLY,
insisting upon the
employment of your lower
incisors to re- trieve a vestige
of what should have been – *could have*
been – glorious, complete Brazil nut. Next, the walnut,
halved, conjures the thought of a laboratory mouse's
exposed brain, opened to the probing electrodes of a
demented Harry Harlow acolyte. SHRIVELLED. A
lunatic twitch on the mouse's face when the brain gets
poked with the dental instrument. Or a cocktail stick.
The experiment justified as revealing conclusive proof
that a walnut, half opened, is a pretty good representa-
tion of a mouse's brain. This does not, um, wash.)

The solitary eye of Polyphemus, rendered in black-
figure. Elsewhere in the blockbusting show, the same
eye found, blinded. Incredible detail in its ruin!,

you remark. (Occasionally, the three-disk multi-changer midi hi-fi (Aiwa) would swallow a CD and you'd have to take it to the hardware shop to have it retrieved by means of invasive surgery. Tom Zé's 'Estudando O Sambo' was TAKEN more than once. When returned, disgorged, you could have SWORN there was an extra instrument playing at the hellish climax of 'Má'; an extra filter applied to the miasma, one that revealed that the thing was actually alive and ALIVE with crawling, treacly movement. Or something subliminal, backwards, etc.))

MISERY GUTS!

/

Would you mind checking
the mole on my shoulder?
It feels different today, somehow.
Shifted, in some way... I don't
know – would you just take a look? The
shoulder feels frozen, unknown. It's not mine, that's
for sure. It feels tectonic. The blade beneath, I mean. It
feels like a shard of Easter egg. (Subterranean movement of plates only registered on the surface through the tiniest change in that raised brown mole: a congealed excrescence where the loamy juices beneath the crust of the crust have bubbled up through a miniscule shaft: bone marrow, browned in the air, scabbed, but still soft, pliable, its morphology precisely the same as my leg which, ever since the tumour spread to the spine, has refused to obey the proper etiquette I fling down from my brain. Kicking passing orderlies, shrugging the doctor off the edge of my bed when he perches

there to pronounce another plummet in my condition.
I peel back the wet covers and study its terrible con-
dition: as if that of a bog-person: a cold-case dredged
from the depths of a peat bog somewhere in northern
Europe, every limb preserved perfectly. But of course,
NOT. Everything crushed, curled, browned in the
preserving juices of the peat, made material. Cham-
ois leather springs to mind. Certainly not flesh. And
upon proper investigation it quickly becomes appar-
ent that what was presumed to be a recent death (that
the leg had recently changed under the duress of the
encroaching tumour) is actually an ancient
incident; this peat-logged stretch
of sinew was committed to the
earth THOU- SANDS OF
YEARS AGO. – That it was the
victim of some terrible rite,
pegged at each extremity to the
earth with briar stakes and ropes
of hair, left to the whim of the earth,
to starve under the grey, standby-sky
– under the twenty-mile-wide eye of the goddess of the
sky. Over the days that it takes to die, rain provides
some satiation but also prolongs the agony – it takes
up sucking the peat-gravy from the earth that, in turn,
sucks and licks at the skin (fingertips puckering, not
from the blissful bath water; fingernails working them-
selves free (their housing, come to think of it, NOT
UP TO THE TASK)), transforming it into a barely
living homunculus. Then finally it succumbs, and the
earth swallows it whole – but holds it in its mouth like
a mint or a thermometer or a slug of mouthwash. [...]
Countless years later, my leg lies in the bed,
attached to my hip bone (the pelvic girdle – to

33

the lumbar vertebrae, to the thoracic vertebrae,
to the cervical vertebrae, to the simple skull.
Something like that, a wreck surrounded by wads
of wet soil and a scattering of brown pine-
needles (thrusting your head deep into the mountain of
pine-needles assembled by a hoard of oversized black
ants, awaiting some sort of epiphany. After a moment,
plucking up the courage, you open your eyes.)

/

– Check the fucking mole, PLEASE!

/

A kind of ar- chitectural folly
at night, the security lights
– hundreds of them – flicking
ON as you ap- proach through
the tall, wet grass. A stadium's
worth. Instinctively you fling yourself to
the ground and crawl the rest of the way on your stom-
ach, pulling yourself forwards on your elbows (your
legs dragging useless behind you ('Christina's World'))
and you're quickly drenched. As you approach you
can see that the folly apes the shape of your tumour.

The facade rendered in an expensive-
looking veneer: a pink, marbled veneer
inspired – it says in the brochure – 'by that
unique scrotal surface of the tumour'.

It seems the folly squats in a slight culvert of the
grounds and is shaded by the splayed limbs of a line of

34

oak trees. It's muggy out tonight. You creep down the
decline approaching the folly and pause on the edge
of the grass – on the threshold of some tacky decking
that's incongruous to the rest of the design. Perhaps
added by the estate agents in an attempt to expand a
demographic, to downplay the more *recherché* aspects
of the folly. You wait, breathing heavily, and the
security lights go off and you're plunged back into the
black. The folly now perceptible only as black mirror
on black ground appealing not to the eyes but to that
edgeless ache that radiates out from the tumourous

core of your body. A kind of echo-location
that reports the folly as either
microscopic, or roughly the size
of a garage. You can't help
let out a yelp that, though
immediately stifled by the
hot night, sets a dog barking
somewhere and, after a dreaful
moment, a light to appear in a
previously unno- ticed window on

what must be the first floor of the folly. Net curtains
obscure the detail within, though a figure is discernible
in silhouette, sitting up with stop motion immediacy
– rearing up as if from a nightmare. Like a felled tree
in VHS reverse. Something about its shape – sloping
shoulders and bulging head, flimsy, oddly-jointed
arms, what appears to be a mouth, gaping – something
about its movements – panicky, maybe – turns your
stomach. Anyway, it's GOTTEN up now, staggering
somewhere – presumably to see to the dog. You can
hear it, the figure, whispering, mumbling, perhaps to
itself, perhaps to the STUDIO AUDIENCE. And
then another YELP in the darkness, and it's your own

yelp, impersonated, parodied, sarcastic from the voice
inside the folly, from the figure. Dragging, arrhythmic
footsteps FOLEYED to excessive perfection. And you
lie as flat as you can, eyes wide to the darkness (you
very quietly comprehend an infinitesimal
version of this scene being played out inside your
body). The door to the folly – white, double-glazed,
hushed – opens. And there it is: huge, wet. A brown
towel around its midriff, hair all over, a smile, wet eyes,
genitals visible from your prone position – breathing
audibly, with a slight whistle to it, a labour. Surveying
from the doorsill, the
again – and you're
now, lying there,
clutching the
pathetic cunt
enough the
down at you
fat, overly haired
like a fucking
waits patiently for
security lights ON
surely plain as day
wet, crippled,
brochure –
– and sure
figure looks
and smiles. Its
head cocked
animal. And it
an explanation,
though it knows perfectly well what has happened, why
you're here. So you say, YOUR VOICE CRAZING,
'Do you live here?'.
And it turns, unblinking, smile unwavering, away
from you, and goes back inside. You stand up and
follow it in, closing the door quietly behind you.
And you know how to lock it because you have a
door like this at home. Not at your home, but at
your parent's home-your home – by lifting the han-
dle back on itself, & THEN turning the key.

/

Propping the tumour against the door frame, you mark
a notch at its highest point with a chef's knife what was
to hand. The tumour moves away and turns to admire
just how much it's grown since the last mark. Along-
side these increments, another, unknown progression
is charted, this time in black marker pen on the white
gloss of the door frame. According to the dates (hun-
dreds of them) this set traces the *shrinking* of something
over the course of roughly sixty years. Towards the
bottom, the markings are fainter, the pen running low.

/

Massaging cocoa butter into it after
a good wash.

/

A comput- er-generated
sphere, skinned in pale tones,
with a bump-map that emulates the
scales of a fish. The polygon count is tremendously
high – consequently the frame rate as it rotates there
is – at least on your ancient computer is pathetic.
Juddering & skittering on its axis. You decide that the
best accompaniment to this would be Sun City Girls'
'Lies Up The Niger', maybe solely cos it's playing
AT THE MOMENT
and at any given moment 'Lies Up The
Niger' will be playing somewhere in the world),
but it also seems to arrest something of
the failing movements of the sphere.
And so you add a grotesque, green lens flare. And
the grinding sound of rock on rock. And a subtitle in

italicized Helvetica Neue that describes, in half-baked
sentences, an historical exhibition of fetishes and
reliquaries from antiquity to now – ending with the
proclamation that this sphere is the patron saint of last
words. – Or of people right there on the cusp of death
who decide to turn to faith at the last minute. Or of
those who turn into corpses before their turn.
– The patron saint of comatose children, of
Alzheimer's patients, of people buried beneath the
rubble, resigned to death, surrounded by those
already dead. The music segues seamlessly into

'Computer Forms' by
Glockenspiel
out-of-tune
asking, 'What
about when all
been pressed?...'
in your bed-
the back of the
sleeping partner,

The Shadow Ring.
and aggressively
guitar – a voice
will they write
the buttons have
and you answer,
room, aimed at
head of your
in a whisper:

/

(Those desperate hours (though they may only be one
or half or just a few elongated minutes) in the abyssal
stretches of the night, lying there, racing over and over
the same worried groundlessness in your head – a
sightless, senseless probing of your fears, ailments,
aspirations, forgotten errands (years ago or hence),
lost purposes – all lashed together into a huge fuck-off
ball you struggle within AND IN your arms like a
bald cuckoo you're forced to parent. 'What will I [...]?',
you mouth to the ceiling. 'How will I ever [...]?', you
think, tracing over and over the idea of a face in the

pattern on the curtain. Another in the artex'd wall.
There's nothing for it, no solution to be found to your
endless problems. And beside you, sleeping soundly,
your partner is elsewhere – they cannot comfort you.
In the morning you'll have to leave, you'll have to
abandon this life. It was never going to work. Idiot.
– You return to the bundle of insolubles,
converging now into one huouge fleshy orb,
and you decide to SWALLOW IT, tears well-
ing AND UP, and you feel it move slowly,
with difficulty, down the alimentary canal).

/

If it's like this in the morning,
we'll go to the doctor.
Of course, in the morning,
it's like this.

/

(In terms of surrogates, the durian fruit looms as
the paragon. But in this instance and at this stage
a satsuma or a clementine (whichever is tarter) is
probably more apposite. Something about the tex-
ture as analogue for some rather graphic skin condi-
tion, tempered by the alien colour – a colour seldom
found in the body but one that, when thrust into the
imaginative context, might imply some particular-
ly effusive relations: iodine & mould, for example.
The lurid orange lichen sharp-popping on the side
of the headstone.) A podgy, jolly little sphere. ()

[...] in the middle of the South Pacific Ocean, a

thousand feet below the surface, what is believed to be an alien spacecraft is discovered after a ship laying transoceanic cable has its cable cut and the United States Navy investigates the cause. The thickness of coral growth on the spaceship suggests that it has been there for almost 300 years or THEREABOUTS. A team made up of marine biologist Dr. Beth Halperin (Sharon Stone), mathematician Dr. Harry Adams (Samuel L. Jackson), astrophysicist Dr. Ted Fielding (Liev Schreiber), psychologist Dr. Norman Goodman (Dustin Hoffman), and a member of the US Navy (Peter Coyote) are tasked with investigating the spaceship. The team (along with two navy technicians) are housed in a state-of-the-art underwater living environment called The Habitat during their stay on the ocean floor. Upon entering the spaceship, the team makes several discoveries.

The first is that the ship is not alien, and that it is in fact an American spaceship. They assume, due to the years of coral growth and the sufficiently advanced technology, that the ship is from the future. The last date in the ship's log, 06/21/43 (21/06/43), does not indicate the specific century (!!). The last entry in the log details an 'Unknown (Entry) Event', which depicts the ship apparently falling into a black hole, resulting in its trip through time. The ship's mission involved gathering objects from around the galaxy to bring back to Earth. An item of particular interest is a large, perfect sphere in the cargo hold. It is suspended a few feet above the ground and has an impenetrable fluid

surface which reflects its surroundings but not people.

Harry concludes from the classification of the event which sent the ship back that The Habitat crew is fated to die: it would not have been an 'unknown event' if they had lived to report about it, he reasons. Harry soon sneaks back to the spaceship, and finds a way to enter the sphere. Soon after, a series of numeric encoded messages begins to show up on the habitat's computer screens, and Harry and Ted are able to decipher the messages and converse with what appears to be an alien (which calls itself 'Jerry'), which has been trapped in the sphere. They soon discover that 'Jerry' can hear everything they are saying aboard The Habitat. Harry's entry into the sphere prevents the team from evacuating before the arrival of a powerful typhoon on the surface, forcing them to stay below for almost a week. A series of tragedies then befalls the crew: Fletcher, the navy technician, is killed by some aggressive Sea Nettles, whatever the hell they are; a giant squid (crockery eye) attacks and damages the station, killing Edmunds by completely pulverizing her body, Ted by blasting him with a large fire blast, and Barnes by slicing him in half with a computer-operated door in the ensuing chaos; and sea snakes attack Norman. Jerry is the cause of these incidents.

Eventually, only Harry, Norman and Beth remain. At this point, they realize that they have all entered the world of the perfect sphere, which has given them the

power to manifest their thoughts into reality. As such, all of the disasters that had been plaguing them are the result of manifestations of the worst parts of their own minds. The name 'Jerry' turns out to have been erroneously decoded and is actually spelled 'Harry'; it is Harry's subconscious communicating with them through their computer system whenever he is asleep. At that point, Beth's suicidal thoughts manifest themselves as triggering a countdown to detonate the explosives that were brought along to clear away the coral. They abandon The Habitat for the mini-sub, but their fears manifest an illusion of the spacecraft around them. Norman finally sees through the illusion, and punches the mini-sub's emergency surfacing button. The explosives destroy The Habitat and the spaceship, but (unknown to them) the sphere itself remains undamaged. As the explosives detonate and create a huge blast wave below it, the mini-sub rises to the surface, to be quickly retrieved by the returning surface ships, permitting the survivors to begin safe decompression once on board a navy ship.

The film ends with the three deciding to use their powers to erase their own memories before being debriefed, in order to prevent the knowledge about the sphere from falling into the wrong hands. Thus, Harry's paradox, in which they are alive yet no one has learned about the 'unknown event', is resolved. As they erase their own memories of the 'unknown event', the sphere is seen emerging

from the ocean and flying off into space...* ETC.

/

Then we watched *Westworld* – another Michael Crichton movie adaptation. He might have even directed this one. It's much better. Brutal and certainly less intellectually pretentious. There's no attempt to explain the intricacies of the robot cowboys, knights and Romans that wander about the three themed Worlds for the titillation of the human guests. At this time, technology is sufficiently advanced for this sort of shit to go on, that's all. Of course – and this the same lesson provided in *Jurassic Park* – the robots go wrong, and the film swings into its moral, paranoiac fina- le. Best of all is Yul Brynner as a cowboy robot baddie, who plays the fall-guy robot for the wealthy tourist's sheriff fantasies – turning mass murderer and terrifying nemesis to the film's heroes when the robots malfunction.

Afterwards, we talk about his perfect bald head, so easily confused with a latex industrial product; his handsome, serious face moving with animatronic uncaring. Lifting his face off to fiddle with the thicket of wires and glowing LEDs behind it. Flinging a flask of hydrochloric or sulphuric acid at his face. Both these scenes remind us that this isn't Yul Brynner, but a robot; not a man but a machine. That we should never confuse the two. But you say you wouldn't mind that: being confused with a robot – or

rather, that you wouldn't mind confusing yourself
with a robot. That, seeing Yul's face melting off to
reveal that thicket of wires and glowing LEDs, made
you yearn to be some insensate robot capable of
functioning in spite of any wound, any infliction.

You're intimating your suffering.

Sitting through two Michael Crichton films – sitting
through any two films – was very, very difficult.
You were constantly swerving between diegetic

absorption and
throughout. I
engrossed in the
way through
Kronenbourg.
whole bottle
It's tricky, you
apparently one
tolerance to the
low-dose morphine

abject, pained reality
didn't notice: I was
film. I drank my
a six-pack of
You drain a
of Oramorph.
say, because
builds up a
analgesic effects of
pretty quickly. So

I need more and more to provide the same relief, you
say. It's particularly good for the relief of the growth
pressing HARD on my vertebrae; this fistful bastard
makes getting comfortable almost impossible, you say.

It's also difficult to watch anything particularly
emotionally manipulative. Any emotional wrench-
ing – regardless of how flagrantly sentimental or
gratuitous – is increasingly difficult to deal with.
I cry at the drop of a hat, you hold back. The same
goes for music: Bartók leaves me sobbing.
I wept uncontrollably listening to *West Side Story*.
Paralysed by *Suite bergamasque*, Baden Powell.

– And it's not cathartic, not at all. There is no solace
in feeling these things – they are merely catalysts
for my own self-pity, primed to drag me back to the
despondent self-absorbtion of my fucking illness.

Sphere and *Westworld* both allegorized my condition,
and sent me plummeting into a Pit of Despair, from
which it will take me a good few hours and some
consistent distraction to pull myself out OF FROM.
Those few things I can bare are those things that nei-
ther offend nor inspire. Nor do anything, really. Soap
operas are perfect, for example. Sport is
perfect, for exam- ple. Fucking darts,
or something. Snooker. *Ski
Sunday.* A con- temporary chil-
dren's book. A magazine about
cars. Something flat but capti-
vating. Abso- lutely smooth.
A massive sheet of stainless steel,
heated by the sun to an agreeable
temperature (spring sun. That forgotten
sun returning after a lifetime of winter blacks, greys).
You lie on it unselfconsciously, not caring who sees.
Nature documentaries seem like a good idea, so long as
you don't fall into that anthropomorphic trap and start
romanticizing the plight of whatever baby whatever.

Whatever. Find that thing, and cling to it for dear
life. Otherwise it's emotional immolation for you.

(At the end of *Westworld*, Yul Brynner's demented robot
kills the protagonist, then turns to the camera and
shoots a single round from the hip to turn the screen
black. Sad Jimmy Bond. 'THE END' appears

widely TRACKED and in the centre, written in poorly animated, warmly graded blood (same blood drooled by the cartoon vampire that replaces the MGM lion at the beginning of *The Fearless Vampire Killers*). Set in Grotesque, BOLD and of blood. The theme tune – some unreleased Wolf Eyes track – careers in like a bad steel bull. Credits roll from top to bottom and are also set in Grotesque, but Light and coloured fluorescent pink on acid green. Strobing, perhaps.)

('ETCETERA ET-CETERA', sung by Yul, on his own in his trailer on the set of *The King and I*, staring blankly at the golden brocade and deep-red flocking of his fabulous, regal coat – staring into one of those make-up mirrors, lined with spherical bulbs. He's on call. A cigarette steadily burning up in the ashtray to his right (left in the mirror), a glass of bourbon and slow-melting ice to his left (right). His head emanating a certain heat (a haze loitering as a halo).

On closer inspection, beads of sweat prickling through the heavy, crude Asiatic makeup. A small patch of putty covering a particularly nautical vein that pumps fiercely on his left temple. Not a vein, but an untidy rise of blue cabling just beneath the latex skin. Blue cabling threading through what turns out to be – not a skeleton of bones, nor a metal armature, but a mahogany scaffold, Renaissance in its engineering, Baroque in its florid detail! Tiny pyrographic vine motifs enwrap

the wooden 'bones'. The skull, notably. At the crown,
the vines converge around a panel that depicts, in
something Runic, hieroglyphic (we can somehow read
it, though), the growth of some thing – the swelling
thingy eventually takes over a body, replacing what-
ever anima the body might have had with a kind of
liquid-clay shadow that, for a while at least, functions,
albeit at a very simplified level (eating, drinking,
sleeping, fucking, shitting, etc.). Accordingly, it takes
a while for the others to notice. Eventually, however,
the fluidity of the surrogate begins to be stymied by

state change into
one extreme, and
the other. These
conspicuous in
to the original –
being, whatev-
cuddle', is how
put it. This
tably, to the sad
surrogate subject.

dry, cracked earth at
brown smoke at
states are more
their difference
the person, the
er. 'Harder to
the hieroglyphs
leading, inevi-
ostracizing of the

Stepping back, it's clear you've made a complete mess
of Yul's head. Shit. Latex skin peeled back, split –
hanging in obscene sheets down his back – parcels of
cabling jutting stiff in every direction. And that beauti-
ful mahogany edifice revealed shining with a beeswax
lustre, the intricate designs of vines creeping up and
about the wood in precise, burnt gullies. Not vines but
briar, densely thorned, leading up to the cranium and
the hieroglyphs whose object, it seems clear now, is
that frightening deity of CGI'd fat and flesh – a capsule
of pulverized flesh, worshipped or at least beatified.
A future foodstuff, genetically engineered and grown

on the side of a fallen tree, accidentally discovered by
dog walkers some time in the twenty-
second century. Meat-spheres. One of which mu-
tates, gains the power of thought, rebels, enslaves,
becomes a god, devours and devours and devours
everything till there's no sustenance left. Etc.

– You go. I'll clear this ungodly mess up.)

/

The tumour, span- ning many acres now
– many leagues, fathoms (lots of
archaic measure- ments) – turns
over in its sleep. Sweating. It
begins to snore erratically, air
sucked in past various puddles
of various sub- stances of var-
ious viscosities, at least one of
which rainbowed and flammable
– gathered in those rock pools at the
threshold of [...]. It's an unbearable sound – somewhere
between a landslide and a child grinding their scabby
milk teeth. Somewhere there's a mouth, webbed and
underdeveloped. Somewhere. Teeth as stalactites and
-mites at the mouth of a cave used exclusively for the
maturing of a provincial cheese that it's illegal to carry
on public transport. That, even in the region it hails
from, is considered an acquired taste, and is commonly
seen at open-air markets writhing with maggots whose
digestive secretions lend the cheese its peculiar charac-
ter. Tiny yellow smears of excrescence providing the
SINCERE tang, the reverie. It all proves too much
for us, and we sprint away from the *fromagerie* giggling

with the scandal. [...] Deeper inside the cave there's a
dramatic diorama of skeleton Neanderthals surround-
ing, as if in a Nativity, a smaller skeleton, prone on
a great slab of rock, with each encircling Neander-
thal plunging a sharpened, now-petrified stick into
what was presumably its abdomen. The scene comes
alive in the flickering light of your flaming torch. [...]
Deeper still is the epiglottis, flexing its cartilaginous
wings to usher you deeper, downwards, through the
brawny pothole. There are taste buds on the epi-
glottal wings, each one an eyeball that winces and
weeps as you sweep your torch close.

(The dreams of the tumour
are sluggish things and
are generally banal. Sartorial
error, embar- rassment in
the workplace, inappropriate
sexual fum- blings with
half-forgotten acquaintances,
etc. These vapid revelations inevita-
bly disappoint. Though they do point out an opaque
truth concerning the mundanity of this disease, the
boredom of that possible death. And God! the fucking
demands to undertake white-water rafting, balloon-
ing, bungee jumping and the like – the demand for
some pre-death disco – is a terrible, obliging myth
started by a cabal of countercultural gurus turned
Silicon Valley cunts. The coercion of positivity, the
demand to BE BRAVE, BE HAPPY – to face death
LIKE A MAN. 'Man up' and 'grow some balls'.
You confess to feeling this duress. How on earth is one
supposed to respond when the only thing that really,
truly appeals in these final days is COPIOUS weeping,

funereal-fantasy and the next, ever-
heavier dose of drugs? This as you unwrap
another book about alternative medicine from a
friend who has absolutely no idea what to say to you.
They look at you from behind pea-souper eyes, head
cocked to one side, brow crumpled, a 'tut' coiled on
the tongue ready to be employed in disbelief and
agreement at some sad whatever from you. Yes,
you're implicit in this exchange – what else for it?)

(Save for tonight, perhaps. When you, up above, are

out, alone, trawling
something – a
Sex, maybe.
Probably just an
disaffection, of
your condition.
of melodramatic
soundtracked in
Barry's 'Mid-
theme (the romance

the local bars for
fight, perhaps.
Probably neither.
affirmation of
the romance of
A performance
proportions,
a style after John
night Cowboy'
of prostitution).

And down below, in that gutted recess, the tumour
turns over and, in a parallel movement, enters another
dream-territory, via a previously unnoticed interior
screen door. Inside, the Staked Plains yawn smashed
teeth and a battle is pitched between an indigenous
horde and a uniformed wedge of cavalry. Gun smoke,
whistling arrows, harmonica. The tumour, in the guise
of a buffalo, picks its way through a carpet of corpses,
each more riddled with arrows, more unrecognizable
than the last. The tumour comes to a figure so
arrow-suffused as to have transformed and happy
into a hillock of spiny grass. Spiny grass daubed with
cuckoo spit. And the tumour starts to graze, forgetting

the battle, enjoying the peculiar sensations, getting
a grip on the controls of this vehicle and its tastes.
Suddenly the tumour feels a terrible pain sear down its
spine and wheels round to discover a cavalry soldier
standing over it, a long foil unsheathed and plunged
deep into its back. The tumour collapses, paralysed
(some vital nervous subsystem has been severed) and
the soldier, smirking all the while, proceeds to skin
the tumour alive, scraping fur back from raw mus-
cle with remarkable proficiency. Within moments he
whips the entire pelt from the trembling body with a
flamboyant gesture.

a geodesic net of
He turns back
now exposed,
sets to dis-
it. Heaving
gash opened
genitals. A cold
it ALL out in
rest on THE DRY

He hangs this over
sticks to dry out.
to the tumour,
uncooked – and
embowelling
gore from a
from chin to
hand pulling
great fistfuls to
EARTH. The

SLAP! of a lung on THE DRY EARTH, etc. Each
organ, each unrecognizable form, will serve a purpose.
We understand. If not as foodstuff for the hungry
party (loitering a ways off), then dried for aphrodi-
siacal use, or stretched into something like a hat or a
condom. 'This thing (holding up a fistful of wet red)
will be consumed by me at the height of a ritual. It will
endow me with special powers [...]. This thing (a sheet
of sagging caul, like brown, once-worked pizza dough,
hung over two fists) will be draped over the lowest
branch of the nearest pine tree, thereby appeasing
the ire of that Peculiar Fleshy God. This stuff (a jet of
milky-white liquid expressed from some pink hosing (a

wrench of pain)) will be heated up, mixed with some of the blood from your head. The mixture poured into a well-greased cake tin and baked.' All of it going to good use. Though at the moment, everything accruing in one huge slag-heap of bits and stuff beside the soldier. Finally finished, the soldier stands, exhausted and coated in blood, eyes and teeth obscenely white against red ground. The tumour feels DE-STRESSED.)

/

Waking with a start,
moment to wriggle
and remember
it is, what's
the END of all
and to resume
SUB ROSA
in through the

it takes the tumour a
free of the dream
where it is – what
possible, what
this might be –
its brooding,
(*). You crash
front door.

/

– You know what I mean. I mean: the tumour is growing at an exponential but forecast rate. AS IN, nothing unexpected has happened. To interrupt its enlargement, as in. AS IN, there's nothing to worry about. Save for the tumour, which may or may not be on the war path.

/

A cave again, this time somewhere in the Arctic circle. Or bored into the side of a ridge in the Himalayas. Or a mine in an abandoned colony on Neptune, a sign

hanging above the entrance, proclaiming something in some unknown pictographic language. A pall of Neptunian dust. Inside this cave it's unbelievably cold. And dark. The kind of darkness that threatens to gouge out your fucking eyes. The kind of darkness that submerges, strangles. There is a smell in here – something forsaken, aeons old, still clinging to the impervious walls. Walls like sheet-metal once used as a massive, geological griddle for the exclusive purpose of cooking buffalo *a la plancha*. Or some sort of megafauna, awkwardly straddling those final, absurd dinosaurs and the modest mammals concurrent with us. The smell of these things cooking against these walls, and over the course of a million years or so – the heat supplied by the weltering blood of the conti- nent – suddenly soused by the instantaneous appearance of a massive ocean FLOORED with vents and infested with coe- lacanths. Then all of this ICED. (Seen in bored time-lapse with sweeping soundtrack) [...]. Towards the back of the cave, the smell intensifies then swerves into something faecal. (You can feel the darkness on your outstretched hands – the shitty stench under your fingernails; the cold, of course, is IN YOUR BONES.) (The acoustic is worth mentioning here. Reverberating footsteps describe something like a tunnel, the walls either side are surely close – just beyond your flailing fingertips, though the entrance behind you and the whatever before are both uncertain. The peculiarities of the echo in here. You blurt out a couple of incoherent yelps, then a yell that's threatening enough to shock you. Then a weirder noise, something

unpredicted. As in, you didn't know what you were going to say until you said it. The name 'Greg'. ETC. Each of these utterances echoes in such a way as to imply a third aspect, something between your voice and the cavernous echo. You describe it later, in the interview, as like double-tracking on your voice, like a chorus addressing the audience with dramatic irony (the audience skulking silently in the darkness, ahead or behind. Probably behind) – relating a truth CONCERNING you but UNBEKNOWNST to you. This chorus gazes out through your function-less eyes, uses your mouth to communi-cate – embedding their laws in that slight trough between voice and echo. This cave, you think, is a theatre. But I'm not an actor, you think. At least, not in a tradi-tional sense. I do *suspect* I'm an actor. You whisper some-thing, apparently under your breath. Something some-thing something. You picture your breath before you, hanging in the air, perhaps drifting over the surface of an audience member silently pacing backwards, inches from your face, not breathing, not making a sound, just observing you – all-pupil, all-black eyeballs swivelling maniacally in ample sockets. Only it's too dark to make any of this out. Still, in absence of any confirmatory sensation, this is all certainly true. Finally, with a sharp inhalation, your loving hands find something: a sur-face, maybe the back wall of the cave. Simultaneously, the acoustic changes to something closer. The dead-ened air of a summer path somewhere at around about sea-level. And underfoot it feels like moss. Or maybe

54

industrial foam. The SURFACE beneath your hands is
something else, something wet. Some of that slime that
musters orange on the side of an autumn tree, perhaps.
Clammy. Like the way one might imagine the hands of
the week-long dead. The underside of a banana slug.
The snout of some big game. Some excrescence to be
dealt with in the preparation of some exotic foodstuff.
The combined foreheads of an entire residential home
on the brink of closure, bowing to the pressures of
a suspicious inquiry. The thickened space between.
Unimaginable on Neptune or any of its moons. It's an
internal texture, a non-surface not meant
to be touched; it is a non-surface,
absolutely indescribable
because – un- der any other
circumstances bar invasive
surgery – it would not be
exposed to any kind
of NERVOUS APPREHEN-
SION. So it smells of nothing,
looks like nothing, feels like nothing,
sounds like NOTHING. Only here, at the
back of this frozen cave, the surface springs into
vivid, terrible being at the first touch of your
trembling fingers. Every sense is arrested simultane-
ously, bombarded with EXTREME PREJUDICE:
a great rent in the PRECIOUS silence of the cave. A
glissando of atonal percussion founded upon a
shifting clay bed of sub-bass; a thick seam of brass
pumping vast swathes of ridiculously oiled muscle,
torn, sprained, PULLED into taut potentials, suspend-
ed, irresolute chords spinning the treble and carving
a fresh tunnel down and to the left of your ear drum,
circumventing those flimsy bones, those trilobite

coils of cartilage, skipping the need for the hairs, twinned with the cilla that wigs your lungs, that waft to the movement of the air that etc. etc. None of that. A brutal hole gouged out of your inner ear, leading straight to that dank region of the brain, seldom used, that can be purposed kinetically. A Harry Partch instrument, unrealized. – A Polyphonic Microtonal Spirit Organ (PMSO). This sound is not sound. – A stink, then, ushered in by the KETTLE DRUMS, crashes against your nose, struggling upwards, into your flaring nostrils, and, impatient, permeating your skull, and heading deep into those dangerous WETLANDS of the brain. Fluorescent yellow putty ROUNDING OFF all those annoying vortices. And it's something like SAGE, only intensified a hundredfold; lined, beautifully, with a shine of slurry. Gangrenous tissue & BRASS – the metallics of blood, frankfurters – an illicit KISS of acidic, chapped, sphinctal, corky LIPS. Hills as far as the eye can see, each one composed of raw sewage with a propensity for lilac, perfumed toilet roll; a swatch of magazine perfume smeared with a CRINKLE (expressed on the piccolo) over a sea of bald, sweating heads; greasepaint, daubed over a dense wall of UNKEMPT GENITALS [...] All of this collapsing, inevitably, into taste in the mouth, and gagging, retching, vomiting, over and over. (The honesty afforded! The thrill of it all!) (Piss sloshing in slo-mo waves, foaming at the crests, bluing, mingling with extra-thick Domestos; rafts, dinghies, plastic kayaks disguised as rim blocks and toilet

mints, cast about, crewed by lepers, lizards in cute
naval rig, fat naked apes, your unfazed mother, etc.))

(When a boy or girl grows up to sufficient size or
age (fat, adolescent), a *Pa-lo-tle-ton* is set apart for his
or her EXCLUSIVE use. This thing right here is a
buffalo robe, neatly dressed, made of a full skin, with
the head fastened by the LIPS to the heads of their
lounge-like, willow beds. The *On-ta-koi* is the ordinary
robe for the bed. It is only a half robe, mind, and cut
off at the neck ALSO. The hide of the *Pa-lo-tle-ton* is
carefully taken off, with all the skill of
the taxidermist, so as to preserve
its full covering of the head, with
even the horns and eyes and
EARS AND LIPS, and also
the legs down to the hoofs,
and sometimes even the hoofs
are retained – even, perhaps,
sods of drying earth as wedges
protruding from the base of the
hooves – even, occasionally, the skeleton of some
Neanderthal foetus, dangling limp from that stiletto of
earth. Beneath that, newspaper spread out (the sports
section) to catch the clods of mud satisfyingly freed
from between the underdeveloped toe-bones with a
butter knife. This is the way it goes. Tough shit.)

/

It is a well observed fact that, when provided with an
appropriate amount of terracotta clay (as opposed to
that grey, Comprehensive School stuff), elderly
outpatients in particular will more often than not roll

a near-as-damn-it sphere between their two dorsal palms. This, however, is a fleeting form: almost immediately – after a couple of ponderous moments holding the spheroid aloft between forefinger and thumb (and perhaps a couple more moments observing the Celtic dying of the other hand's palm with terracotta blush) – the sphere will be squashed into a disk, the disk then rolled into an extruded spiral, the extruded spiral then homogenized, SUBSIDED into a cylinder. A few moments attempting to flatten the ends, then the clay is discarded. (We found one of these on the bedside table which happened to be weighing horrible-heavy on the manuscript they'd been desperately trying to finish before the end. You got bored reading it, perched on the edge of the bed, and, against the assumed propri-etary etiquette of the mourn-ing, declared it insipid (!), deriv-ative (!), tepid (!), and promptly burnt it in the incinerator in the back garden, along with a mountain of exercise books we'd claimed from the skip a month before. A month ago, we wanted to keep everything. This month, October, is a more realistic month. We have no room and we and our current shit must take precedence. A-men! you cry, jostling a gardening cane in the blazing incinerator, sending a particle effect of embers and ash up into the TWILIGHT. Again, you've managed to polish off a whole plastic bottle of Oramorph, while I, unimpeded (*well*, to the best of my knowledge) only had a couple of glasses of red. Incidentally, it's the red you brought home the other month (that same month that feels so, so long ago – that month of resolutions

and potentials and sex) from the posh shop. NOT
the usual cheap shit. Now stood on the counter top
in the kitchen with one of those rubber stoppers in
it. Not the cork, that was decimated in the opening.

/

You're still not really eating. You can taste nothing,
apparently. Which I find hard to STOMACH, consid-
ering the effort I put into the meals, night after night. A
protest, of sorts – though you could easily call it denial.
I like to think (not 'like': again, a lie) that it's the tumour's taste. That the tumour is the one with the ashen palette, the overly sweet tooth. Sugar sprinkled liberally over Original Alpen! A WHAM! bar, etc. The juvenile desires of that cellular rapist that is, at this moment, the size of a golf ball or a gobstopper. I fuck-
ing hate golf, you say, and we share a smile. The camera
plummets in, past the smile, down through the red lab-
yrinth and slows to a stop before the altered tumour – a
false idol to that fleshy god, always-already rendered
in the latest HD technology – an Nvidia graphics card
with some unholy amount of memory, running on a
quadruple, quad-core thing with two massive monitors
– one for editing on (vivisection), the other for view-
ing the rendered footage. The rendering on the hair
of the GOD: moving in treacly gusts, slow, as if held
underwater, snagged in the hatch of the bathysphere by
the sleeve of the bathrobe it went in wearing; wet-look,
clumped together in attractive, sinuous ridges, the way

you wish you could get it. Perfect drift: a lunar tide, sucking the hair eternally. Perhaps even a few fizzing bubbles added – an excess of demonstrational effect – to CONVINCE. On the surface, the lens of the camera BOBS, the upper half of the image relatively clear, though flecked, again, in an effort to convince, with droplets that act as prisms to the image), while the lower magnifies. Bifocals, then, worn by someone clearly in need of something more variable, less harshly delineated. Certainly a relative of ours. Mitochondrial. And in the distance – seen in the upper, above-water half – a

dramatic shoreline:
fictional island
if you will –
presents a front
screeching
crest of jungle
all that – a
a retarded gape
like mouthwash
KEEN, sharded

the shoreline of a
– a Skull Island,
that forbodes,
of jagged cliffs,
seabirds, a
visible beyond
cave, its mouth
– swilling brine
or drool over
rocks. An ominous

tone from the soundtrack. Still, you decide to strike out, front crawl, towards what looks like CERTAIN DEATH. Fool! – You can barely swim! (The camera shoots upwards to take in the whole scene – your pathetic figure receding against a swollen, dark blue ground – then the island whole, as we pass through a winding sheet of cumulus cloud – a vast, protruding geometry is revealed, to the shrill, discordant strains of a string section, as to be a perfect metaphor for your, um, tumour. A lay estimate might put it at four or five miles across. Your SCULLING figure is now invisible and the scale of the shot starts to buckle under the considerable weight of the analogy, the sea resembling

some sort of amniotic fluid (maybe, as movement is
less apparent from this GOD's eye vantage, agar jelly)
a mongrel iris surrounding the tumour-island, pro-
truding sore and alien and thrumming in the midst of
such uniformity. A shark's fin in its emotional affect.
This coming as something of a shock. Importantly, this
predictability does *not* diminish the effect. We both
cry. We hold one another. Later, I admit [...] the geology
of the tumour seems to confound human physiology.
As in, geology does not belong inside your black-red
innards. A stone. Only it looks man-made, like a mus-
ket ball or something fucking else. Different
to those stones that accrue as a
result of stress or your diet
of cigarettes, vodka. Though
of course, it's precisely that,
all of that, catalysed by
this text. Gall stones, kidney
stones, oto- liths, teratoma,
etc. It's crucial we RECTIFY
any confusion in this matter: the
conjuration that this text performs – is performing
right now – is reliant upon the context it finds itself
in – within – inside your would-be steaming guts.)

/

As previously discussed elsewhere, a model
of the process might be like:

Words – a word – for example, 'GRISTLE' (though
sentencing, paragraphing, type, kern, track, etc. is criti-
cal. And those parenthetical inverted commas are a ter-
rible concession) – seeps in through your bovine eyes.

61

This much so familiar. So at this point, the word's state is closest to gas. Though it's very much really not at all in any way gas. The gas of a Gas Giant – impossible to comprehend, though apparently scientifically verifiable (the science, blah blah, eludes yours and my slow wits).

Imagine GRISTLE whistling in through your pupils: tiny jets of GRISTLE through your pupils. Tiny jets rushing in through your massively dilated pupils – the pupils of a HOP HEAD. This gas is visible, is GRISTLE. There. (At this point, a section clarifying the workings of your eye: The human eye belongs to a general group of eyes found in nature called CAMERA TYPE EYES. Instead of film (or full- frame digital sen- sor), the human eye focuses light onto a light sensitive mem- brane called the RETINA (jab- bing at it with thorny twig). And here's how the human eye is put together and how it works: The cornea is a transpar- ent structure found in the *very front* of the eye [my emphasis] that helps to focus incoming beams of light. Behind the cornea is a coloured, ring-shaped membrane called the iris (think: nebula). The iris has an adjustable circular opening called the pupil (think: sphincter), which can expand or contract depending on the amount of light beams, rays, whatever, penetrating the eye. A clear fluid called the AQUEOUS HUMOUR fills the spectacularly slim space *between* the cornea and the iris [my emphasis]. Situated behind the pupil is a colourless, transparent structure called the CRYSTALLINE LENS (think: the plastic beak of a cuttlefish or -esque). Ciliary mus- cles have the lens surrounded. These thuggish muscles

hold the lens in place but they also play an important, manipulative role in vision *per se*. When the muscles relax, they yank on and iron down the lens, allowing the eye to see objects (bucolic landscapes) that are far away. To see closer objects clearly (the too-close face, looming in for a drunken, booze-saturated snog), the ciliary muscle must contract, shrivel up in order to thicken the lens. The interior chamber of the eyeball is filled with a jelly-like tissue called the VITREOUS HUMOUR. This place is like a flotation tank – meditative, though not for you and your hysterical claustrophobia. A wet elevator. The surprisingly cramped belly of the massive-est whale. Anyway, after passing through the lens, light must travel through this vault and its stagnant pool of stinking vitreous humour before striking the sensitive layer of cells called the retina. The retina is the innermost of three tissue layers that make up the eye. These are unimaginably thin. The outermost layer, called the SCLERA, is what gives most of the eyeball its white colour – the rest of it provided by a complex system of mirrors erected to reflect the image of a scrubbed femur. The cornea is also a part of the outer layer. The middle layer between the retina and sclera is called the CHOROID. The choroid contains billions of blood vessels that supply the retina with nutrients and oxygen and also removes its waste products in an undocumented process we all find incomprehensible. Embedded in the retina are millions of light sensitive cells, which come in two varieties: RODS AND CONES (rods of uranium; paper cones for drinking water-cooler water

OUTUV that while ago). Rods are good for mono-
chrome vision in poor light (that figure... down by the
scout hut at 3 a.m), while cones are used for colour and
for the detection of fine-grain detail (A Frans Lanting
coffee-table photography book – loads of them – in a
bargain bookshop called BOOK WAREHOUSE or
similar. Adjacent: a stack of pink, branded book-cum-
play kits. These a RIOT of spangling girlification).
Cones are packed into a part of the retina directly be-
hind the retina called the FOVEA. When light strikes
either the rods or the cones of the retina, it's converted
into an electrical signal of very low
wattage that is THEN relayed
to the brain via the OPTIC
NERVE. The brain then
translates the electrical signals
into the images we, um, see.
This description is a simplifica-
tion and is gen- erally only ped-
dled in preschool textbooks. 'E' is
for Eye, etc. ('C' is for cyclophosphom-
ide, etc.)) (Polyphemus again, depicted on the following
page, with a long-winded description of how he might
have seen, plus a pedantic revision of his encounter
with Odysseus according to diminished depth percep-
tion. The drawing of the scene is in unfixed charcoal.)
[G]RISTLE gathering treacherous in your eye socket,
mate. Vapour swilling into liquid, ever more viscous,
until, at the opportune moment, it hardens completely
– the difference between snot and dried nasal mucus,
a scabrous pinnacle presented to the wandering finger,
dislodged, PULLED, unexpectedly releasing a great
divestment of moist, gelatinous snot; a pendulous tear,
tipped with a splinter wedged under fingernail (pulling

out some vestige of yer brain: a sneeze with the EYES).
This then swallowed (aided with a slug of whisky and
ice water) – entering the digestive system –
PSYCHOPHARMACOLOGICAL AGENTS.
Gristle, similarly to every word uttered mute by these
pages, contains – within ITS shifted, congealed state,
behind the eyeballs and on – a certain amount of
SOMETHING SIMILAR to dimethyltryptamine
or some such. As with psilocybe or other fungal mani-
festations (the closest similitude), GRISTLE
(for example) might be more

common, or per- haps more effective,
according to the season, according
to certain cos- mic
alignments, etc. For instance,
this month we're in: the
manifest effect of THIS
MONTH WE'RE IN
upon the effect of the words you're
subsuming will directly influence
the texture of the tumour. We're in*.

Those aforementioned rivulets will trace a more drunk
path – will steer a more wayward path across the sensi-
tive outer [...] of the tumour. The result will discern the
metaphorical boundaries – Aztec, Houndstooth, that,
um, mouth of an angler fish – these are brought to mind
more readily than, say, the fluid cursive of a coin toss.
This is seasonal and should be well noted. In about half
an hour you'll come up, and dependent on the height
of the sun in the sky, the temperature of the earth,
the humidity levels, the alignment of the planets, the
amount of gamma rays suffusing the air, the contrast
and brightness of the ambient light levels, the duration
of the GREEN RAY as the sun DIPS (the lolling head

of a CPR dummy), the number of spawn that makes it to full-frog in the dismal pond (if you can even call it a pond) at the bottom of the play area under the shade of the diseased walnut – dependent on the alcohol content of the home brew, the result could well be horrific.

/

Feel its tentacular motion inside your florid gut! Writhe in RAPTURES as your cells are subjected to The Peculiar Rummaging! [...] The twisting, groping shoots of that triffid word, 'GRISTLE', spreading out, easing into your desperate openings. Rimming them with its Stratopharia Cubencil-blue tongue; – quivering, blind – a fractal degenerate of only a few of the darker colours, though each one as rich as Guatemalan chocolate or cacao nibs, even – bitter stimulant halved like a capsule of cyanide disguised as a tooth (the initiation rite involved the dashing out of a full four teeth with a tiny geological hammer wielded by someone else's mum, the gang whooping) and swallowed as if a spot of bile: with a wince. This fractured disappointment spreads out, a patch of time-lapse mould in a forgotten Petri dish, and infests your entire body and in a flash – blooming (*tired*) then receding, until coming to rest, hardening into that clot, into that ballbearing tumour right up in your IN. Meanwhile, upstairs in your brain, VISIONS! (accompaniment by Josef Van Wissem or Carl Stalling or Smegma or Evangelista or Kim Doo Soo. Any or all of these

made unrecognizable by your tuneless hum (I strike
up an accompaniment on my teeth, striking them like
a marimba with my thumbnail (the temptation always
to go for the William Tell overture, only as covered by
Spike Jones: all belches, thigh-slaps and glottal tics).)

/

Then you say, 'The only chance you get is the one
you take,' and we laugh like jackals. This time, as so
often, laughter leads to spasms of agony. Sorry, I say.
'But it's worth it?', an open hand on your
shoulder. You're bent double before
me, one hand to your chest,
tears on a face
I find hard to recognize, let
alone console. It's exhaust-
ing, you say, later. So we
go for a nap.
(You nod off to begin a nightmare
confrontation with the tumour,
to demand, somehow, the cessation of its aggression.
The tumour answers – first in rubbery squeaks, then
renting sounds, a sort of lower gargling. This is the
only way you can apprehend the thing: in dreams.
Sprinting through the long wet grass, away from the
terrible oasis of security lights and the tumourous folly
and its familiar occupant – heading for a long shadow
on the horizon you take to be a line of trees. The sound
of your heavy breathing alongside the swishing and
quiet thwap of the grass. Somewhere behind you (you
do not turn to look) comes your own SCREAM, fil-
tered through everything (Auto Filter, Auto Pan, Beat
Repeat, Chorus, Compressor, Corpus, Dynamic Tube,

EQ Eight, EQ Three, Erosion, Filter Delay, Flanger, Frequency Shifter, Gate, Grain Delay, Limiter, Looper, Multiband Dynamics, Overdrive, Phaser, Ping Pong Delay, Redux, Resonators, Reverb, Saturator, Simple Delay, Spectrum Utility, Vinyl Distortion, Vocoder, Arpeggiator, Chord Note Length, Pitch, Random Scale, Velocity; AKA: Altretamine, Hexalen, Asparaginase, Elspar, Bleomycin, Blenoxane, Capecitabine, Xeloda, Carboplatin, Paraplatin, Carmustine, BCNU, BiCNU, Cladribine, Leustatin, Cisplatin, Platinol, Cyclophosphamide, Cytoxan, Neosar, Cytarabine, Cytosar-U, Dacarbazine, DTIC-Dome, Dactinomycin, actinomycin D, Cosmegen, Docetaxel, Taxotere, Doxorubicin, Adriamycin, Rubex, Imatinib, Gleevec, Doxorubicin, Liposomal, Doxil, Etoposide, VP-16, VePesid, Fludarabine, Fludara, Fluorouracil, 5-FU, Adrucil, Gemcitabine, Gemzar, Hydroxyurea, Hydrea, Idarubicin, Idamycin, Ifosfamide, IFEX, Irinotecan, CPT-11, Camptosar, Methotrexate, Rheumatrex Dose Pack, Mitomycin, Mutamycin, Mitotane, Lysodren, Mitoxantrone, Novantrone, Paclitaxel, Taxol, Topotecan, Hycamtin, Vinblastine, Velban, Vincristine, Oncovin, Vincasar, Vincrex, Vinorelbine, Navelbine. All the gang.) You surge forward, stumbling, weeping, still clutching the brochure, delirious, POOR THING. Under the influence. Any autopsy ignorant of your condition would have a field day. Luckily? at the hospice, they know full well.

/

Later on, in the forest.
Cool sunlight. Shin height brume. Dead trees.

You're a state.
Clothes hanging in ribbons and you're covered in
shit.

Falling to your knees, you begin to frantically fill your
cardboard trug with the various fungi poking through
the decaying forest floor (conocybe, predominant-
ly – along with a few morels, a cep and – careful – a
jade-gilled death cap) – eating the odd one.

Meanwhile, the	tumour shuffling
around Sains-	bury's, pushing
a demi-sized	trolley, picking
up everything	from the
shopping list	you provided
– avocados,	broccoli,
cabbage, cauli-	flower, carrots,
chilli, any weird-	er cruciferous
vegetables, figs, flax,	garlic, grapefruit,

red seedless grapes (the convalescent's archetypal but
tokenistic foodstuff), kale, liquorice, some sad-looking
button mushrooms under cheap cling, mixed nuts,
oranges, lemons, papayas, an overpriced punnet of
raspberries, a few boxes of Jacob's Creek Syrah, a
bushel of rosemary, a bucket of bladderwrack, sam-
phire, a tight wet brick of tofu, sweet potatoes, lots of
tea (green), a few of those pupae-like cassavas, tomatoes
on the vine, turmeric, turnips. Collapsing in through
the front door, slouching towards the kitchen, a quick
glance at the clock, and it starts preparing dinner.
Chopping everything up roughly, flinging it into a
slate-coloured cast iron oval Le Creuset casserole.

Swamped in olive oil and the majority of the red wine.

The tumour devouring the lot as is, *non cuit*, then
throwing it back up and into the pot and popping it
shaky on the hob, bringing it to the boil, then turning it
to a simmer for the next forty minutes. Radio 4,
distortedly loud from a tiny Roberts radio,
the tumour sat massive and oozing under the
kitchen table, waiting. The cat seems to like IT.

/

(And every one of these words
spiralling into feedback,
infecting to the point of nausea
to UPCHUCK that toxic slough
– though not all of it – some
residue re- mains to baste
and bolster the tumour, which
seems to act as a kind of magnet for
that sort of shit – the meatier, bloodier end
of things – the ragged, in-season behind of a put-upon
ape – a raging, throbbing red light to illuminate every
inch of your guts, flooding it all with that stultifying,
sordid light to connote depressed and stricken sex,
lumpen weight, splintered taxation – this month, here –
this month –ß the month after the previous month that
was CERTAINLY free, clean, demonstrably clean.
Softcore, soft focus, nubile, RIPPED. BUFF. Picture
lens-flaring morning light (mid-morning), Egyptian
cotton sheets, perfect, dumb specimens of blasé human-
ity writhing happily beneath. The lexicon of privilege,
an economy of virility, futurity, the texture of insipid
emotional nerve endings, etc. So different now,

WHEN everything I say is heavy with leeches of
clotted shit, loosened with piss from the inside of your
cheek to hang as accidents in the most inopportune
location (public somewhere); blood or something less
dramatic, less decorous, caking the sheets, the mattress,
the walls, the floor – tinting the windows as if for a
brothel or an Argento scene or both or after the crash,
in the ditch, everything illuminated by the brake lights
– the last, too-late dream of the Toyota, now upturned,
leaking its passengers in meaty chunks all over the
place. After a moment's pause, each discreet piece
vibrating, moving, rolling up the hard
shoulder and onto the road – speed-
ing off to join the billions of
other homeless swatches of dead
bloody tissue in a fusional
orgy – the very crucible
within which the tumour is
founded. That spheroid of
terracotta clay, handled warm
by the hands of those closest to a
quiet, moth-wing death – indented with the inopera-
ble, a palmistry of NO FUTURE, every life-, fate-,
etc.-line trickling into a microscopic hole – fired in
the kiln, glazed with a slip of machete grey, used as the
basis for a soup. Retrieved from the bottom of your
bowl at the end of the meal. No – retrieved from your
throat – you're choking on it so I WHACK you on the
back, between the shoulder blades, hard as I can, and
that dislodges it, and you fire it out at an amazing rate
and it smashes the window, splinters the tree, bores a
perfect hole in an apple, tears an Ace of Spades playing
card in two, bluntly pierces the earlobes of an entire
youth club (all of this in super slo-mo and to the strains

of mascagni) – shattering the windscreen of the red
Toyota Corolla, straight into the forehead of the driver,
sending the car careering off the road, and it flips and
flips and flips (we hope against hope it will land right-
ways), crashing down hard on its roof with a speak-
er-blowing CRASH. The brake lights on in the dark,
the passengers eviscerated by the impact. The spheroid
of clay rolling back to the residential home to accu-
mulate another layer of clay, Slip & Fire – the meat,
MECHANICALLY RECOVERED and patted by
blue-plastic-gloved hands into one massive meatball to

be eaten at the climax
while all the rest
Mr. Brain's
of slowly drying
thin wash of
sional glances
direction as
with the task.
down with lager;
served a tankard of

of the meal, by you,
of us are served
Faggots on a bed
mash and a
Bisto. Occa-
thrown in your
you struggle
We wash it
you have been
Oramorph, which

you have been instructed by the doctor you can now
knock back with impunity, which what when you
readily do do between great gobbets of tumour flesh.)

/

(That, um, great and terrible deity, unnamed, cast as
the gravitational antithesis to a supermassive black
hole, a boundless protrusion that repels everything,
is apprehended everywhere. Physically manifest
omnipotence: What a terrible thing! Fleshy sur-
face right there – RIGHT THERE – perpetually
kissing up against you, breathing its hot, belched

breath into your lungs (the smell of sausage meat, coke, onions); its thick nylon eyelashes scraping upwards against your cheek, opening, blind).

INTRUSION

Extruded from a previously unnoticed orifice situated somewhere on your reverse. [EYES ROLL BACK]

Some sort of duct at the very centre of the crown – a tiny pinprick in the eye of the eye of that whorl of hair dreamt up by the skull. Somewhere near the root. Perhaps haloed by a few telltale white hairs, blanched by sheer proximity; SCALDED by hot zephyrs vented from the orifice. (Those hairs are thinner, too. Worried (as in 'worried') to distraction, they're not sleeping properly. Perpetually bolt upright despite the considerable application of calming hair products. (Clays, waxes, mousses, creams, putties, etc.)

/

A grove of silver birch trees at night, signposting the mouth of a cave, are plucked one by one by the light of my torch. The light interrupted by a stooped figure. Not a cave but a slate mine, long abandoned. Abandoned but sporadically occupied by local teenagers. They go there in the nocturnal depths of summer to conduct their bored, occult ceremonies. Thousands of them, sat cross-legged on the soft soil and hard rock down there. A mile down. Breathing in unison, quarrying into one another and the slate-shagged earth with nothing but their combined languor and a bucketful of veterinary drugs passed hand to hand to ass to mouth. An orgy of fecklessness and animal despair. Then a disconsolate voice from the mouth of the mine confuses the scale and petrifies the trees.

/

An elegant hand, while caressing the head, lingers
too long at the crown. A finger delicately tracing the
perimeter of the orifice (an idle game at first, an
infinitesimal sentence, tactile-signed quickly on your
head. You understand that those peculiar etymological
roots common to both 'comfort' and 'vestigial' are
being discussed by fingers and skull. [...] You
understand more than you can speak). A tight black
dot only apprehended as an opening and not a mole or
a fleck or a biro-written full stop when you run your
finger over it. A narrow jet of sulphur-inflected air
FORTHCOMING. An inhalation to be taken for the
alleviation of depravity – a geological vent
VENTING the gas generated as a by-product of the
process of maintaining the memories of forthcoming
commitments – a wind instrumentalized by the distinct
corrugations scoring the edge of the hole – the note,
pitched in wasteland, is a kind of harmonic overtone
between two inaudible voices, whispering down the
precious, velvet network of a bat's ear (a tear welling in
the bat's right eye) – a damnable draft, its true source
remaining unknown despite your increasingly
desperate search about the walls of the flat – we must
submit to wearing an extra layer at all times – a stream
of compressed air delivered from a canister,
intended for photographic purposes but employed here
to dislodge satisfying fragments of STUFF from a gap
between the staves that make up the tabletop. An
emergency TRACHEOTOMY – an incision made
using a paring knife – an old fashioned paper straw jos-
tled into the gash – precarious, gargling breaths drawn
(praying that the wetted, sagging straw will hold till the

76

paramedics get here) – a familiar whistle, through the chipped gap between your two front teeth ('Camptown Races' or whatever – a blowing, aimed as precisely as possible at the flame of a candle – the slightest ripple to interrupt its verticality (LIQUID SHADOWS across the walls) – the straining fan inside the old laptop. Etc.

/

Situated at the precise cranial antipode to the burnt tip of your tongue, as seen protruding between your teeth, just a little, like the cat's. An idiotic, lobotomized expression landed heavy on your face. And the tip of the tongue burnt, a tiny hemisphere raised angry, red – a sore, snagged by the incisors with alarming regularity while eating, maintaining the sore, keeping it from calming, reminding you, with every sharp nibble, of the miniscule orifice at the top of your head.

One day, the escaping breath, the gas, becomes liquid – wetting the cap you've taken to wearing for shame of the hole. A dark liquid. Black semen. Thick ink. And an alarming amount. Discharged when you're worried, maybe, too. When everything feels on the brink of collapse. You're career, you're life. – In those moments when you feel the shameful fraudulence of your existence, your undeserving, your absolute worthlessness.

/

You make your excuses and scurry off – to bolted toilet cubicle, to carefully unpeel the cap from your head in private: gluey black liquor extend like the ill mozzarella. Examined, rubbed between finger and

77

thumb. Held up to the nose and fuck! Running your head under the cold tap, trying hard not to splash water into the orifice. For fear of exacerbating the problem – we'll shave around it, maybe try to stopper it with some sort of makeshift bung.

I've noticed that the white hairs are spreading. I mean, there are more white hairs in the vicinity of the hole now. Spiralling out. And the smell is worse than before. Meatier. I can almost taste it, acrid at the back of the throat.

(Did you always have such a prominent cowlick?)

The next morning, there's an object lying heavy on the pillow beside your head. A black amber to the liquid's sap, it looks precious. Coated in that residual black amniotic SLIP. It looks meteoric; something perverse delivered from a vacuum by a blind midwife – birthed from a vast wet mouth attempting to describe a terrible fire. Coughed up on the table in the interview room – an audible *slap* as it hits the veneer tabletop – a disgusted silence falls. A pause – long enough to make the holding of a breath uncomfortable – then, as the screen FADES TO BLACK, 'Die Moritat von Mackie-Messer' FADES UP.

[And the shark, it has teeth,
And it wears them in its face]

MATERIAL WITNESS OR A LIQUID COP

My daughter says she loves to ice-skate. Which is utterly absurd to me: I staggered out of the fucking desert!

Or, when did you find out? – Or rather, where were you when you found out?

My answer will be an improvisation and not a meditation. Trace evidence. An interview being a crucial step in the processing of a crime like this. Also, a certain channelling going on here. Clairvoyant practice. Mediation. As in, I am a medium.

Or remembering thinking: I used to have a favourite dish but now there's a mosquito bite rising angrily between the third and fourth knuckles of my right hand. And so,

How did that happen?

Or that you might begin by drawing a link between the distended tummy of an undernourished child and that protuberant bite. The mosquito here acting as a kind of intermediary of metaphor and context. A meta-topology of pregnancy in evidence here, also – the entry hole of the bite corresponding to the navel; the hungry belly the anaphylactic swelling, etc. Also, of course, the vaster, brute correspondents of famine, pestilence, etc. – the APOCALYPSE!, dawning in huge ebbing clouds of dry desert horseflies, read tentatively as if a kind of occult smoke signal or a flock of Scandinavian starlings. The drone to drown out your PLEAS, perhaps. Or that single, angry red eye of Jupiter, repulsing everything, sick to death of the sight of everything. Fucking hell!

– I use the hardback edition of *The Great Red Spot and Other Vortices*, as a makeshift weapon whenever required.

Or those phenomenally black plumes of smoke that suffuse the news. SUFFUSE everything.

At night I can't even see you.

Black smoke emanating from some genuine tragedy: a terrible fissure in the rock.

Later, a sandwich-board near the site of mourning declares: 'The Gestation of a Cosmic Maggot!' on one side – and simply 'OUT' on the other. That easy, pub, pseudo-longhand – chalk pen with plenty of comic outline.

Or that sadly, I'm allergic to anthisan. To all antihistamines. Or perhaps merely INTOLERANT. – Though intolerance suggests some sort of ethical failure – that my reaction is unethical. Which is possible, I suppose, as regards some fundamental comprehension of the circle of life, SYMBIOSIS, etc.

Isn't there some precedent for the administering of an analgesic by the mosquito? By CHOICE? Doesn't their proboscis deliver something like an anaesthetic? – In amongst the cocktail of potent natural drugs to thin the blood and prevent coagulation? Aspirin?

Perhaps that's what I'm allergic or intolerant to. Perhaps that's where the unethical is righted. The perversity of the swelling in response to the mosquito's generous administration of anaesthetic.

Or the Superior, Middle, Inferior frontal gyrus. In FORGET reference to the frontal lobe, Precentral and Postcentral sulcus: in reference to the central sulcus; Trans-occipital sulcus: in reference to the occipital lobe. There is an attempt here to get into the world – to get out of this unreal.

Or the admission that I bought a knife.

Beech wood handle and a high carbon XC90 steel blade. Preemptively. In preparatory self-defence. And I'd walk about in the evenings, turning it over and over in my pocket, fondling the soft-metal cuff that restrained the blade inside the handle. Catching the foolish eyes of passersby, firing a look as if to say: What I would do if you fucking so much as fucking, etc., You just fucking try it you fucking, etc. And, beneath: WHERE CAN WE FLEE TO NOW?

Manifest destiny stalking the streets. And – as should be clear to anyone present – not just mine but everyone's. Shuffling inexorably toward the same wet hollow.

An ancient mass grave prophesied all of this – isn't that amazing? The depth of the grave, the position of those interred, the way in which each was dispatched with a single SMITE, etc. Each characteristic of the thing to be read as another warning. From history. Though I don't suppose there's any other way of reading it. Like the kind of expression worn by the surprised dead.

Or the question of a weapon. A weaponized question.

Or the platitudinous, 'As vital, thrilling and life enhancing as anything in modern fiction.'

Or a simple list, a curriculum of sorts: Black Powder, Black Magnetic Powder, Silver or White Powder, Fluorescent Powder, Black Powder Fibreglass Brush, Silver Powder Fibreglass Brush, Fluorescent Powder Brush, Camel Hair Brush, Magnetic Powder Wand, Black and White Lift Cards (100), 2" FP Lifting Tape, 4" FP Lifting Tape, 1 1/2" Plastic Tape, Scissors, Tweezers, Permanent Marker, Ink Pen, Pencil, 'L' Square (Carpenter's Square) or folding scale, 6" Scale, Small 'L' Scale, 12" Ruler, 30' Steel Tape Measure, Hand Magnifier, Blue LED Flashlight, Box of Silicon Casting, Alcohol Wipes, Dust/Mist Disposable Mask, Photo ID Card, Small Jar of Plumber's Putty, Roll of Evidence Sealing Tape, Sterile Swabs (10 or 11), 16" or larger tool box with lift out tray.

Or the kind of uncomprehending expression worn by those confident mortals – those alien and most dangerous people – whose expression is one of bafflement that you didn't just go to the doctor at the first sign. What's wrong with the doctor?, they ask, IN ALL SERIOUSNESS. Their reading of the situation is always so terrifically BASIC, expedient.

For once, PLEASE don't offer a fucking solution – just listen, PLEASE.

Or those *arseholes* grinning, laughing in the cinema as you silently weep. That sensation of utter, obscene disparity.

Or the crimson flesh, the crimson fatted mosquitos, those crimson skies, those crimson dresses, the crimson lips, that crimson flower, all that crimson blood.

Or the gap in the journal here. A few pages missing. The next entry – July 7 – simply reads, '?', followed by a list of repeated consonants – the first capitalized, followed by a string of lowercase, as is customary:
'F'
'S'
'T'
and, most ominously:
'J'.

Being an attempt, perhaps, to document the language of the mosquito. At night, whining obscenities into your ear. Calculatedly obscene stuff, just before tucking in and blacking out.

Or necessary cowardice. As in, running away. The refusal to get caught up in the situation is, in some ways, the baldly ethical thing to do. Though I'm not sure you could live with yourself; always looking over your shoulder. Or jerking your thumb in some depraved parody of a hitch every time a fucking hearse rolls past.

Or the wings, the dangling legs, the weaponry, the flight path, the disease. *Legible*. – But again, should I try to READ a thing like that? I'm not sure the findings would HELP in any real way. A lifetime spent (SPENT) translating the devilry of insects.

Or the clumsy, 'Elegance, verve and style!'

Being symptoms that correspond to the functions controlled by the area of the brain that is damaged by the bleed. Other symptoms include those that indicate a rise in intracranial pressure due to a large mass putting pressure on the brain. Intracerebral haemorrhages are often misdiagnosed as subarachnoid haemorrhages due to the similarity in symptoms and signs. A severe headache followed by vomiting being one of the more common symptoms of intracerebral haemorrhage. Some patients may also go into a coma before the bleed is noticed.

Or the risk of death from an intraparenchymal bleed in traumatic brain injury is especially high when the injury occurs in the brain stem. Orange peel used to rehydrate some ancient, prehistoric tobacco.

Or we return. Back to them plumes of black smoke.

Reading THEM.

A hushed, economic language. A neverending longhand – the pen dragged about, never lifting off the paper. A retarded, BRUTISH hand, as evidenced elsewhere as the disappearing actor of the disaster. No caps: a treacly runnel of lowercase ink, kerned to within an inch of its life. Monosyllabic words drawn out over pages and pages.

Two hundred words for 'sorrow', listed alphabetically.

No full stops, just ellipses.

The longhand of death, really.

Or someone once writing something about the difference between losing a limb and being horribly scarred. The former, a piece of you lost – the remainder still being fundamentally you. Whereas with the latter, you are irredeemably CHANGED, and entire. In the example I'm thinking of it was a burns victim. An index of tragedy. Interesting thought, however, to reverse it – to understand an absence as an index.

Or the deep folding features in the brain (an envelope), such as the interhemispheric and lateral fissure (a deep-sea vent), which divides the left and right brain, and the lateral sulcus, which 'splits-off' the temporal lobe, are present in almost all so-called quote unquote 'normal' subjects.

Or that my longhand is pretty much defunct nowadays. Having amalgamated into a handful of simplified gestures: the swipe, the pinch, the trace, the drag. The tap. The jab. The Poke. My longhand now only employed if required to sign something – which is in itself an increasingly rarified experience. And each time I do I feel further away from any proper, expedient use of longhand. Writing my signature these days feels slowed, dumb – guided by a blind, obstinate hand.

Memories of SELECTING a signature, then rehearsing the hell out of it. Such a simple seeming constitution of self. Today I plump for Grotesque or Gill Sans** predominantly; Baskerville or Century Schoolbook on occasion. As representative typefaces.

Or, I should remind, maintained only by ARCHA-IC rituals. A once proud pragmatism, boiled down to a decorative tic. Like the sediment-gathering lip on certain amphora. Like fucking amphora, FULL STOP.

Or 'expedient meaning'. What might that be? Sounds lazy, dangerous, to me.

– Well, it might be qualified somewhat as a kind of 'First Meaning'. A meaning that's simply sufficient to progress but is pretty much acknowledged by everyone as more or less intuitive. I remember Luce Irigaray answering a complex question from the floor like that. A long pause, then saying, 'This is my first answer.' I remember that. Something about provisionality, plurality, etc. Though I neither remember the question itself nor the event. Also, I think of Badiou or someone very similar to Badiou saying something like: 'This answer will be an improvisation and not a meditation.' Which is similarly SWELL, I think. Again, I can't remember the question.

Or that, in an attempt to remember more, I had this pixellated quill and inkwell tattooed on the back of my hand. A pretty complicated image, I thought. A few good ideas in there.

A history of indices being one.

Or this tattoo here of an elephant (African) and this one of a piece of knotted string.

Or that an index of absence is an interesting thought. Like the missing limb of that amputee over there. The LACK at the end of the forearm as a perverse index.

Along THESE LINES I had this lack tattooed across my forehead. Made sure it was in reverse so that every time I look in the mirror I'm, um, reminded.

Or that understanding the relationship between the brain and the mind is a great challenge. A great challenge. One that shouldn't be taken lightly. Do not underestimate your own mind, for pity's sake.

Or the admission that, WELL, I've killed in dreams before. Wacky, soft-focus murder where PURCHASE with fists or whatever weapon was impossibly slow and treacly, with the result: sleight. Similarly, running away was always a problem. As if on a particularly resistant treadmill. This is classic stuff.

Or culpability. Cytoarchitecture. Which, incidentally, I have no real grasp of.

Or – picture it – cowering behind the low walls of some recent ruin, I'd pick off distant targets with an ornate silver pistola. Not that I actually 'shot' anyone 'dead' – just that my aiming and squeezing off of a round (quiet, wadded) would result in the DROPPING of some figure on the horizon. Death lurked some way off. Reality at arm's length.

Or CONSEQUENCES, you fuck. Which reminds me: incredulity about the possibility of a mechanistic explanation of THOUGHT drove most of humanity to dualism. A terrible error with terrible, terrible consequences.

Or the admission that I've sleepwalked AND SIMI-LARLY. Oh, only ever doing banal, habitual stuff, like fixing myself a jam sandwich or pissing into a waste-paper basket. Though once I did apparently complete a particularly intricate Airfix kit. Transfers, paint and all. I remember the model was part of a subrange of model kits from pre- and a-human scenarios – in response to the demands of those children who had no interest in war machines, cars, architecture, humanity. Mine was a pterodactyl, though I distinctly remember a nebula, a deep-sea cephalopod, and a cross-section of an as-tral spider's egg sac as other possible projects from the range. Complicated stuff like that. 'The Ninth World', the range was called.

Or that I might then quietly think of the case of the woman in LA who, one cool spring night, murdered her entire family. Slid out from under the covers, padded into the bathroom, retrieved the blade from the Gillette, returned to the bedroom, slit her husbands throat, went next door to the daughter's soft room and did for her. Then, um, drove some fifty KILOMETRES to her parent's home in her pyjamas and slippers – let herself in, PADDED up the stairs, and ended them where they slept. Drove home, crept upstairs, took a piss and went back to bed. BESIDE THE HUSBAND'S CORPSE. She'd been asleep throughout and was subsequently ac-quitted in court.

Or I say, in response to this and so much more, 'That can't be right.'

Or something like that. Diminished responsibility, at least. The thing that sticks in my head is that scene where she's sleep-removing the blade from the razor. Such an intricate operation!

That and the look on her face throughout: complete serenity. A markedly beautiful sleeper, she was.

Or we remember Tarzana. Where she lived. Remembered in fragments with surf-rounded edges. Smeared edges. Legato edging.

No sound – slow-motion – tight focus.

Or there's nowadays, by which time she lives in the void and of course glancing occasionally at her hands as if in an attempt to catch them off guard. Her hands were lucid where her mind was not. A dreadful thought, that: lucid hands. That we understand anatomists as describing most of the cortex – which is a slice of the brain, after all – the part they call the ISOCORTEX in most, and something else entirely in HER – as having six layers, though not all layers are apparent in all areas – and even when a layer is present its thickness and cellular organization may vary. Several anatomists – if very few I've ever met – have constructed maps of cortical areas on the basis of variations in the appearance of the layers AS SEEN thru one of those cheap plastic microscopes. One of the most widely used schemes came from Brodmann, who split the cortex into fifty-one different areas and assigned each a number (some anatomists have since subdivided many of the Brodmann areas). For example, Brodmann area one is the primary somatosensory cortex, Brodmann area seventeen is the primary visual cortex, and Brodmann area twenty-five is the anterior cingulate cortex. Something like that. Brodmann area twenty-three is, I think, entirely missing in our example. Which might go some way to explaining the lucidity of hands, in her case. As discrete from the lucidity of the mind. The absence of area twenty-three being connected to certain cases of Cotard's syndrome, also – the syndrome being a rare neuropsychiatric disorder (or genuinely neurological, in the case of a lady from Tarzana) in which the patient holds a delusional belief that they are in fact dead (either figuratively or literally) – that they do not exist, are putrefying, or have lost their blood or internal organs. In rare instances: delusions of immortality.

Or the recollection of that Peter Lorre vehicle, *The Hands of Orlac*. Or perhaps it was simply called, *MAD LOVE!* Lorre plays an insane surgeon who transplants the hands of an executed murderer – a notorious strangler, to be precise – on to the arms of a concert pianist who's been in some dreadful, HAND-RELATED accident. The preposterous result of which being both the pianist's inability to play anything bar 'Chopsticks' with his new thuggish hands, and a proclivity for strangling.

I remember a close-up of the transplanted hands: hairy, perhaps tattooed. Comically unsuited for piano playing.

Or the thought that material CANDOUR is something else.

Or those examples of typical trace evidence in criminal cases that include fingerprints, hairs, fibres, glass, paint chips, soils, botanical materials, gunshot residue, explosives residue, and volatile hydrocarbons (being arson evidence).

Or the truth, then, rising up in great black plumes from that slag heap of noxious stuff.

Or we could chant, together, eyes closed:

Seagulls wheeling above
Great steppes of guano.

Or a detail to the northwest: a wet, dead fox with ropey URBANIZED tail.

Or that wonderful correlation between the romantic lexicons of snakes and smoke. Those forked tongues of flame, too. Though perhaps, really, there's a similar sort of EASY correlation between snakes and more or less everything. Snakes being a pretty fundamental shape, a pretty fundamental movement. The topology of a snake is pretty much just a sausage, isn't it? A turd by any other name. Which is the material RESET. In the end, etc. SCAT.

Or, O! those horrible tan-lines from wearing a Casio and a wedding ring. I took the watch and the ring off at 3.30 (a.m. or p.m., who knows. Besides, it's analogue), to fling in a sorry bundle at the retreating back of my soon-to-be-ex-spouse.

Or another dream where I'm employed as a kind of evidence gatherer in some subterranean world. My task is to retrieve those incriminating items that suspected criminals might have tried to dispose of by flushing down the toilet. At one point I find a severed finger. I bag it up and send it off to the lab for tests. Which involves me posting it through a fissure in some rock. After which I look down at my right hand and too late realize that the finger is mine! I comically slap my forehead with my good hand, pause, then continue about my business. Evidently this sort of thing happens all the time. And it occurs to me that this position I hold – a kind of forensic binman – was bestowed upon me as punishment and for killing my family in my sleep. In fact – and this dawning as a very real and very terrible revelation – I am here gathering evidence for the prosecution AGAINST me! The finger! I curse myself for being so easily suckered. A recurring dream, that.

Or the too-late comprehension that my body will testify against me. I plead innocence in spite of my blood-caked hands. A plea for a revision of the location of culpability! As in: it's fucking cellular! – If a murderer's hands, transplanted on to the delicate wrists of a concert pianist, are still a murderer's hands... Well, what then? We're all doomed, is what. Doomed to incarceration and (self-)flagellation.

Or this damnable case. The exception that proves the rule, no? Though anyone who knows about this sort of thing will tell you that it's no fun at all playing the juridical guinea pig.

Or subsequently the entering of a plea of diminished responsibility. As if responsibility were scalable. – Surely you either take it or not, are given it or not. What you do with responsibility is your responsibility. End of.

Or, while the juveniles are almost transparent, adults are dark brown and covered with a gelatinous sheath. This truth seldom revealed.

Or there's THIS, off the TOP OF MY HEAD:

(((((Hindbrain – Myelencephalon (thoughts of he), medulla oblongata (Saguaro, Papago, Arizona, 1938), medullary pyramids on the horizon, inverted; medullary cranial nerve nuclei thrumming (wing beats), inferior salivary nucleus (DROOL), nucleus ambiguous (?), dorsal nucleus of vagus nerve (the pains of the WEST), hypoglossal nucleus (New York, 1941), solitary nucleus skulking elsewhere THAN HERE (X, in a moment of reflection, gazes idly at a kitten from the comfort of a bed. The informal quality of her kicked-off shoes and the soft way the kitten seems to blend into the wooden floor connote the quiet and casual tone of the scene, a relaxed time of serenity and ease). Metencephalon: pons!; respiratory centres heaving, laboured; pneumotactic centre (Santa Fe Engine), apneustic centre (Church Door, Hornitos), pontine cranial nerve nuclei (Cracked Earth, Borego Desert), chief or pontine nucleus of the trigeminal nerve sensory nucleus (V – (Abbr. CoPNotTNSV, or something. Seldom used, that); motor nucleus for the trigeminal nerve (V: spinning through a great dollop of neural grease, applied – a tiny kitten, barely able to open its eyes, mews in protest against the confinement of the hands that hold it. To us, this squirming creature represents the most positive, joyful thing there is: NEW LIFE, BURSTING WITH PROMISE...), abducens nucleus (VI – 'Dante's View'), facial nerve nucleus (VII – lost: Ranch Market, Hollywood, 1956), vestibulocochlear nuclei (vestibular nuclei and cochlear nuclei – NUDE) (VIII – for the pronouncing of Latinate glottal stuff), superior salivatory nucleus (the accurate spit), paramedian pontine reticular formation (hot coffee!), cerebellum (particular), cerebellar vermis (April – that is the fool month, isn't

it?), cerebellar hemispheres (axioma – juniper), anterior lobe (Iceberg Lake), posterior lobe (an elevator is a small and intimate enclosure, yet the people who ride it are often anything but intimate. In this impersonal record of an elevator ride the operator, looking rather forlorn, seems not so much human as A PART OF THE MA-CHINERY), meri, flocculonodular lobe (dangling), cerebellar nuclei (dunes), fastigial nucleus (a laceration), globose nucleus (online), emboliform nucleus (sleight...), dentate nucleus (hardened, in this case). Midbrain (mesencephalon: a plateau of dried grasses – thousands of different genuses, swaying in unison with the wind and shaded in great damp patches by the clouds): tectum (tacit), inferior colliculi (cochleal mess), superior collic-uli (scrabbling inside; a writhing), mesencephalic duct (cerebral aqueduct, Aqueduct of Sylvius – a round man; one of the earliest defenders of the circulation of the blood in the Netherlands), cerebral peduncle (a retired fisherman, deprived by old age and failing vision of the dignity of work), interpeduncular nucleus (dependent), midbrain tegmentum, snagged; ventral tegmental area (approaching the core), RED NUCLEUS (staring right back at that churning eye of Jupiter, fearless), crus cerebri pretectum (velveteen cord); forebrain (prosen-cephalon: Antarctic ice cap, a volcanic plug; the 'throne'): diencephalon (Greco-Roman), epithalamus (a threshold), pineal body (slumped), habenular nuclei (A desperate plea), stria medullares (culpability, see?), tenia thalami (NOVATION), third ventricle (abstruse-ness), thalamus – meaning 'chamber' – anterior nuclear group (Aruba!), fermenting, anteroventral nucleus (contrary motion), anterodorsal nucleus (slumped, irre-trivable, I fear), anteromedial nucleus (The Warm Jets), medial nuclear group ('He was an extraordinary

performer'), medial dorsal nucleus (In praise of...), MIDLINE nuclear group ('satisfactory'), paratenial nucleus (reuniens nucleus (a vineyard worker in the Cognac region of France stands up to the camera with the serene gaze that comes from pride of workmanship – seemingly unconscious of the ironic contrast between his threadbare suit and the expensive liqueur his strong hands toil to make), rhomboidal nucleus (data recovery), askance – intralaminar nuclear group (baffled at the sight), centromedial nucleus (a night in), parafascicular (!) nucleus (for days we watched this woman feeding stray cats and dogs. She was outraged when she caught us stalking her with our clumsy box camera), paracentral nucleus (we are divided on this), central lateral nucleus (another plateau, this time of rock scored with deep fissures), central medial nucleus (a future involving emigration to a planet in the Goldilocks Zone; disaster before reaching it), lateral nuclear group (behind another barbed wire fence, no longer serving its purpose, the parched Dust Bowl stretches beyond empty buildings to the horizon), lateral dorsal nucleus (an effect to make the image judder and jump with faux interference), lateral posterior nucleus (lateral, mind), pulvinar, ventral nuclear group (a tobacco sharecropper), ventral anterior nucleus (two men walking their bicycles down a dusty road that leads into the central Mexican town of Xichú; for a moment they are silhouetted in the light filtering through the trees. The smallness of their figures, the twin church spires that are the only clue to the nearness of the town, the trees towering over the scene – all combine to make an unrepeatable, split-second record that testifies to the ever-changing nature of life on the road), ventral lateral nucleus (life on the road), ventral posterior nucleus

(asinine!), ventral posterior lateral nucleus which is solely iterative, ventral posterior medial nucleus (X wears a scowl, permanently), metathalamus (the implication being total), medial geniculate body (another example of life frozen into immobility), lateral geniculate body (squat, horrid), thalamic reticular nucleus (crawling through ducts, vents – below, everyone else is already dead), hypothalamus (limbic system) – (HPA axis) – anterior medial area... Umm... Parts of preoptic area (preoptic stains where the eyes will determine to take root – alternatively, shadows or bore holes or buttonholes – like a specimen pinned to a wooden wall, verdigris, shockingly bright, encrusting the copper pin): medial preoptic nucleus (something akin to those vestigial or prestigial stalks leaping out of the foreheads of primordial, deep-sea fishes), suprachiasmatic nucleus (UNRELENTING REALISM), paraventricular nucleus (UNRELENTING REALISM), supraoptic nucleus (mainly forever), anterior hypothalamic nucleus (the lowest, supporting branches), lateral area – consignments of antivenin (SPINNER at frame; a glance in our obnoxious direction). Parts of preoptic area: lateral preoptic nucleus (dark), anterior part of lateral nucleus (light), part of supraoptic nucleus (blinding); other nuclei of preoptic area: median preoptic nucleus (scabbed), periventricular preoptic nucleus – tuberal! – medial area (a certain limbo perceived) – dorsomedial hypothalamic nucleus (the hour was three a.m. when these boys were at work in a bowling alley. Three pin boys went unseen, presumably because they were even younger.), ventromedial nucleus (the potter slumped at his wheel, the handle of an awl protruding from between his shoulder blades), arcuate nucleus (light weaves among the receding columns of plane trees and statues),

101

lateral area (the angle of view), tuberal part of lateral nucleus (at Versailles, even nature was used to serve the kingly design...), lateral tuberal nuclei (Jesus's blood...), posterior (a light supper), medial area (eggs, done some crude way), mammillary nuclei (part of those mammillary bodies – enacting their groping, desperate love), posterior nucleus (a frightening symmetry of limbs), lateral area (caryatids based on extraterrestrial beings), posterior part of lateral nucleus (the basement of Debenhams. Working there), OPTIC CHIASM! – subfornical organ (stout), periventricular nucleus (rotund, attractive), infundibulum (dreaming of X), tuber cinereum (that rhythm), tuberal nucleus (an erection), tuberomammillary nucleus (furtive looks cast!), tuberal region (beneath all of that), mammillary bodies (they approach. Let them!), mammillary nucleus (Painswick churchyard); subthalamus (HPA axis) – thalamic nucleus (pine), zona incerta (lopsided), PITUITARY GLAND (HPA axis), neurohypophysis (a watched sleeper), intermediate pituitary (strychnine), adenohypophysis (A groundbreaking work of genius), telencephalon (cerebrum) CEREBRAL HEMISPHERES [...] white matter (semen, wax – a dietary viscosity): corona radiata (splintering light), internal capsule (fragments of Etruscan civilization; residual, vestigial), external capsule (a plummet), extreme capsule (latterly a novelist and film-maker – talks with passionate erudition, disarming candour, and acerbic wit about the early influences that shaped him and led to his pioneering... etc.), arcuate fasciculus (kneeling, cradling that ever-heavier head in your arms), uncinate fasciculus... subcortical hippocampus (medial temporal lobe), amygdala (limbic system) – (limbic lobe) – (paleopallium – a sumptuously befurred promeneuse!

102

A darkening leaf-mulch! A terrifically painful bout of! Retreating into the dark, away from an island life), central nucleus (autonomic nervous system), medial nucleus (accessory olfactory system, becalmed), cortical and basomedial nuclei (main olfactory system, though currently not working), lateral and basolateral nuclei (frontotemporal cortical system – currently imagining everything as hostile – a classic anxiety attack. A first foray after a fever into the snow: the world's rhythm suddenly aggressive – suddenly unbearably aggressive, as if attempting to shake you off of it), base head (limbic system) (limbic lobe) (archipallium), dentate gyrus (memories of an exile), cornu ammonis (CA fields – 'to the Duke's health, 1899'), claustrum (Albert Angelo), basal ganglia, wrapped around some poor sucker; striatum (archipallium), dorsal striatum (again, slumped), putamen (unfurled, but not like a flag), caudate nucleus (camels sculpted from white limestone; the stink of your oral hygiene), ventral striatum (a document; phoney aging), nucleus accumbens (removed!), olfactory tubercle (retrieved!), globus pallidus (forms nucleus lentiformis with putamen; a chain reaction of stunning beauty), subthalamic nucleus (sincerely yours), substantia nigra swollen, rhinencephalon (paleopallium – a whole animal), olfactory bulb (once chastized for the theft of some shameful [...]), piriform cortex (lamprey-like), anterior olfactory nucleus (a pilgrim boy carrying a miraculously replenishing basket of food), olfactory tract (an eloquent preacher), anterior commissure (arching), lateral ventricles (prolegemon), cerebral cortex (neopallium), frontal lobe (he healed the severed foot of a man who had cut it off as a penance for kicking his own fucking mother!), cortex (also, preaching to the

103

fish), primary motor cortex (precentral gyrus, M1), Brodmann area 4 (concerning supression), (primary motor cortex), prefrontal cortex (before before), supplementary motor cortex (diagonal wish), premotor cortex (a plague), gyrus (Martian), Superior frontal gyrus (this and other stories concerning your fading marriage), middle frontal gyrus (a stupendous effect), inferior frontal gyrus (droplets of human blood. In addition to analyzing for DNA, the droplets are round and show no splattering, indicating they impacted relatively slowly, in this case from a height of two feet. – Incidentally, the coin in the picture is an old five pence piece, which is a little odd.), Brodmann areas: 6, 8, 9, 10, 11, 12, 24, 25, 32, 33, 44, 45, 46, 47, etc... – all of which concerned with simply regulating the rhythms of your wretched heart. Parietal lobe (opened the wrong fucking way), cortex (a disaster!), primary somatosensory cortex (S1), S2 (two), posterior parietal cortex (proof of identity), gyrus (more of this), postcentralgyrus (primary somesthetic area) – OTHER – precuneus (linked to Padua, Italy), Brodmann areas 1, 2, 3 (primary somesthetic area); 5, 7, 23, 26, 29, 31, 39, 40 (all of which concerned with the delicate sculpting of metaphor), occipital lobe (SWIVELLING), cortex (a smooth pan), primary visual cortex (V1), V2 (two), gyrus (more of this), lateral occipital gyrus – OTHER!... Cuneus, Brodmann areas 17 (V1, primary visual cortex), 18, 19 (two of which are obscured in the print I have – the other seemingly a king of neural machete – hacking out a path. Rusted, no doubt), temporal lobe (famous, the), cortex (derogatory, if you ask me), primary auditory cortex (A1), A2 (Two), inferior temporal cortex (an attempt – unsuccessful – to seduce X. Clumsy, in retrospect), posterior inferior temporal cortex (certain rules concerning dissection.

Or vivisection), gyrus (simply), superior temporal gyrus (accusations! Accusations!), middle temporal gyrus (some would say this were a too-late suppression of the truth), inferior temporal gyrus (controversy, certainly), fusiform gyrus (provocation – fingered), parahippocampal gyrus (the story of voodoo), Brodmann areas: 9, 20, 21, 22, 27, 34, 35, 36, 37, 38, 41, 42 – all of which concerned with governing the musculature of those various sphincters dotted at strategic points about the body), insular cortex (scenes of sexual abandon suggest lust as the cause of humanity's downfall), cingulate cortex (resplendent in shocking pink!), subgenual area 25 (the garden), anterior cingulate (*malade au coeur*), posterior cingulate (*amici del cuore*), retrosplenial cortex (resplendent in sacking, for fuck's sake!), indusium griseum (born in Berlin, of all places), Brodmann areas 23, 24 (a necessary retardation); 26, 29, 30 (retrosplenial areas to augment reality); 31, 32 (a counter movement). neural pathways (that machete): arcuate fasciculus (the sound of thunder...), cerebral peduncle (now distant wing beats), corpus callosum (prattling), pyramidal or corticospinal tract (or a Bremen physician, sixteenth century), major dopamine pathways (wine made from mandrake), dopamine system (pining for the loss and consequence of Ultima Online), mesocortical pathway (sleep is death), mesolimbic pathway (deadly nightshade), nigrostriatal pathway (certain uses), tuberoinfundibular pathway (an action RPG that's perfectly tailored for the pick-up-and-play crowd: in other words, it's a likeable confection that's as witty as it is insubstantial), serotonin pathways serotonin system (X failed to find a wide audience during their lifetime, and in death likewise), raphe nuclei (chapped lips). And the motor systems: motor system, extrapyramidal system (banned

in 1943), pyramidal tract (agape), alpha system (we agree the ceasefire – the conditions being too numerous and complex to relate here), gamma system (nucleic acids, I should think), NERVES – SPINAL CORD – BRAIN STEM, CRANIAL NERVES, CRANIAL NERVE (0), OLFACTORY NERVE (I), OPTIC NERVE (II), oculmotor nerve (III) (an entropic relationship related here), trochlear nerve (IV), trigeminal nerve (V), abducens nerve (VI), facial nerve (VII), vestibulocochlear nerve (VIII), glossopharyngeal nerve (IX), vagus nerve (X), accessory nerve (XI), hypoglossal nerve (XII), neuroendocrine systems; HPA AXIS – vascular systems: VENOUS systems, CIRCLE OF WILLIS (arterial system), blood – brain barrier (terrifyingly thin), dural meningeal system (do you think we), brain-cerebrospinal fluid barrier (deadening pain in those injured or burnt), meningeal coverings (modelled on a door key), dura mater (a hunchbacked man and an ancient-looking midwife help a woman birth a brood of huge brown eggs), arachnoid mater (the astral spider, enwrapping the planet), pia mater (he turned his bulk to profit), epidural space (gigantic, slick, imposing and archaic), subdural space (sumo providing the unlikely inspiration), arachnoid septum (130 years of pointless history), ventricular system (devolved), cerebrospinal fluid (LIVE CHAT), subarachnoid space (tentative steps), third ventricle (3rd), fourth ventricle (in every port), lateral ventricles – anterior horn, body of lateral ventricle, Inferior horn, Posterior horn, superior cistern, cistern of lamina terminalis, chiasmatic cistern, interpeduncular cistern, pontine cistern, cisterna magna, spinal subarachnoid space...)))) ETC. – brought to LIFE.

A map of my brain, charted crudely on the deck of an ancient junk.

AND a pretty heavy shitstorm.

AND the brute indomitability of a list. We are all of us incorrigible.

Or what about these neglected horror-hands, eh? They itch – they're too big, too heavy. I feel clumsy, drunk. And they taste... metallic. As if infused with OLD blood. I can scarcely trot out the melody to 'Greensleeves' anymore, let alone get back in the studio to record my sophomore album.

Or it's opacity, irony and incoherence. Or, irony, incoherence and opacity. Or with that mosquito bite as a glorious full stop. I should think that you could come up with a whole, weird parlance of punctuation from various bites. Vampire, snake, etc. Anticipatory pseudo-ellipses. Waiting for an end result – revenant transformation, anaphylaxis, DEATH, etc.

– A friend of mine had a vampire bite tattooed on his neck. Which is pretty good, if you ask me. Tattoos in general in regards to representation. Like the tattoo of a mole or a scar or that WARREN of liver spots. There's something gloriously wilful, pre-emptive about something like that. Self-defence, your honour!

Or there's the thought that a depiction of a vampire bite seems to encompass something essential about a tattoo. Affected rebellion, DISAFFECTION, a kind of proud dysmorphia, deferred impotence, membership, affinity, rejection, sociopathy, artifice, ancestry, some pseudo-masonic furtiveness, tolerance, adulthood, adolescence, taste, faith, primitivism, KITSCH, statement, submission. My grandfather had a vast number of tattoos. On account of several years in the merchant navy, I think. Predominantly they comprised a kind of dermic map of the major ports of the world, applied using whatever local method to crudely depict some local icon or object.

Or the terrible PARENTHESES of some huge carnivore's bite. Contained within: an undeveloped, arrested, now-MOOT point.

Or a massive tattoo of a shark bite scar spanning the left flank of a surfer.

Or that sentence preceding the mosquito bite full stop.

Or there's evidence enough to prosecute, I should think. You certainly have a case.

Or: she stands at or near the beginning of creation.

Or, to reiterate and somewhat simplify: firstly, the posterior commissure. Then, the medial forebrain bundle. Followed by the appearance of the mammillothalamic tract. Out of the blue, more or less. The stria medullaris thalami! Somewhat gruesomely, the axons in the optic stalk as a kind of GASTROPODA. Inevitably, the external capsule appears (I say inevitably with a certain FATALISM.) Stria terminalis appears. Then, dramatically, the optic axons INVADE the visual centres. The internal capsule, DRENCHED. After sixty-three weeks of this, fornix – tragedy inscribed on its face. The anterior commissure enters, similarly shaken. Hippocampal commissure assuages as best it can. Then corpus callosum. Only at this point does the eye open, easy as you like. (Ipsi/contra segregation in LGN and SC).

Or, really, I suppose that the main terror of 'The Murders in The Rue Morgue' is the physicality of the ape. Its musculature, etc., untethered, so to speak. Also that *scraping* that goes on with the razor. Gnarled, orangutan palms proffering the cut-throat razor, handing itself in. Or simply the hurling of the waif-like out the window.

Or, described as being part 'ocular bat', part 'unusual hoon', and part man. Cruelly.

Or those three distinct phases: the reptilian brain, the limbic (mammal) brain, and the neocortical (human)

brain. Before such time it's impossible to discern any BRAIN at all. Simply convocations of matter. A rock, sat heavy inside my skull. What dreams of a rock?

I mean, what does a rock dream about? Don't fucking tell me they don't dream.

Or – to focus a little – the reptilian brain – the oldest on your brain list (to which I would gingerly add terrestrial and extraterrestrial as mega-taxonomies; gelatinous, viscous, carbon, silicon, muddy, marbled, etc., to those sub-, meta- and para-genuses) – includes the brain stem, which regulates digestion, breathing and heartbeat. More importantly for our purposes, it provides the basis of emotions such as hunger, fear, excitement, pleasure and anger. These basic or 'core' emotions were not developed enough for these species to love and care for their offspring properly. These underdeveloped emotions might have led the parents to commit FILICIDE if some predator they couldn't protect themselves from didn't already kill them. The next big phase of development, the limbic brain, is discerned to have begun as the first mammals appeared. The parts of the brain's nervous centres that were developed at this greying time were the hippocampus and the amygdala, which are the parts of the brain that are RESPONSIBLE for storing memories. (Those first memories swaddled in thick, warming fur and reeking of hay. Chirping like guinea pigs.) Think of it as a kind of solid-state hard disk, if you really must. These brain developments combined with an increased emotional dexterousness allowed for mammals to not only care more coherently for their infants, but also to live with their partner and/or herd/school/flock without the incessant threat of violent irruption. The neocortical brain phase occurred one hundred million years ago and was the last big phase of brain development. Which is shocking, no? During this stage the cerebral cortex was greatly enhanced, allowing for the lucky species to plan their own actions, learn information quicker, and so adapt easily, communicate efficiently (with their own

112

species), and portray empathetic and altruistic characteristics. This might lead you to think of LOVE. Which is all it's ever been about anyway. As in, love and other malcontents. Love, The Great Destroyer. Love, that paradigm. Love: The Vanishing Point. Love: a certain perspective. Isomorphic love. That visceral love between molluscs. A terrible, grotesque love manifest in FILICIDE.

Or just listen to this, Mike:

Or, that we are not limited to verb-noun commands, such as 'take bottle', 'open eyelid', and so forth. Instead, the parser supports more sophisticated sentences such as, 'put the bottle and canister in the orifice', 'look under the bed', and 'drop all except dignity'. The game understands many common verbs, including 'take', 'drop', 'examine', 'render', 'climb', 'harass', 'close', 'count', 'regret', 'intone', and many more. The game also supports commands to the game directly (rather than taking actions within the FICTIONAL SETTING of the game), such as 'digress' and 'weep', 'paraphrase' and 'typeset', 'restart', and 'QUIT'. Limitations are a thing of the past, lest we forget. Lest we forget that limitations were once commonplace. Walls, cliffs, oceans, quicksand, etc. 'Calmly await rescue from quicksand', or 'Desperately reach for vine that looks suspiciously like a snake'. Go for the vine every time – the game recognizes the bold.

Or us, finding all of this, um, nutso stuff in some forgotten ring binder marked 'CIRCUMSTANTIAL'. Tucked in at the back is a glossary of terms. This, apparently, also understood as a slice of LEGALESE. Each one with a number beside to denote, we presume, the maximum sentence attached: Suicide; Autocide; Medicide; Aborticide; Familicide; Feticide (or Foeticide); FILICIDE; Fratricide; Geronticide; Infanticide; Mariticide; Matricide; Neonaticide; Parricide; Patricide; Prolicide; Senicide; Sororicide; Uxoricide; Amicicide; Androcide; Ecocide; Femicide (also Gynecide, Gynaecide, or Gynocide); Gendercide; Genocide; Homicide; Omnicide; Populicide; Xenocide; Giganticide; Deicide; Dominicide; Episcopicide; Regicide; Tyrannicide; Vaticide; Chronocide; Famacide; Liberticide; Urbicide; Algaecide; Acaricide; Avacide; Bactericide; Biocide; Cervicide; Ceticide; Culicide; Felicide; Fungicide; Germicide; Gonocide (also Gonococcicide); Herbicide; Insecticide; Larvicide (also Larvacide); Lupicide; Microbicide; Muscicide; Nemacide (also Nematicide, Nematocide); Ovacide; Parasiticide; Pediculicide; Pesticide; Pulicicide (also Pulicide); Raticide; Scabicide; Spermicide; Tauricide; Teniacide (Also Taeniacide, Tenicide); Vermicide; Vespacide; Vulpicide (also Vulpecide); Virucide (also Viricide).

Omnicide. As in everyone.

Or perhaps it's more useful to begin by speaking of individuals. To cite the exemplar, Rasputin was reportedly poisoned, shot in the head, shot a further three times, bludgeoned and then thrown into a frozen river – only after being castrated. When his body washed ashore, an autopsy showed the cause of death to be hypothermia. Some now doubt the credibility of this account. Another version of events holds that he was poisoned, shot, and stabbed – at which point he promptly got up and ran off, and was later found to have drowned in that same frozen river.

Or Marcus Garvey, who died as a result of a double stroke after reading a negative premature obituary of himself. Or sadder still, Basil Brown, a 48-year-old health food advocate from Croydon, who drank himself to death with carrot juice.

Or there's Robert Williams, who worked at some Ford plant and was the first human to be killed by a robot. The first of many.

Or you might ask, Is the brain like a big phone system (because it has a lot of connections), or is it one big computer with ON or OFF states (like the zeros and ones in a computer)?

Neither of the above correct.

Or why not let's look at the brain using a different model? – Let's look at the brain as an orchestra. Embedded in its pit. In an orchestra there are different musical sections. There is a percussion section, a string section, a woodwind section, a brass section, some, um, others. Each has its own job to do and must work closely with the other sections. When playing MUSIC each section waits for the conductor. The conductor raises a baton (or if not: a SIMPLE hand, never FISTED) and all the members of the orchestra begin playing at the same time, playing the same note. Or at least SIMILAR notes at the same time as one another. Or at least in some deliberate & contrived relation to one another. Or fucking something.

If the drum section hasn't been practising they don't play as WELL AS the rest of the orchestra. The overall sound of the music seems 'off' or plays 'poorly' at certain times. This is a better model of how the brain works.

We used to think of the brain as a big computer – but really it's like millions of little computers all working together. Or a billion piccolos in tune, keeping time with celestial movements. Or the innumerable valves on an entire continent's worth of saxophones. When employed as a weapon or a man, all of this flies out the window.

Or, to say, I'm just thinking right now about all of it ruined and with a blunt instrument. ALL OVER FOR. I suppose that, in some previous inception, that would have been some kind of omnicide. According to some essential relativist conceit.

Or, I suppose.

False positives and contamination by subsequent handling or nearby objects (e.g. the mixing of blood from victim and attacker), for example, are problems owing to the presence of many common substances and the necessity of human involvement in the collection of trace evidence (if only robots were sufficiently developed). Both can occur with DNA traces and fingerprints. Partial fingerprints are even more vulnerable to false positives. Samples from accidents or crimes should therefore be protected as much as possible by enclosure in a sealable container as soon as possible, after an incident is under investigation.

Or the locked room, in which a crime – almost always murder – is committed under apparently impossible circumstances. A crime scene that no intruder could have entered or left. Following other conventions of classic detective fiction, the reader is normally presented with the puzzle along with all of the clues, and is encouraged to solve the mystery before the solution is revealed in a dramatic climax, etc.

Or, it's worth noting that in the fifth century BC, Herodotus told the tale of THAT robber whose headless body was found in a sealed stone chamber with only one guarded exit.

Or that the head was eventually found and shrunken, some thousand odd years later, on display in a provincial museum somewhere sad. Apparently mistaken as the reliquarial head of a saint, it was preserved in what looked like a huge, gilded and jewelled tea urn, in a chamber (THALAMUS) somewhere off the transept. The first to be suspicious of its provenance was a Japanese tourist who happened to know something about this sort of thing. Interest piqued, he contacted a local archaeological department, who obliged with a visit and a series of tests. Dating, etc. Anyway, nothing came of it: the tests came back inconclusive, apparently; save for the fact that the head was too old to belong to the particular saint the church believed it to be, so they didn't want it. So it ended up as a curio in a local museum above a label bearing the enigmatic legend, 'The once-head of a once-saint'. And there it languished till very recently, when a professor of these things, holidaying in the area, visiting the museum on one of those dreary, drizzly non-days you get on British holidays, spotted it and, with growing excitement, requested a closer inspection. The expression on the face of the severed head, she later relayed to the local, and subsequently, national newspapers, was 'the first give away'. Somewhere between impish and surprise'. After a bit of haggling she managed to convince the director of the museum to allow her to transport the head back to her lab, which was in Edinburgh. Needless to say she happily cut her holiday short. After a series of intense tests, examinations and staring, it was finally established – just as the Japanese tourist had suspected – that this was indeed the lost head of the robber found in a sealed stone chamber with only one guarded exit.

Or we might agree that that offers no explanation as to how the robber died. It's what we call a COLD CASE. At the time it caused quite a stir – and in a wholly sinister fashion. Being a historical precedent for a fictional trope. So, although Herodotus should be understood with a great scoop of salt, the corrosive processes of history – of histories *per se* – have rendered the decapitation of a robber harmless, ahistorical. A-legal, certainly. Through this fictional prism, I might picture some classical detective pitting his wits against the puzzle of the situation. When I take it away – that lens – I can see the simple, terrible corpse, sprawled, decapitated on the stone. The missing head simply adding more horror.

The story spread like wildfire, of course. Plenty of us lost sleep over it; the guard in particular. It was a far more superstitious time, is what you should remember. Things like this were inevitably read as omens, and almost always of imminent tragedy. Burning the body on a pyre; black smoke rising in a great column – a fetid incense to calm the gods. Ares in particular – but also Hermes, Hades and, of course, that horrible Zeus creature.

Or you could climb the dangling rope left behind from the second trap and jump two gaps up here, as the next rope is pulled up. Could just drop off the right side of this ledge so you don't land in the traps off the left side. Go right to reach a small log as that fucking giant spider surfaces, then push the log into the water and climb on top. Jump to a small ledge in the water and another log beyond, then run right to a log that's balancing like a see-saw. Wait on the right side of this log until the spider puts his foot on the other end, then jump to the next ledge while you're up in the air. Push the next log over and jump the gap beyond it, then run right to a boulder that's propped up by a tiny twig. Jump on the twig to release the boulder, then run left towards the spider, hugging the right wall. This lets the boulder roll harmlessly past you and right into the spider.

Or, then again, that black smoke. Any HUMAN breathing it is well-murdered almost instantly. Elsewhere, the smoke forming a gross scum upon contact with water. Consisting of an unknown element that shows four blue lines in a spectrum analysis.

Or the particular of insisting on eye-witness accounts. Being that it makes for authenticity. Or the sense of authenticity (and this 'seeming' being the whole deal). All knowledge of the past which is not just supposition derives ultimately from people who can say, 'I was there', dad.

Or Udet flying over the Alps. Udet's landing on the Mont Blanc (glacier du Trient, 10,000 ft). Udet over the Alps again. Etc.

Or I'm thinking of Grant Morrison's Key 23 drug (... 24). A fantastic hallucinogen that makes the taker confuse words with the concepts they represent. So that, say, reading the word 'aneurysm' would be to have an aneurysm. The line (jagged, infinite) between language and the reality it represents would blur entirely. Representation would, for all intents and purposes, cease to be – everything would always be the thing. At least for the taker. This only really explored concerning nouns and verbs, seldom adjectives or pronouns which, presumably, would either remain stubbornly significatory, dull – or would cause some sort of feedback embolism.)

Or without representation, a kind of doubling, tripling, etc. Some sort of paradoxical simultaneity.

Or what was once your favourite meal: chicken with gravy and peas and jacket potato. Recited at speed, urgency and thrill: 'chickenwithgravyandpeasandjacketpotato'. The immediate recollection is the gravy beneath a pale, slightly dry shred of breast. A fork – upturned to form a shovel – scooping gravy and peas, somewhat desperately; the gravy dripping with its particular meagre viscosity. Smearing a skewered chunk of the chicken about in the gravy. Butter in the potato; potato opened with a pinch of a single line incision. You, escaping the table after dinner to attack the carcass. Returning to the table, in a frenzy of joy, pretending to murder each member of the family in turn. Miming yanking the ripcord of a chainsaw, revving, juddering as it lurches through dad's thigh. Tilting back your brother's head – tenderly, almost – and gliding a mimed blade across his throat. Piercing mum with a barrage of arrows loosed from a mimed bow. Each of them giggling, obliging with their appropriate death throes.

Or a diagonal movement across bus seats.

Or why do I bother when you're not the one for me? Is enough enough?

Or: under the pale moon for so many years I've wondered who you are. How can a person like you bring me joy?

Or Peter Smythe, who took a turn.

Or witnessing a Viking burial.

Or the fruitless search.

Or this here clay pipe.

Or a terrific number of insects.

Or that fucking look.

Or, I know that fucking look.

Or we end it here, now.

Or we caress.

Or I must admit something to you.

Or you CONFESS!

Or understanding that by far the most terrible feature in the malady was the dejection that ensued when anyone felt themselves sickening, for the despair into which they instantly fell took away their power of resistance, and left them a much easier prey to the disorder; besides which, there was the awful spectacle of people dying like sheep, through having caught the infection in nursing each other. This caused the greatest mortality. On the one hand, if they were afraid to visit each other, they perished from neglect; indeed many houses were emptied of their inmates for want of a nurse: on the other, if they ventured to do so, death was the consequence. This was especially the case with such as made any pretensions to goodness: honour made them unsparing of themselves in their attendance in their friends' houses, where even the members of the family were at last worn out by the moans of the dying, and succumbed to the force of the disaster.

Yet it was with those who had recovered from the disease that the sick and the dying found most compassion. These knew what it was from experience, and had now no fear for themselves; for the same man was never attacked twice – never at least fatally. And such persons not only received the congratulations of others, but themselves also, in the elation of the moment, half entertained the vain hope that they were for the future safe from any disease whatsoever.

Or being an aggravation of the existing calamity, which was the influx from the country into the city, and this was especially felt by the new arrivals. As there were no houses to receive them, they had to be lodged at the hot season of the year in stifling cabins, where the mortality raged without restraint. The bodies of dying men lay one upon another, and half-dead creatures reeled about the streets and gathered round all the fountains in their longing for water. The sacred places also in which they had quartered themselves were full of corpses of persons that had died there, just as they were; for as the disaster passed all bounds, men, not knowing what was to become of them, became utterly careless of everything, whether sacred or profane.

All the burial rites before in use were entirely upset, and they buried the bodies as best they could. Many from want of the proper appliances, through so many of their friends having died already, had recourse to the most shameless sepultures: sometimes getting the start of those who had raised a pile, they threw their own dead body upon the stranger's pyre and ignited it; sometimes they tossed the corpse which they were carrying on the top of another that was burning, and so went off.

– An account from 430 BC.

Or we ask, tenderly, How would you like to be buried?

And you answer, You can bury me however you please... if you catch me and I do not get away from you! (*SOFT LAUGHTER*; looking up at us) – I cannot persuade Y, my friends, that the X that is now conversing and arranging the details of his argument is really I; he thinks I am the one whom he will presently see as a CORPSE – and he asks me how to bury me. And though I have been saying at great length that after I drink the poison I shall no longer be with you, but shall go away to the joys of the blessed you know of, he seems to think that was idle talk uttered to encourage you and myself. So, give security for me to Y, the opposite of that which he gave the judges at my trial; for he gave security that I would remain, but you must give security that I will not remain when I die, but shall GO AWAY, so that Y may bear it more easily, and may not be troubled when he sees my body being burned or buried, or think that I am undergoing terrible treatment, and may not say at the funeral that he is laying out X, or following him to the grave, or burying him. For, dear Y, you may be sure that such wrong words are not only undesirable in themselves, but they infect the soul with evil. (*PAUSE*) No, you must be of good courage, and say that you bury my BODY – and bury it as you think best and as seems to you most fitting.

Spoken – calmly, a little dolefully – in 399 BC. Not for the first time.

127

Or again, in 2012, albeit INTERNALLY. A doubling, a tripling.

Or again, in 2460, by a seated individual, exhausted.

Or a precedent set, a stylistic paradigm, a rule base, a perimeter carved out of the flagstone, a minimum SENTENCE, a maximum sentence of life.

Or I admit that I cannot conscionably say that it is beyond reasonable doubt. My thinking of and about guilt, Sir. No, Sir. I cannot say that. I will not say that.

What I will say, however, is that some part of me is guilty. Some part. Literally. Which part, Sir, I cannot say – but some part of me. Physical, yes. Mental, spiritual. Some part of me is riven with guilt. I can feel it, Sir. Specifically, Sir, I could not tell you. But I feel it, Sir: that constantly swelling kernel of guilt. That very steel ball bearing of guilt. Absolutely insoluble guilt, Sir. I know that I did it.

Spoken sincerely (sworn to truth with the left hand resting on a book and the right on where one imagines the heart to be), from somewhere in Tarzana. Where she lived.

Or The Cavern Under The Cloud.
Where we are now.

A PRIMER FOR CADAVERS

Can you smell that?
(*RUMMAGE*)

How about now?

See the shuffling, idiot figure a few hundred yards ahead?

Have you noticed the slipstream of rancid vapour we're in? – That hallucinogenic wind that conjures and affords this whole scenario?

Is everything losing its edge? Everything bleeding into everything else? A pixelation or a Gaussian blur or a pornographically short depth of field creating the most abject, vivid kind of attention in me. Details (a lesion, maybe – or just its wet, ragged edges) prick my eyes like a vinegar. The rest – the blur – sloshing in corneal recesses like that tide of saliva involuntarily summoned before vomiting. Magic, metallic saliva.

Is that how you'd describe it?

– An emetic avant-garde?
(*SMACK!*)

A tsunami of mice breaking cover into a clearing, fleeing a forest fire, the grass of the clearing seething.

– The mice maggots, the grass the flank of a long-ago fallen horse.

– The mice blowflies, the grass your own sullen scalp, magnified 20x.

– The mice sepia flames in soft-focus, the grass a microcosm of the forest that's being devoured by flames some half a mile behind the fleeing mice.

– The mice an army of red ants attending to an unseen queen, the grass the perpetually decomposing forest floor.

– The mice a shower of summer rain, the grass some intricate Venetian-esque blind, part-drawn across one panel of the glass roof of your conservatory.

– The mice your fingers moving through and parting the hair of [...], the grass.

– The mice a landslide or an avalanche, watched in awe and safety from the banked cockpit of a helicopter, a thousand feet up; the grass, the devastated village below.

Etc.

And now I'm squinting through a prism of tears, crystallized at the corners into that same sedimentary glue to wake up with – to lie with, blind but awake for a few terrified years, eyes and eyelids in a loving, desperate clinch after a sordid night transformed into objects embedded in your rock-like skull. Sorry: MY rock-like skull. Your skull is more porous, somehow. Another kind, perhaps. When I say 'rock', I think of something impenetrably hard – a proverbial 'rock', rather than something distinctly difficult to [...]. Like, say, pumice.

As in, 'your pumice-like skull', describing the porousness of your skull, your uncanny absorbency of, say, TRIVIA. Or languages. Or 'your pumice-like skull' describing the colour and texture of your head – like the moon, all acne pitted and hollow cheeks. With that texture, pumice-like as it is, is it worth entertaining the thought of your head applied to the Crow Crag of my heel? The memory of the heel of a friend's father, squashed and split in sandals, walking before me. Gourd-like. Exoskeletal. Certainly, it's too late for him: no amount of scrubbing with your pumice-like skull would remove that SARCOPHAGUS.

A family description of my head that I used to like was that it was like a cannonball. 'Cannonball-head'. I would take great pride in feeling nothing whenever I banged my head into things. The corner of the kitchen table, for example. Now I can't remember whether I actually felt no pain whenever I took a blow to the head or whether I just feigned it to maintain the, um, REPUTATION. – What a pathetic reputation to maintain, you're thinking, but actually you understand perfectly the pride one can have in the seeming immutability of some part of your body. Do you or did you ever have any terms of endearment for your head or any other body part?

I no longer consider my head such a proud object, though it is notably large when trying on someone else's hat. And when shorn, it looks pretty good.

Can you smell that?

– The smell of Copydex or maybe those cyanide-scented gluesticks (Niceday? Pritt? – Either way, fish and

133

almonds and infancy) reaching my nostrils, funnelled straight to the hippocampus and the memory of that bone-coloured scum that gathered at the hem of the river. I grew up within raft-lugging distance of a river. Smell it?
(*SMACK!*)

How about now? The various glue smells? Hooves in vats.

The cadaver's whole body thickly coated with PVA, then.

That bored, mute thrill of peeling it off in ever larger sheets (the faint thought of the sole of a foot, upturned – the heel a bluff of eroded granite – the ball a softened plateau of dead skin). Paring off an entire back's worth would be wonderful, wouldn't it? – A particular technique required, like removing the baking parchment from the underbelly of a tier of sponge cake. Delicate, potentially ruinous. Can you, somehow, smell that?

Is there beauty in that sort of skin condition? Does that exist only as analogue? Metaphor? I think – and THAT'S WHAT MATTERS HERE – not.

People are always declaring the resilience of babies.
(*SMACK!*)

That frightening sink-hole on the back of a baby's head: the fontanelle. An elephant trap for an unwary finger, covered-over with grass, leaves, vines. Beneath, a pit filled with thick, machete-hewn pikes. Ahead – a hundred yards or so – there's clearly a hole in the back of the

cadaver's head. Something has already fallen into that trap. Edged with browned, SHARDING skull. Your scree-like skull. – Movement from within! A blink or a turn; a coiling or a twitching. A snake, perhaps? Or one of those trapdoor spiders. Those trapdoor spiders that fashion a trapdoor from some quiet wad of moss, and place it over their burrow with a hinge of twisted silk, then await the tiny, tremulous footsteps of a passing [...] – plunging out the trapdoor like a sailor's open fist to grab the [...] and drag it back into its unimaginable lair. What it does down there scarcely bares thinking about, does it? Needless to say, if there ever was one of those spiders living in that hole in the back of the cadaver's skull, it's gone now – that den's abandoned. No doubt an apparition, brought about by the fumes. The cadaver is haunted. – And if it were to be haunted, it would *definitely* be haunted by the ghosts of trapdoor spiders, exemplars of horror and murderous shock.

Footprints of the cadaver, trod impossibly heavy into the tarmac, are stagnant rock pools filled with caramel piss.
 Caramel is a filling in chocolate.
Is the movement involved in 'catching' the caramel contents of a chocolate on the first, halving bite, AFFECTED? Is it learnt? Fingering the mess of a Flake into the corner of your mouth.

Caramel. A worrying colour to discover in the toilet bowl after a loved one.

You might think: How old is that piss?
– A crucial question whose answer might excuse the colour. Perhaps it's matured, you think. Aged. – Don't

be a fucking moron. He or she is horribly dehydrat-
ed, and water – mineralized if you have it – should be
administered as soon as. Plain water restores only the
volume of the blood plasma, inhibiting the thirst mech-
anism before solute levels can be replenished. In more
severe cases, correction of a dehydrated state is accom-
plished by the replenishment of necessary water and
electrolytes by INTRAVENOUS MEANS. We want
to avoid that if we can. Hydration should be a pleasure,
a romance.

I've never been good at drinking much. You?
– I don't mean alcohol (I am a professional DRINK-
ER), but water or whatever similar. Squash, as a child.
As a consequence, dehydration is a lurking danger. I
suppose that when you piss (or shit or whatever) you get
a glimpse of what on earth is going on in there. In the
dark. Some sort of Victorian distillery. Rusty pipes and
the like. Jack The Ripper describes obscene.

But my god it stinks, doesn't it! Sugar Puffs or aspar-
agus. Others? – Other consumables that change the
smell of your urine?

Can you *smell* that?
(*SMACK!*)

How about now?

Amazing how quickly peroxide fills the air, isn't it?

An approximate location might be established by the
volume of acetone fumes in the air on any given street.
Think you could do that with just your nose and the

shedding of a few tears?

– Those rock pools are lined with plastic. Sanitary blue. And what's that disastrous larvae protruding from the surface of the piss? What dry, flying weight will that slimy, gristly thing become? A meniscus of piss dragged up around the mucal face. That's the birth of hell, don't you think?

Parasites are bastards, aren't they?

Particularly the ones that burrow into your heel or skip up your piss-stream. The ones that hook-on or are LAID-IN. The ones that *replace*! A SLEIGHT OF HAND. Whipping out your spleen and replacing it with a spleen-shaped mollusc with one massive blind eye. It performs the chores that would have been performed by your spleen, only in a more sinister fashion, perhaps oozing some substance of its own design into your splenetic system, gradually (over a course of decades) poisoning you. And, like Secretariat's massive heart, the spleen-locum-monster is only discovered in autopsy, too late to save you but there it is, *still alive*! Mature and ready to lay its own spleen-locum-monster hatchling. And someone says it looks just like you. Someone said that, didn't they. And how ridiculous that you could live a whole life ignorant of something like THAT, clinging to your innards, staring into your blackest internal cavities with that milky, saucer-eye. Muttering its dastardly pitter-patter to our 9th, 10th, 11th and 12th thoracic ribs. Christ knows what it's saying. Perhaps something frighteningly important that, if you were swift or patient enough with your stethoscope, you might hear, jot down, and try to decipher.

Hear that rhythm building? That weird, tinny beat?
The cadaver's singing, I think. Or its skin is singing. Or
its bowels are singing – cooking, distending.

– I don't think that's singing as communication or
pleasure or any kind of rehearsal for any kind of per-
formance. I think it's involuntarily. Like an Aeolian
harp played by that hallucinogenic wind we're lost in.
Or played by some unembarrassed wind secreted from
a lifetime's worth of ossified shit (Is it only the sun that
bleaches shit white?), deposited in cavities as a symp-
tom of a particular diet that foretold this treacherous
song. – Can a song stink? This one does, I think, and
not metaphorically.

Are you familiar with the smell of any one person's
farts? To the point where you don't merely tolerate them
but rather APPRECIATE them – their unique texture,
whatever diaristic qualities, their TRUSTING?

Can you even *smell* that?
(*SMACK!*)

How about now?

The index of decay is worse than the thing in itself,
don't you think? I mean, like a bloodstain. I mean, get-
ting shit on your finger – your shit, mind – condemns
that finger for a long time, doesn't it? The bedclothes
of the terminally ill seem like incredible, classified doc-
uments. Again: a diary, but written with the left hand
and automatically. In that circumstance, how to avoid
descending into desperate scribbling? Your body – in-
capable of holding anything, let alone a pencil or pen

– awkward-prone-ish in the hospital bed (propped up brusquely by some idiot fucking orderly unheeding of your wretched pleas) – nevertheless does A LOT OF WRITING. The surge of need for a piss, the desperate attempt to position the cardboard receptacle around your genitals (completely, to make sure) – perhaps the lack of shame attached to any of this (this being your umpteenth distress in a litany of distresses far worse than pissing). And after all that effort, you can only muster a dribble – a retarded Crayola scrawl in the tilted corner of that fucking receptacle.

[...] There are so many incongruities here, so many betrayals to account for, that outrage and protestations are absolutely useless. In any case, your body is deaf, mute, dumb and, more importantly, dangerous. No use talking to it, is there? Anyways, it's busy. Busy identing the mattress, excreting sweat, shit, tears, piss and – in a case all too familiar to me – SOMETHING ELSE. Something grey, produced wrongly, through all the wrong channels. Purposeless. The stuff I knew (knew?) was ash grey and reeked of the petrochemical, the truffley.

Can you smell *that*?
(*SMACK!*)

Particles of that forbearer of death filling your lungs, disseminating its abyssal inversions. Your body, thumbed inside out!

A little like papier mâché made exclusively from egg cartons. Daubed over a balloon, dried, the balloon popped, a primitive mask remaining. Would you be alright if I gave you the task of painting it? Only, I'm

all thumbs.

Tufts of the cadaver's hair snagged on the barbed wire lining the road, the path, whatever. It used to have a full head of hair. An abundance of hair. A fucking thick black slug of hair draped LIKE A SLUG, pendulous down the neck. Now it's almost completely gone. Now we can see that perverted fontanelle, can't we? – What's left of the hair is greyed and fluffed or tough and pubic; either way absolutely repulsive. Not like yours.

The cadaver's whistling now. But like a kettle, not like a father. Though kettles and fathers are connected in many, many ways.

The cadaver's skin is blistering. Or is blistered. I hadn't noticed before. And how are your feet?

A pair of forearms, slashed with shiny calligraphic burns, caused by either reaching into the oven and just grazing a scalding bar of a shelf – or with the iron, some-how. Maybe while doing the cuffs of the men's things.

How long, do you think, before we'll take the clothes to the charity shop? Charity shops are spilling over with dead people's clothes. Racks and racks of them. All of them too wide and too short for the living. Everyone dies short and fat, it seems.

Can you smell that?
(*SMACK!*)

And now?

[...]

When the undertakers came, we were respectfully asked to vacate the vicinity. We (you too) went into the room next door while they, on the other side of the wall, wrestled the cadaver into a bag. Not wrestled: folded. Respectfully, quietly folded the cadaver into a bag. We watched silently through the window as the undertakers – eyes averted, seemingly from everything – carried it up the drive and out of sight. To a hearse, presumably. Though I can also picture a white Transit. When we returned to the room the cadaver had been in, the undertakers had left behind the cadaver's glasses and pyjamas. Which was shocking for you in particular, I think – they had *undressed* it. Pyjamas like the pages of yet more diary. Skid-marked maybe, though I'm pretty sure I didn't see that. Maybe you did. You won't talk about it.

Ahead, the cadaver is naked. Naked but clothed in abrasions, wounds, ulcerations, etc. Lichen, moss, ferns. Prehistoric dragonflies acting as wing men or a wide-brimmed hat.

Sweating profusely now.

The sun beating down on the cadaver up ahead, heightening the stench; the miasma a visible shimmer haloing its shape. The whistling, singing – whatever it is – is more piercing now. A high-pitched whine that's setting my teeth on edge and further blurring the edges of my senses. A vignetting at the boundaries of every sense. My fingers are numb.

Dead arm!
(*THUMP!*)

Can you smell that?
(*SMACK!*)

How on earth would you describe it?

– The back of a latex mask, worn for hours as a child, wet with condensation and a few tears?

– An ill bit of wind?

– The foundations of a house?

– The gummy corners of your hungover mouth?

– The airing cupboard?

– The collapsed PLASH of a beached jellyfish?

– An unkempt hearth?

– Tinnitus?

– Lynx Africa?

– An alcove beneath the duvet?

– A Precambrian continent seen from the upper starboard wing of a biplane?

– The split-spine of a Picador paperback?

– The infinite tonnage of cosmic space?

– A familiar gesture from an unfamiliar source?

– The unexpected bounce of gristle between molars?

– A clumsy but efficient and self-taught method of typing?

– A splinter in your palm from lugging an untreated, pine coffin?

– The upturned body of something like a scarab bee-tle, delicately righted in the hand to reveal irridescence; savoured, pocketed, only to be sprinkled out of same coat pocket a year or two later as sad, dessicated glitter?

– The thimble of stomach acid unexpected in a burp?

– Your face, transformed with upset.

AIR FOR CONCRETE

Delivery to the following recipient failed permanently:

When I speak the word 'smoke', for example, there certainly seem to be ways in which I might invoke a more material sense of the word.

Inside your brain, I mean.

As a haemorrhage of sorts, is how you might like to think of it.

If I nurse the word in my mouth and on my lips and with my throat – if I shape it, turn it in the right fashion with my yellowing, allergenic tongue and my beak teeth – I might manage to send the word spinning off more '*smoke*' than if I merely say it, hidden amongst so many other words in some banal sentence ('there's no smoke without fire', etc.).

That suctioned, backward stream of smoke from mouth to nostrils.

I want to make you aware of my mouth. I want to map my mouth comprehensively using the word 'smoke', and make you, you know, 'breathe' it. I want to make the word lap about and plot the position of every surface in there. In my mouth. And, so turned, carefully release the word, and the word fanning out into the cool evening air, in the still gulf between my mouth and your sexy little ear, coagulating as it goes, thickening, so that when it arrives at your ear, it's ONLY JUST. Turning into matter and it barely makes it on such hardening bakelite wings. Landing ominous as a fat black beetle on your earlobe, just outside your peripheral vision – its surprising weight understood most obviously as an earring. From there it works its way in, dowsing lazily with its antennae. Then purposeful: quarry found. The word has been fashioned by me to fit perfectly inside

your convoluted ear. Snugly. It's a tailored word – every surface of its ever-stouter body correlating with every surface of your diminishing inner ear – prodding, caressing purposefully, in the way that one might communicate with the blessed deaf-blind – the shape of my mouth mentioned; instructions for the re-formation of the word 'smoke', which convulses up to your brain, then swerves left and down into your gorgeous mouth.

Do you even have a mouth?

Would that matter?
– If you didn't have a mouth?
Perhaps – and this like, um, smoking, like drugs, like certain sexual practices; like liver – so long as you've tried it once, so long as you once harboured a mouth, I reckon this'll work. – So long as you've tried a mouth out before, so to speak; so long as you've let stuff in, expelled stuff via a mouth; shoved a salty finger in there to retrieve a nugget of wet-wadded Walkers Crisp-pulp from a craterous molar; felt the relief of removing a too-thick strand (sinew, herb, hair, other) from between two of the more plate-like teeth; suffered an ulcer or a cut or bitten a lump of cheek clean off; temporarily disabled the tongue with a bite meant for other, dead meat; burnt your tongue to leave it craving abrasive, toast-like textures; DETAINED something in there – smoke, an egg, a momentary orb of spring water; expanded the mouth and proceeded to aerate and cool some scalding morsel of [...]; performed that particular sucking *moue* – matched by, MAYBE, a look of utter contempt in the eyes – concentrating the saliva in your mouth into that depression in the tongue solely conjured for the purpose of spitting; hawked up some tough, slimed chunk from a sinusoidal passage to complement or empower or

146

justify the spitting; so long as you've confused the scale of things in there...

Most importantly is for you to have some appreciation of the complexity of the tongue. To have licked an ice cream, a plate, softened wood, a clitoris, a stamp, a wound, a penis, etc. – So long as you can appreciate *something of the mouth and the tongue's hegemony*, then when that word 'smoke' reaches into you and reveals its shape and its weight and the ways in which these correspond to the movements of my stinking mouth – you should be fine materializing it, making it JELL.

/

I have tried to swallow words. I have tried to force them down with a gulp of saliva-bilge recovered from around the teeth. I've tried to cosset them, swaddle them in saliva to give them a fighting chance at digestion.

I've found that the instinctive thing is to just, um, BREATHE the word. And LIKE smoke, of course. Though that should be resisted. In this here perverse account, smoke is too much like air is too much like nothing. What little body there is to smoke is predominantly visual – a little scent, sure – a little sting in the eyes – but no real weight, no splashing turd. You should try to swallow it properly. Swallow it down the wrong pipe. – You may choke a little at first (to be expected) – you may gag. It's a good sign. It means there's something there, something is taking shape. Something is thinging-up, becoming itself, solidifying, fleshing-out, thickening. And in an instant – and as your tongue spasms imperceptibly – you stuff wads of STUFF around the constituent letters of the words; drape steaks of STUFF over the crossbar of the 'A'; pack sausages of

147

STUFF into the snaked scaffold of the 's',

– *What on earth are you spelling, by the way?*
 Every metaphor here should relate to the tongue –
to your own tongue. Every metaphor should, ideally, *be*
your cuttlefish tongue.

/

Certain licks will tattoo, so
 careful.

/

I'm sure you can picture as well as I those children that
seemed to lick their lips perpetually, to the point where
their lips were outlined clumsily with sore red skin. Is
that from the acid content of your saliva? Why did you
persist? Surely at the first sign of your face eroding,
you'd stop licking? A terrible sort of narcissism, that.
Especially as evidenced in a child. Though it is surely
of interest that the child (you) would be addicted to tast-
ing their own lips, or the skin immediately surrounding
their lips. Maybe the flavour improved, the sorer
the skin became. I immediately think the taste would
steadily become more HAMMY, but I could be wrong.
Perhaps some flavour would be revealed – somewhere
between the fifth and sixth layer of downy child's skin
– that defied analogy. An original flavour. Like Coke.
Or metal. Metal-lick. – Can you remember if those chil-
dren who licked their lips raw were the same children
who took a while to speak? Or that they mispronounced
words? Or that they swore shockingly and that no one
– particularly their parents – could work out where

148

they might have heard such appallingly coarse and bi-
ological language? Sandpapering off their mouths with
their rasping little kitten tongues. Tongues for blowing
raspberries similarly, or for eking into the top dint of
raspberries or for rolling and jutting as a demonstrable
birthright. – Tongues for being pressed down with the
flat side of a wooden lolly stick, for some unknown ex-
amination or in seeking the last bit of red slush.

/

Your tongue laps this way and that, gesturing, enact-
ing that convulsive spell to summon the body of the
word while simultaneously expunging its symbolic
order. Your tongue calling upon the word to shrug off
its fears, its aspirations, its fucking being! – Your tongue
the merry murderer. Sitting there now, in your ignorant
mouth, feigning immobility when truth be told it's the
most mobile thing I can think of. Picture the uncanny
swaying head of a cobra before a strike – only look-
ing like a mole rat – only speckled, flecked with those
marks of abuse (chilli, smoking, coffee, cripplingly sour
gummy sweets, etc.), worn with pride, as testament to
its impressive grimoire [...]. And so the swaddled word
(imaginatively rendered in a pertinent typeface. Maybe
Bembo, DUNNO) is swallowed, whole (do not involve
the teeth), to be dispersed by the various acids, ammo-
nias, bleaches, pressures, etc. (I have no REAL IDEA);
absorbed into the bloodstream and carried, illicitly,
about the body, swept along that cardiac tide, to affect
its changes, to transform, ultimately, every single cell
of your oblivious body into something always-already
appended – syntactically but also cystically – with the
affective word. It's hard to describe, darling. Moulting.

There are some correlatives:

An ovoid of mercury placed on the back of your hand – slowly, impossibly, passing through said hand over the course of a year, maybe – emerging, birthed from invisible stigmata on the palm and dropping to the linoleum floor like a fatted grub – only having shrunk, having shed some of its whatever inside your hand, your blood obliging-shuttling those fugitive, glimmering globules (only they wouldn't glimmer in that darkness) – glimmering globules sliding about the body, TOUCHING the sides, inducing the thick ache in your veins and that dull thrum in your brain.

Those music-box bones on the back of the hand: CRUSHED. And if we don't operate now, you might [...].

– You're going to lose the hand either way. *I am sorry.*

/

Or at the other end, that atomic universality that says we are all of us, everyday, inhaling particles of dead people's bodies. Microscopic flakes of, um, Leonardo da Vinci (it's always fucking da Vinci) drifting about the place, breathed in, clogging your lungs, fluttering around the mouth of the trachea, seeding your capillaries. Notionally, you embody da Vinci. And if you suck up enough, he lines your innards – a shadow inside you, an obverse-you, pressed python-close to your arterial walls, nose bent, eyes bulging, tongue lolling – pressed as if against a photocopier. Again, impossible to tell: you can see nothing in there. Inside you, an abandoned colour darkroom.

150

/

Or drugs. The flavour of some drugs. Summoning the idea that maybe you're in fact tasting yourself, as stripped and marinated by the drug. SWALLOW HARD. – And that the effect of the drug is a sub-functionary of yourself, you; a subcutaneous seam of affect that was incised and prepared by the drug, SURE – but it was IN FACT yourself. A regurgitating process, then – OUROBORIC.

Whereby you ingest yourself in order to affect yourself. – Parts of yourself you had no idea existed. For instance, there is a purple layer of skin somewhere in the middle of the dermic sandwich that, if uncovered and licked, will summon frightening and erotic visions of [...]. And for instance, behind your right eye is something like an otolith, only jet black and mercurial – an obsidian slug murmuring something about the woods. [...] Or more likely YOU, quaffing Oramorph with impunity. The doctor said that was fine. Which was a little worrying, really. Because the warnings on the bottle explicitly contradicted that. It's morphine, after all. So you might then extrapolate that you were in some way beyond or exempt from those universal cautions, that you had entered a different phase, an advanced phase, an inhuman phase where you MAY AS WELL drink as much of the stuff as you like, as much as it takes to dull the pain. Because it's all irreversible now. From here on in, my friend, it can only be palliative. That's how she said it, THE COW. [...] And with every ever-easier swig, the effects appear duller; with every ever-greedier swig, it's harder to achieve the same alleviation from the pain. You find it very difficult to remember what it was

like to be relieved by that first prescribed swig, let alone what it was like to live without the pain, the illness. (I find it equally hard to remember sex with any accuracy. Or the weather. Both exist in an incoherent fug that harbours solid formations, but which lurk indistinct, out of reach). Oramorph approximates a representation of that, I suppose – but only a representation. You are not well, my friend. – That's how she said it, with an ignorant, condescending crumpling of the brow. – I'm not your friend, COW, is what you thought. And this life you lead now, sloshing about full of Oramorph, is as if on the brink of death beneath your own smothering pillow – above that, the ferocious arm of a loved one.

/

Swallowing words like snot, amassed on that bridge between your gagging throat and your nose. You're filling up on that stuff. Careful: it has no traditional nutritional value. A similar sublimation to smoking, praps. As in, SMOKING KILLS – but that's also its charm. Words, thing'd words, will not cure – neither are they a palliative. They are functionless, meaningless – a symptom of their becoming, their deviant unshackling from deference; a symptom of their materialization. They are themselves, irreducible – etymologically, even – no, especially – when surging round your guts. It's worth spending a moment pondering your role in all of this. That the ingestion of words is only possible through your gut, through your mouth, through the flowering of those particular macrobiotic fungi inside your cess-pitted, ransacked innards. They materialize through your body. [...] Surrounded by gratuitous substance in the mouth, the word is changed, inflected so much

by your particularly thick accent, your thick slab of tongue, your bee-stung lips, your mucoid throat (clotted & clagged) – so much so that it cannot but *appear* (as described previously). – Imagine a barn owl hunting down and eating a pellet of fur, bones, shit, etc., propelling it round its body, then ejecting it back out through its beak, only the pellet has been transformed into a living, breathing field mouse. Skittering off, swallowed by the darkness in turn. The barn owl sweating with the effort of it, eyes rolling.

What just happened?

The internal mechanisms have been repurposed. In turn, back in its depressing hovel, the mouse constructs a host of ants from a bowl of droppings.

/

The flavour's correlatives are those existent flavours that are, I would and have say-said, fundamental. A periodic table of consumables that are constituents themselves and are, as such, indivisible. Coke, lemon, durian, mint, Marmite, alcohol, potato, almonds, gherkin, crisps, chicken, milkshake, white pudding, sugar, flour, water, sweat, gloves, wax, skin, Snickers, ink, pine, tears, Muscadet, herring, thyme, lemon, lemon, varnish, lemon, grass, Mars, etc. Though this of course, is inaccurate: every word *is* a flavour, not *has*. This a perfect insistence. The materialization of a word requires the shedding and not the subjoining of attributes such as flavour, texture, toxicity, ETC. – Those are the strivances of a desperate mind – a faithful mind that seeks solace in its own murky piss-puddle reflections. The coils of such a mind are morphologically identical to those obtuse convolutions found at the

tip of a dog shit. A golden ratio expressed most convincingly there, in the curls and flicks generated by the contractions of a mongrel's anal sphincter. What a fucking [...]

Shits of words as uncut diamonds. As they travel down alimentary canals, renal passageways and rectal tubes, the words both secrete and absorb. No: secrete and accrue; they snowball. LIKE A SNOWBALL. From nothing, of course – from less than nothing. So that when they emerge, having deposited a consistent skid mark throughout your innards (more words, there), they have grown in size. Not too much, but enough to remark. Enough to comprehend as perverse. – Shiny, black, voidal things – typographic mutations, slumped like some funereal urn of defective Murano glass, glossy and alien in the toilet bowl. You stare at them, mingling in there, sounding off of one another like snooker balls. Kneeling down, you pull back your sleeve and plunge an arm in to retrieve a particularly heavy word. Cooled magma. Patted dry with toilet paper.

Studying its surface:

A certain sheen of cross-sectioned charcoal;

A huge, dilated pupil lacking its housing, looking up;

A dog's healthy nose;

An egg – indistinguishable from the others in the box – cracked into the pan, too late, is entirely black, rotten, stinking of some genital infection.

The day utterly ruined;

Dark matter;

Liquorice;

A corvid's face;

A cavity harbouring a breathing
 thing;

A hole in the road emitting an occasional rhythm;

That cheese retrieved from the deepest corner under your right big toenail;

A tank of silage, viewed through a hatch in the roof, a shaft of light illuminating a cheap, black men's shoe stood on the surface of the silage, offering consolation for something or other;

The brooding presence of a TV on standby in an unlit living room in the countryside;

Your father's horrific sunglasses that he pretends to be blind in;

An eye socket, gaping, the eye dangling treacherous on its optic nerve, fiddling with the rear;

The submarine sight of the patient;

Pitch;

The place furthest from the surface inside you;

Certain caves – the guide turning off the light;

Something DROPPED in the club; unexpected, frightening somehow – a track whose subtext seems to involve massacre, though you can't be sure – you're senses are impaired every which way;

Massacre inside the club, music continues;

Distilled bin juice;

Eyes from the back;

A cinema, in the daytime, showing pornography: no one in the audience;

Something clenched in the fist;

A bubo under the armpit, found by an exploratory finger – confirmed in the mirror;

The centre of an asteroid;

A fucking lie;

Your middle name;

Your mother's maiden name;

An entreating gesture that descends into anger;

The black snooker ball in your palm (the cue

clattering to the floor);

The first blooming of a black eye: the outraged red maturing, decaying;

The final part of a time-lapse video of a piglet putrefying – the part where even the maggots are abandoning the carcass.

SLUDGE;

A giant squid, discovered suckered to the underside of a sperm whale – lanced open at sea, ink flooding the surrounding seawater like a storm;

Someone else's hair gathered forensically in the plughole;

Avoidable incident;

Everything removed from everything else;

An 8B, applied to censor –

Or to redeem;

The stuff he shat out when suffering from a suspected superbug and/or reacting badly to the Sunitinib (sp);

Pulped egg boxes (etc.);

A certain kind of shell, dark at first – fresh from the water – then lighter – dried in the sun, crystals of sand sat;

Tears summoned by not blinking while playing something shit on the computer till about five in the morning;

The first hour of developing light in the morning, early May, London;

Smoked glass;

That last cigarette – ever, apparently – smoked and understood standing atop a moss-covered boulder on an island near Helsinki;

The smoke, I mean, streaming from every orifice, solidifying into the form of a dung beetle on your delightful ear;

Apple Mac Grey;

Tim Hecker, the bastard;

Dishwater, tomorrow;

The floor of this place;

Overcast sky on its way to another continent;

The waves, Padstow;

The head on a pint of [...], the light dimming in the beer garden;

The engine room;

The absent legs of a quadraplegic, glimpsed on the horizon from the window of a double-decker bus driving through rural Oxfordshire;

A story that ends ambivalent – your response is fierce;

Your head, hitting the pillow, trying very hard to summon the face of [...];

A fucking truth;

A beautiful goose;

The majority of Onibaba;

The sun, actually;

ETC.

etc.

Tomorrow is the anniversary of Dad's death. It's strange that I had almost forgotten about the significance of tomorrow.

How can I *know* it and *have* it?

/

You lick the digested and shitted word and a great curve of tongued STUFF flicks off and into your mouth. And your whole mouth turns black, impossibly dark. And even when you open it for inspection by your family.

We can make nothing out, they say. But it reeks, they say. Putrefaction. A tar pit full of sheep carcasses, says your tiny infant son. A bloody basin, offers mother. Your mouth has become a massive infected wound, riddled with [...]. A nightmare trip to the dentist confirms this. He loses his tools to the void. The nurse faints. All the dentist can add to the diagnosis is that, apparently, there's a sound coming from inside. Something insistent – nasal, apparently. Sounds familiar, he says, but beyond that opinion, I want nothing more to do with you. And there's something particularly worrying about being abandoned by your dentist.

/

Something else ALTOGETHER is quicksand (apparently a myth, someone told me). The prospect of drowning in the earth, like being buried at sea: absurd. That scene from one of the Tarzan films where Sean Connory plays a baddie. He steals a locket from another one of the baddies. A chase through the jungle ensues, with Sean smirking and catcalling to the ropier, angrier baddie who thrashes through the foliage after him, threatening ALL MANNER [...] (Dramatic music: the music of 1950s America: Timpani, snare, brass – a militarized orchestra). At the height of the pursuit, the other baddie – flailing wildly – surprises a jaguar, which snarls and leaps and claws at his face (some sharp editing here: the kind of editing required to get around the absence of a jaguar – to smooth over the seam between stock and original footage. The sequence of shots is something like this: thrashing baddie, face on – perhaps wielding a machete (sweaty, stubbly, murky tan, wild eyes; a loose, stained vest) – diagonal gesture across the shot and the

vines blocking the way (top right to bottom left); cut to stock footage of hissing jaguar, hackles raised; cut back to baddie, surprised, a yelp; a whip pan to incorporate the leaping jaguar (shadow on shadows); a prop jaguar paw raking across the baddie's face quickly but not quite quick enough to convince; the baddie clutching at his face). The baddie stumbles back then lurches diagonally forward, away from the jaguar, groping blindly at a wall of vine which promptly gives way. He collapses forwards, straight into a [...] of quicksand. He sinks as he screams, devoured by the sand; only his right forearm and hand remain protruding, seemingly stuck. A shot of the hand: rigidified into agonized claw. Sean standing off some distance, shaking his head, thinking 'Poor schmuck' or some such. He toys with the stolen locket in his hand. He opens it; a close-up of the open locket – a woman (mother, sister, lover, wife). He closes it with a click, looks up towards the ossified arm and hand and tosses the locket at it (a funereal gesture: the locket as meaningless as a fistful of soil, now; a snagging rose stem), and it lands beautifully, perfectly – the chain forming a kind of cat's cradle of angles, with the locket itself hanging pendulous, just above the upturned palm.

/

A lesson learned, there. Something about the meaninglessness of the material world – the inchoate power of nature – something about memory, family, 'some mother's son', etc. – some sort of comeuppance for deserters, the desperate – something about the accidence of beauty – the coincidence of geometry – the golden spiral of quicksand, sucking clockwise – how genre functions – how incredible it is that we continually *don't* die, in

the face of the myriad traps set by the bland hand of nature, let alone the connivances of MAN – how whatever god is a fickle aesthete with a penchant for the *appearance* of provenance – something mourning the use of huge soundstages and the Cold War orchestras, the particular economy of certain montage – the exchange of vistas for close-ups, of open spaces for edits – the imaginative description of infinitely thick and teeming jungle using a few hundred square feet of props, a comprehensive rig and a crew of craftspeople. All that STUFF. – Perhaps most accutely, a message delivered concerning the physicalism of cinema. My memory of that scene is surely inaccurate and though I describe it using the idiom of cinema, that use is to be understood as interchangeable with the way in which my heavy brain functions. As in, an analogue that is most fluent for me is all. Coincidence that I happen to be recollecting a sequence of cinema, here. Sex would be summoned similarly, dear. As would illness, as would the weather. As I've TOLD. Those infective 'memories' (suspended between parentheses to connote an ambivalence, an insufficiency in the word) that are indexed within some particularly wet, turd-like chamber of my *real*, subterranean brain. – Not a chamber but a soft, wet rock: no room. [...] Imagining all of the air in a given space – your bedroom, for example – replaced instantaneously with concrete. All of the air, all the apparent space in the world, exchanged in a blink for concrete. Again, everything full, close, cold, dead, dark. INSTANT DEATH. That's how I'd like to go: all the way from sensation – grounded in the comprehension of greater or lesser distances between myself and everything else – to abject insensation. Nothing but infinite, motionless density. All those gaps in the cosmos, those unaccounted-for spaces between everything

and everything else – the infinitesimal rifts between quarks; the vast drifting nothings between galaxies – all of that, suddenly filled-in with concrete.

/

[T]he shed skin of the word has drifted up to form a lens over your eyes. Your ears are clogged with same – ambient sound is translated, filtered. Compressed, chorused, distorted, bit-crushed, reverbed, etc. – The euphoric acoustics of a CATHEDRAL OF THE FUTURE. And everything looks way too sharp, too crisp, too juicy. A lucidity to the visual world that was not there before – everything is now too close, too vivid, as if pressed on your eye – as if circumventing the whole eye thing and lunging straight at the brain, groping and pummelling its surface with unmediated bluntness. Everything is gratuitously PRESENT. Sound describes itself excessively – too many adjectives, superlatives – a thesaural superabundance of descriptions, analogues – all the while oscillating wildly between gut-wrenching sub-bass and piercing treble. Parenthetical confusion! Grammatical and syntactical confusion, also! – What the fuck to do with a semicolon? When to use brackets, and when to use dashes? – In the sensory confusion none of this matters, and the response is simply to use everything with impunity, fearlessly, expressively! Saturation is the mode, YOU BASTARD!

/

You left the freezer door ajar. A careless act that forces the freezer to attempt the impossible feat of freezing the entire universe. A cosmic ice age ensues. The

subsequent defrosting – the bleeding out (I discovered this on the kitchen floor when I got back at about seven, seven-thirty) – a symptom of the physical failure of the freezer in its task. Nausea and vomiting brought about by exhaustion. I close the door and mop up the accident.

/

At night I dream of Pluto, the dejected ex-planet. A sphere of ice, four billion miles away from the bedroom.

DEPRESSION

Dear [...]

This letter will be presented in halves. Though this only understood after the fact. Both halves are from you, if you like. Not halves: more accurately we would say, 'hemispheres'. The hemispheres of a blasted second or third moon, orbiting a bloated planet. The halved brain, clamouring at the door. Or squatting in the dark in the loft, forgotten. A cool phlegm congealing amid the dust. Or on the black back lawn at night, in the drizzle, forgotten. You no longer forget, you imagine. – The worst kind of forgetting, to only imagine. This bifurcated moon. Arid, equatorial separation. A literal polarity: the two halves of this moon intensely intimate somewhere near the lipped midriff. A Saharan midriff. We talk about the difficulty of picturing things that should be understood as wet, malleable – like molluscs going all the way; or that transparent second set of eyelids – but which are in actual fact bone dry, brittle; precarious in their completeness. As in, holding on to form and the form of the other by the SKIN OF THE TEETH. On the cusp of disintegration. Chafing against one another. Ice-cold embers of our form drifting upwards from the brazier to confuse the scale of a billion-year constellation. Picture us, together.

In love or something.

There is a desire here to finally put to rest those duplicitous terms I feel we've been stymied by for so fucking long:

Close
Intimate
CONTIGUOUS

Imminent

The technocratic PROXIMATE

The archaic, overblown PROPINQUITY

––– Together

––– A thesaurus of words that, while describing how I might be closer to you than I am distant (whatever that means), nevertheless reports our separation. In the final estimation: polarized, I suppose. The repulsion of two-two fleshy magnets, back to back. Fleshy – nowadays crisped. By the back of the sun's face, which is of course terrifically cold. Represented here by sprawling negative numbers. Degrees beneath degrees. Beneath long divisional lines. Some new term of measurement in use. Its devising a consequence of reaching the limit of a prior standard. A cold, dead, snake-like sibling for Kelvin, Celsius. The apologists of Fahrenheit, the *juju* of sprained *frenulum linguae* – the thin purpled muscle connecting the tongue to the bed of the mouth, where you and I both have buried hundreds of those metal tips of thermometers. This cold being one of a suite of environmental factors that have been suggested as aggravating to this skin condition I suffer from. The list also including stress (depression – perhaps by that FAT THUMB, or the terrible THREE FINGERS that shift between dimensions on that glass tablet of yours, etc.), withdrawal of systemic corticosteroid, some form of *feng shui* of the internal organs, etc. Few have shown statistical significance. So we turn to the advice of quacks and tabloid scientists and wolf down great handfuls of blueberries and drink pots and pots of green tea. Subsequently, you're in and out of the downstairs toilet a lot.

We've noticed, of course.

I *would* say because we care, but I can't really say that

with any conviction. Conviction, I'm afraid, is reserved for abuse.

Over there, the lure of the parent planet, attracting and repulsing our clinched beings for its own conceit. Tides, night, light, some forms of beauty – lunacy, even; especially lunacy – derived from our distant apprehension. While up here at the source, in the silence we are, I think, essentially bloodless and essentially motionless, transfixed. The only movement you and I experience being the direct result of a larger object's whims.

This kind of deferential behaviour fools no one.

The entire cast of a Bresson film. Inscrutable but simultaneously, miraculously, utterly clear, opened – gaped, like those eyes of the dumb owl – interpolated by us: holes in search of boundaries. You and I understand them, their frigid faces. You propose a film in which 'models' from Bresson's company perform as the sixty-six natural satellites of Jupiter. Jupiter being something like a central bank, or a river, or a castle, or a prison, or a farmhouse. The satellites wander – impassivity veiling desperation – around Jupiter, coming into contact – *just* – with one another. The lightest kiss, the slightest graze of a hand on a forearm; the warm – or cold – depression made by a gaze. Though it would be more accurate to call such a gaze a reflection. Nothing behind. As in, no source to outward movement. At least, nothing we could describe as being for or at YOU. Each model's stark face turned toward us. For our inspection, though it's hard to look for long at or into the gathered moons. Simply depressions, concave mirrors. Reflecting our own unresponsive faces in grotesquely impassioned, perverted expressions. Empathetic crumplings of brows,

flirtatious pouts, encouraging smiles – warmth, living plumpness. Molten glass mid-blowing, basically. This hall of mirrors, stalking the film set. We turn each over in turn to gaze into the mirrored bowl at our distorted, lacking selves. Serving simply to ape our emotional coherence.

A certain lexicon of gestures, infinitely evolved from those contemporary touch screen swipes, pokes, smears, dismissals you're fluent in. We eventually worked out how to leave a trace on these impervious touch screen surfaces. As in, we worked out how to depress them. Troughs ploughed while 'dismissing' through photos – or 'sacking' or 'deposing' about the internet. Eventually, the flaccid median of 'liking' everything – and any concomitant, infantile niceties – are eroded. Or rather, collapsed into passionate, urgent *né* violent oppositions.

Hold my hand, you ask.

We hold hands. Fingers interlaced and clenched, confused, balled into planetoids. We hold on to one another, willing spontaneous synthesis. We can never be close enough, you and I – there is always some barrier, however imperceptible.

An illusion of penetration.

– At no point do you make it all the way through to the other side. Which would necessitate one of us submitting to becoming a hole: defined by the other who one would wholly interpolate. The quandary being ontological, at least initially. How can I BE, if I am defined as an absence within you? Hemmed by you, you define my perimeter. Without you, I would yawn apart. Lacking edges, skin, slickening substances, I am nothing; a hole

without a brink is NOTHING. Which returns you to your terrible, insurmountable proximity with renewed resignation – a renewal of its abject necessity: definition, noun, adjective, etc. Slump, slouch, withdraw, fuck it.

A never-ending, terrifically chapped kiss. The two hemispheres of this thing dry-snogging. Passionately, though not without a certain reticence. A reticence echoing backwards from some inevitable finitude over there in the future. Kissing at the widest point. Four vast lips depressing one another. Attempted coalescence through the desperate application of terrific pressure – the upshot being a kind of continental lilo, scored with industrial *appliqué* dividing the cushions of lipids, blood.

In two; on,
two. Two. Two.
(*BLOWS ON MIC*)
– Is this thing on?

This is an attempt to speak of depressions. To speak as depressions. For speech, words, etc., to depress. A coincidence of forms to depress. A critique of depressions also, if I fucking say so. To speak of depressions from within depressions – from the wet floor of depressions, looking up at that blurred chink of grey light. An echo in here that serves to plot the internal walls of the depression. – A sorry parody comes drifting back.

(I don't sound like that, do I?)

– Conveyed from this narrow black bed at the bottom of depressions. This narrow, black, piss-wet bed – the ceiling above which artexed into complicated symbols

169

that denote the more familiar constellations rendered absurd – properly alien by this dislocation beneath the skin of a moon a few light years away. A dislocation half a mile or so below a sea-level of tranquillity. The schism between a sea on earth – quaint, perversely – and the lunar reality of countless voided craters we understand as a fossilized sea, geologic strata a daguerreotype of the tide. A sea churning with tentacles and incontinent spurts of foetid black ink. The canyon floor. Or skulking in depressions, entrenched. – A perspective afforded of a cross section of the topsoil: roots, worms, nests, bones, dense clay, inorganic, multicoloured MISC. Where a kind of rancid milk flows. Or a kind of tar or CRUDE, exhumed from the crevasse. This, then, delivered with a chasmically depressed expression on the face – all pro-trusive aspects having subsided. Over years, perhaps. A depressed index of dumb scorings, brute incisions – made using blunted instruments. A pair of those snub-nosed metal scissors to suit stumped, inelegant fingers. Only managing to DEPRESS the sheet of blue card: toothless scallops forming some careworn pattern. As in, the depression in the pillow, the mattress; the depression of eyeballs through eyelids with heels of hands – they give, slightly, with a muscular wrench. An expression of humour. Or tears, of course.

They say things'll get better.
All I know is, they fucking better.

WARM, WARM, WARM SPRING MOUTHS

And you don't seem to be.

And how could you be?

And no provision has been made for the casual life in casual, freshly laundered bedclothes; trousers dropped to excessively conceal the ankles.

And pain exists in the concave.

And pain exists in the convex.

Allowing liquids to puddle, importantly.

Allowing the camera to pan back to the groin.

(Certain skittering forms impressing the rainbow meniscus.

– – – Lifespans of a few bleak seconds.)

And there's a certain earth mover named 'The Dispassion'.

– Printed in an ersatz military typeface on the bright yellow muzzle, right beside the curled exhaust flue:

'The Dispassion'.

Named after an icebreaker that used to clear those unnamed straits at the top of the world. To allow for the blood to flow thickly

RED one way and

BLUE the other.

Or to flatten – to medicate and temper the earth.

And I'm here in this trench.

The final trench, perhaps.

This one goes out to the damp clothes balled up and forgotten in the washing machine. Secreted inside: a still-foiled condom and the pulp of a letter.

This one goes out the door and into the squall. A HERO!, we shriek.

This one the last thing you hear on the radio:

I don't want to hear any news on the radio
about the weather on the weekend.
Talk about that.

Once upon a time
a couple of people were alive
who were friends of mine.

The weathers, the weathers they lived in!
Christ, the sun on those Saturdays.

And this whole thing a concession, really.

A compromised surrogate for a REAL fucking experience. All hobbled legs and gelatinous irresolution, hauling itself inexorably through the murk by the will of some unknown coronary motor.

I say 'coronary', but I have no idea whether it even has a heart.

Or a brain.

Or kidney-shaped kidneys.

And what would these things be for down here?

And what desires power it?

And where is it going?

And what will it bring back?

And where will we hide when it's back?

And what the fuck is it looking at?

And what will we watch while it's out?

But you know, it's often all I want:

The kind of sodden, soppy flights of fancy afforded by unworthy, conspicuously dumb slabs of culture. The kind that lolls on paper plates and reminds us all of a kind of cakey sex.

And malnutrition offering the kind of pathetic solace that news of a foreign suicide might bring. Or what post-masturbatory succour might actually be. Or the laboured sketch with the hard pencil of the video-game character, scanned and offered up and rejected.

Something about external legibility, etc.

The ability to find the right TACK, to grope out the syntax with toner'd digits.

The ability to apprehend the perimeter: to trace the shape of something before it's completed.

A particular kind of forecast – fate that deals in objects and their metabolic relations, possibilities. As in, PRE-DIGESTION, which would – IF would – be properly understood as a kind of legibility or, elsewhere, as a sufficiency of aero- or hydro-dynamism.

And a bullet, for example, makes use of a VISCOUS context of ignorance.

Ignorance of how it works.

The shape of a bullet being DELIMITED by the rest of the world's inability to empathize constructively with it. A kind of INDIGESTION the realization of this empathetic failure.

A description I remember of a Christopher Nolan film was that everything in it looked like a fucking gun. That the camera moved like a fucking gun. That the music sounded like a fucking gun. As if heard down the barrel of a fucking gun. That Leonardo DiCaprio looked like a fucking gun. That he would approach his reflection and apprehend himself – with WILD ignorance – as a kind of fucking gun.

And (what) I want(ed) to say is that none of us could make a fucking computer.

Beginning with what? A fistful of sand? The wherewithal to make ORANGE fire? Access to oil? A few rudimentary tools? A thousand glum years.

And there's down here.

Down here everything is STRUCTURAL.

And ornate gods stalk the corridors, taking it all in via twelve-inch pupils and twelve-ton jaws and twelve-year metabolisms and twelve-month gestations.

And it's not too much to imagine their defining the tides AT WILL.

And it's something I can't come to terms with, however.

– Their existence: which would have to preclude the existence of the floor.

And it brings cold comfort.

– The irony being that neither temperature nor poise is possible, of course.

This one goes out and comes back:

I don't want to hear any news on the radio
about the weather on the weekend.
Talk about that.

Once upon a time
a couple of people were alive
who were friends of mine.

The weathers, the weathers they lived in!
Christ, the sun on those Saturdays.

And bullet-time, really, is a life-saving bit of exegesis.

And things often came sellotaped to the covers of specialist magazines. Or conspicuously missing from the covers of specialist magazines, pocketed by specialists who determined to maintain their specialist status by denying access to other, non-specialist or pre-specialist plebs.

Beautifully written, ain't it? That scene with the playing card and the bullet. Or the one with the balloon and the bullet. Or that one with the apple and the bullet. Beautifully scored, also.

And it's not for nothing we named the camera 'Phantom'.

All that excessive recourse to revenant forms as cultural analogues.

And there's plenty of that sort of stuff conjured down here: the pressure, the proximity to RED hell, the lack of ocular privilege – the lack of ANY sensory privilege

– has harboured the idea of a haunted house thick with zombies, ghosts, ghouls and vampires. Ruled by the notorious, prehistoric Vampire Squid from Hell.

> This one goes out [... –––›››] then ploughs hard into the shoulder at a grim, determined pace. A drill whining at the end of its charge.

And I mean to say that, I don't really know how to make a gun.

I could make a bullet, I think – and perhaps eventually come up with a way to propel the thing sufficiently enough to make a mark. Perhaps even kill something.

And I don't know.

And I can make educated guesses, of course. Provisional education.

And I certainly do have a relationship with guns.

One of semi-intelligibility.

A little one-sided, I suspect.

And I darkly suspect that guns know a frighteningly large amount about me.

– Their particular penetrative aspect, etc. Never CONSTRUCTIVE.

As in: 'We'll never manage to put that playing card back together.' Or, 'we'll never manage to put that balloon back together.'

Guns don't work down here.

And nothing works down here.

– Nothing save for that NASA pen and the currently off-screen bathysphere.

> This one goes out along the long, oiled cock of a rifle. The ornate, occult rifle and its occult subject/object proposition.

Think of Pinocchio and Geppetto lodged in the fat colon of the whale: the mast of Geppetto's junk stuck, spanning the bowled diameter of the whale's large intestine. Mulched krill BACKING UP. Insolubility is a decision, we should say.

Dispassion, also. 'Dispassion' as a verb, as something I do to myself, to other things.

'I'm going to DISPASSION this.' Etc.

More often than not, this is the kind of violent placative mode I plump for. A low polygonal boulder presenting the easiest, most comfortably abject (mattressed) means to approach the great wall of my frustrations. Both the boulder and the wall are, of course, hollow.

Moreover: me too! A hollow man: a bed sheet of ferociously detailed skin tossed over chicken wire, sealed with a gallon or so of PVA semen.

Dispassion also the name of an earth mover, an icebreaker, a cloudbuster.

This one goes out to an intricate foil helium balloon, bobbing obediently at a safe distance behind and above:

I don't want to hear any news on the radio
about the weather on the weekend. Talk about that.

Once upon a time
a couple of people were alive
who were friends of mine.

The weathers, the weathers they lived in!
Christ, the sun on those Saturdays.

Inexpensive. Which is part of it, too.

And in your absence, your very possibility is pretty much repealed by the terrifically oppressive atmosphere.

It's as if someone had died in here or something!

No room, we whisper to the room
and no one.
No room, despite the space.
Like space there's no space.
As in
as it is in
Outer Space.
Which is of course stuffed to the gills with unlivable conditions, thick stories of our massive thickness.
Similarly, down here, there is no room for human life. The ordering is wrong, for a start.

The fantasy goes something like this:

I am at the bottom of the sea and, consequently, die.

A second attempt might be:

*I am at the bottom of the sea and my lungs, spine, my inner ear, spasm and collapse with a violent, alien *CLICK!* under the enormous pressure and, consequently, I die.*

Third, corrective attempt:

I am at the bottom of the sea. Every sense is so comprehensively annihilated by every characteristic of the scene that there is, nor IS there ever to be NO APPREHENSION.

I AM AIN'T at the bottom of the sea – I AM AIN'T
anywhere. I am INSIDE MY HEAD. Bogged by them
licks of grey matter – the licking grey matter –
the licking mists I inhale blown back shroud gag.

Most likely, however:

I am at the bottom of the sea. Essentially a purgatory;
essentially a prison. A site of total deprivation.

In this sensory STRIKE my imagination swerves and lunges and weaves to ascertain – based upon a kind of inward RUMMAGE and with the hang-nail'd fingers – WHAT THE FUCK is going on. Without recourse to empirical sensation, my mind swerves and lunges and weaves at the infinite, maintaining as it does so – and indefinitely so – LIFE, if simply because there's no way of confirming the circumstances of my situation, let alone that of my DEATH, which must be conspicuous to be ANYTHING, surely – which must be fucking CONSPICUOUS, otherwise the retroactive repercussions would be too much to bear and, um, suicide would determine to CROP in prepubescence.

This is probably no longer an experience but more likely a concession for the impossibility of experience – of any more experiences to be had at this point.

And you're at the bottom of the fucking sea!

– Experience is both thrust into supersaturation and completely, coolly obsoleted.

And CUT!

And meaning that us ponderous us's are frustrated by our own debt to some precarious lip of determined life.

Black curtain dropped. More an accident than stagecraft.

'Here',

and the semantics of presence are borne out as demonstrative bags of flour or sugar, and one or two defrosted, sagging cod loins, held aloft.

Or swollen, obsolete telephone directories, on the verge.

– Swollen with the same name over and over: the name of the ONLY PERSON that ever really mattered.

And these are redundant equivalents in this context.

Presence is something we need convincing of via the complicated arrangement of the wet polygons, dear.

'The Sandbox', as we call it, is, in fact, a model for perceiving the outside of our brains while remaining definitively inside them. Labyrinthine/moronic orientation.

And any appeal we might make for a modicum of space – for just a little breathing room – is spurned and punished with a WALLOP! to the solar plexus.

Folding, doubling over –

the springing open of all the sphincters to receive that HOT black lope of voided

VARIOUS and SUNDRY AND.

The origins of which we are mutually ignorant of –

save for some image of an armour-plated mollusc whose inverted body lined with FILLED MOLARS, beaks, the BREAKS, the rub, the palm, the oil, the grease, etc.

I don't want to hear any news on the radio
about the weather on the weekend.
Talk about that.
Once upon a time
a couple of people were alive
who were friends of mine.

The weathers, the weathers they lived in!
Christ, the sun on those Saturdays.

A heavy mood that turned its back on the light mil-
lennia ago, riding down with the first wreckages of the
first gunboats on that first fateful day, and the first light
all the way to this frigid sound stage.

In a few devastating ways, that first night never
ended.
As in, here we are.

And dumb-bells silently repp'd by those eight long
purple arms, in advance of trammelling your HOT
body with repulsive hugs.
A sincere attempt at contrition that will never dis-
guise the fundamentally TOKEN aspect that outlines
the basis for their inexcusability.
As in: fucking tentacles!
As in, frankly, oxygen GOES ALL TOXIC under
pressure.

– Alliances forged up there in the
RED fire among the
GREEN forest under the
BLUE sky.
 – All are conspiracies down here.

Then comes a voice, webbed somewhere near the back, fibrotic negotiating & the baleen, extruded slow, tight and surreptitious.

– A jellied, off-white speech bubble barely supporting the weight of the dirge:

> *I don't want to hear any news on the radio*
> *about the weather on the weekend.*
> *Talk about that.*
>
> *Once upon a time*
> *a couple of people were alive*
> *who were friends of mine.*
>
> *The weathers, the weathers they lived in!*
> *Christ, the sun on those Saturdays.*

(Is this thing on?)

And a trellis of smooth, thick cabling across the floor.
A confounding of muscled tentacles
 and the thin, cheap speaker cabling dragged about by coelenterate
 and certain slow-wave-forming eels
 and the stiff, glowing pricks emerging from certain lophiiformal foreheads
 and the too-straight lines of scientific investigation, photic empiricism
 and them pasty gymnastic ribbons of jism jamming pubes.

And all this fucking hair!

And me playing the role of the decrepit spider
who most certainly belongs on the landing and not
in the bathtub, at the terrible whim of your ghastly
children.

This one goes out to you, slathered with
HIGHLY-factored sun cream, picking your
way across the beach, taking in the unwound,
undressed bodies, scattered according to the ge-
ometry of sunlight – two proud ellipses of yellow
sand stuck to your two tremendous buttocks.

My name is (*unrepresentable*) – to rhyme with
some sort of rampant acne. Or the general state of our
combined adolescent skin. Though pronounced as you
would your own. Your own name, that is.

This one goes out at a terrific velocity, flung by a
confident, comely arm, arcing across the summer
sky to never, ever land.

As if we can believe that sort of thing anymore.

A stone skimming the surface:
for a moment there, joined by a flying fish
– the both of them – fish and stone – coins.

This one goes out to the French Foreign Legion,
trudging their silica scabed to the beat of their uni-
form hearts.

This one goes out to the desert.
– Being a ship of the desert, if you like.
All coarse hair and dry, mutable geologies.

Yellowing waves as half-turned pages, corners perpetually folding like sugared egg whites in a glorious gesture of inchoate demarcation.

To summon such-and-such.

A recipe, a quote; those parts that chime with your own inadmissible ideas. Supportive: scooped bucket seats in the dunes. A world whipped into representations of provisional shelters moulded by deft hands of wind and dismantled in an instant by the simple, devastating absence of a single moist brain to sustain them.

This one goes out to the French Foreign Legion.
– Over there and someways off.
This one goes out of the dock, slips out of those handcuffs, slips out of those wet things, (PLEASE) slips into something more comfortable, (DO) slips between the hands, the tongue, the hot tarred eyes, (turned) – slips out of sight.

Into the cool water.

This one goes out to the sand-blasted basement, priorly encrusted with the obscene graffiti of a listless troupe of AWOL legionnaires, chronicling, after the fashion, their rise and fall from the sun's favour.

This one here – here – here is not a holiday destination. Just to be clear.

Loud and clear:

This one goes out to the teetering heaps of count-
less vitamins walking upright along the beach
toward the harbour, gingerly avoiding rock pools
and the inbound tide. In flagrant excess of your
RDA.

And barrels of salted meat and fish; great coils of
neck-thick rope; freshly laundered linen from the lov-
er's cabins down below. Huge, plunging necklines of
sail slung across the rigging and the skeletal masting.

Drying in the sun.
A den beneath.

I'd lie beneath this erased planetarium – the only ce-
lestial body, the sun, appeased, buttered under there.
Me, buzzing from a fill of dry sherry, dry white wine.
Pickling in the HERE.
And shooting fiery, Martian Scotch poured
from crystal decanters into crystal tumblers.
The scrape and fit of sanded glass stoppers; the facets
of the crystal throwing slivers of light, ventriloquizing
the sun's baritone in an elegant soprano:

> *I don't want to hear any news on the radio*
> *about the weather on the weekend.*
> *Talk about that.*

> *Once upon a time*
> *a couple of people were alive*
> *who were friends of mine.*

> *The weathers, the weathers they lived in!*
> *Christ, the sun on those Saturdays.*

This one goes out to your singular hands that once held firm.

This one goes out to your singular hands that once held firm
and to the point of really bad callousing and the crusting.
And the liberal application of Atrixo hand cream (the choice of the blasted Norwegian fishermen), applied by one hand to the other – though both hands, in this instance, were and still are mine.
The sometime application of moisturiser by sometime other hands or hand-singular on my hand-singular or hands: so the whole mess of palms, digits, knuckles, diminishing wrists, balling, fisting together beneath a slick bind of artificial or sometime natural oils – humectants, emollients, lubricants, etc.

Down here, I think of everything
according to the morphology
of gastropods.

Up there, the sculpting of the self assumes cellular annihilation or apoptosis.
In order for fingers to form, a separation between the fingers must also form.
It is apoptosis that produces the interstitial void that enables fingers to detach themselves from one another.
– Down here, it's the opposite
or very nearly.
– Down here it's all parthenogenetic convulsions and metastatic stings.
And nothing is separate from anything else.

And everything shares a dermic fibrosity.
And everything is hollow.
And everything is a drum, now.

For what it's worth and for all the good it'll do you:

I like to watch archive footage of fagged stand-up.

You like to watch pneumatic, hetero-stale, oatmeal-porn.

We like to watch state funeral coverage.

He likes to watch drastic, surgical makeovers.

She likes to watch parochial videography on shagged CRTs in the dim, sweet rooms of provincial museums.

It likes to watch the crude brushstrokes, made.

I like to watch catch-up TV.

You like to watch the infographics proving culpability.

We like to watch for the change on departure boards.

He likes to watch the scene unfurl through the fat GRID of a portcullis.

She likes to watch the decline.

It likes to watch the blue ECG and the blue light
fade.

Acrylic plastic porthole of the hushed wet bell.

COMING UP
through the moon pool:

I don't want to hear any news on the radio
about the weather on the weekend.
Talk about that.

Once upon a time
a couple of people were alive
who were friends of mine.

The weathers, the weathers they lived in!
Christ, the sun on those Saturdays.

I wanted to ask whether you thought that finding an eyelash under your foreskin was significant?
 – Because, truly, it felt pretty signal to me.
 A magnificent and rare episode.
 Or at least, a rare and magnificent appreciation of a common episode.
 A moment afforded, certainly.

(Testament to the particular auterist, directorial technique: natural light, digital cameras, skeleton crew, to be ready to shoot if the cry goes up.)

 – *Ho!*

Sex, death. Intimacy and its melancholy impossibility. REPRESENTATION – exhumed, upended, turned over in the hand, either to discover the seal of its authoring or, with a little shock, to discover that, IN ACTUAL FACT, it's not a representation at all but the real thing: a curlicue of eyelash *disguised* as the pronominal self
 – as I, as 'I' –
bedded down beneath the foreskin, awake to that sensitive ground. Like an implement of dowsing.
 As in:
 Blackened, dead dermis as incisive, essential, esoteric. As fucking deadly: there under the foreskin, clinging to the glans like some missing, nascent grapheme.
 Lost.

In the way a fossil is impossibly lost.
 That crippled, ammonite curve of
 mascara'd spines, smashed

– fucked,
– shaved,
– sunk.

(The unimaginable, fabulous skin-tones of dinosaurs.
Most audiences would decry a fluorescent pink Brachiosaur)

An ecstatic fossil. Unearthed tenderly from the sweet sod. Manicured hands in talc'd latex gloves.

Powder-brush brushed to reveal a kind of irresistible legibility.

A primordial story of separation. Of everything apart from everything else. Told brashly by two discordantly tuned kettledrums at either side of the stage.

'Intimacy'.

Producing its own fucking paradox: its charred, shined hand revealed (slowly withdrawn from a change-filled pocket or from behind the muscular back) – a surrogate for the impossibility of ever coalescing, of ever rescinding yours and my DISCRETION; 'intimacy' forming some heavy-metal barrier cream.

(At which point, a climactic spraining at the roof of the mouth followed by histrionic tears)

– Ecstatic.

Ecstatic!

A singularity. Gazing down, planted at the urinal: an image of such searing clarity. Considering the circumstance. – Not a singularity: a plurality. Of meanings, thoughts, analogues, images – under the duress and heat and unbelievable humidity and toxic needles and taut canopy and pregnant clouds and slow air and purple, sourceless light of DESIRE! Compounded into a sweet, slick sauce.

Accompanied by the carpet-muffled – subsequently tile-reverb'd – pub foley.

Ammonia; dark sweats; citrus bleach; ready salted potato.

An apex of the sensational, is what I thought. Which hardly trips off the tongue but does FIST the brain, necessarily.

I wanted to ask how you might have considered such a scene, if at all. And if so, how you might've interpreted it.

Whether your first thought might have been unabashedly romantic – a FLUSH of entertaining;

a FLUSH of obnoxious lavender!

– Concerted fantasizing upon the provenance of the eyelash in relation to its PRIVATE situation. The eyelash stemmed and shorn from an other's fluttering, crêpe skin; the eyelash trapped beneath your foreskin after a forgotten night of unveiled fucking. Or – more TERRIFICALLY – a night of average sleep as any other, with a for-granted lover who, in our scene, heaves into view like a red ship.

Whether you would have *grinned*.

I wanted to ask whether, finding that eyelash secreted under your foreskin, you would have grinned.

– In waist-high remembrance of that intimacy, that stab of pleasure – this eyelash proof of a level of congress, of an acute, sparkling tenderness; of eyeballs and penises, of nervous overload. Of your intimacy – of your CAPABILITY for intimacy (resoundingly proven here, thank GOD) with the eyelash as a simple, FELT smile to brim over, GRIN all the broader for the isolation of this urinal, the circumstance, the line of

sight – the solitariness of such knowledge, the thought, the memory, here, performing something as perfunctory as pissing.

Whether you would've grinned with the plain absurdity of the discovery, which would, could, might perhaps be quickly, irrevocably inflected with a surge of – TRULY – love.

Whether your first thoughts would have been romantic or perhaps, in actual fact, judging by some of your previous work, your first thoughts would more likely have been morbid. Perhaps, upon discovery, the eyelash took on the portentous aspect of a curse; an precise black inscription condemning either you or, more likely, the previous owner of the eyelash, your lover.

– Being a stiff wilt of dead matter. Doubly-dead here: disinterred from its loose soil and reburied beneath a thick fold of another's clay-like skin.

I wanted to ask whether this congress, between living and dead matter, would have struck you as sick, somehow.

As in, unwell?

As in, whether you would have reached for parasitic equivalents. Infectious equivalents. Gangrenous equivalents. Swollen skin splitting along hairline fractures.

The SQUEAL of the wood on the ghat.

Or the skin.

As in, unclean – heretically FILTHY.

I never thought to ask whether you considered this smell sexual or deathly. In origin. As differentiated from its reception.

196

– Whether in identifying one or the other as the source you might in so doing demonstrate something of your DISCRETE LIBIDINAL ALIGNMENT. Your somatosensory 'calibration', as it were.

Really, I simply wanted to ask about what happened?

As in: what on earth happened?

As in: what the fuck happened?
 (What I wanted to ask)

For a long time there, it was all I could THINK to have asked. To ask what happened; to hear your take on things. To RELIEVE the unbearable pressure that'd been placed upon my own shaky testimony.
 To ask such a question being tantamount to a very real demand for the exculpation of my EVERY SINGLE FUCKING responsibility.
 To you, in the main.

The fuck happened.

The thought of a single black line drawn with a brush made of a single eyelash. The rarest kind of sable, etc. In black Indian ink, at the head of a penis, in one deft, tender stroke. Ermine-tailed. Barely registered, the slightest titillation. The other hand supporting, similarly tenderly.

The mark constituting a perfect double for the eyelash used to draw it. An eyelash grown backwards by the lover.
 Meaning?

Meaning:

I didn't think it would turn out this way

(A line that should really be delivered with a perfect and MATTE indifference. Or, not indifference but ambivalence. To reflect some sort of agnostic remove.

As in, a ballot paper spoiled with an exquisite essay on the process of precipitation. Or an immaculately rendered drawing of the back of an unremarkable, bald head. Or filling the entire ballot with a black mirror of graphite, leaving nothing but the metal eraser cuff of the pencil. Hours in the voting booth, distantiating.)

The smell was certainly sexual, I think.

I wanted to say that the smell was surely something originally sexual.

That the smell, perhaps, made me *feel* sexual.

As in aroused.

Though clearly with some... posthumous aspect.

– From over there.

As in: the memory of arousal. The echo of specific arousal. Remembering sex at work. While at work, I mean. And with a morbid growl. Thinking of a defunct sex act.

Sex with putrid caveats, rank rejoinders.

More than the usual, of course.

A residual stink, rather than something immanent. There's some stale, mouldered undertones – a *sporangial* ground – right there.

Either that or it's the scent of LIVELY excretions from a pair of corpses in stultified congress.

Or a pair of thick-set, crepuscular animals rutting.

Black hair.

– Glandular, pheromonal and utterly shameless.

Or the reek of some bundle of Neanderthal genitals: unkempt, ragged, swollen, tied off.

Caked.

Regardless: death – or rather, extinction – being explicit – being beside, beneath, on top of – the SEX. One discolouring the other.

Or making the other transparent with a perpetual expression of buttery grease.

(Those gigantic, bluebottle-snaring eyelashes of elephants.

As in, the ice-shagged, arachnid limbs of a crustacean.)

Our courteously HUMAN bodies, apart from areas of glabrous skin, are peppered with follicles which produce thick terminal (pubic, -lash, pits) and fine vellus (scalp) hair. Varying quantities.

I wanted to ask whether you would concur that most (predominantly *blithe*) interest in hair is around hair growth, hair types and hair care. Whereas you might rejoin – or at least redress, reset – with a sentence like: hair is an IMPORTANT BIOMATERIAL primarily composed of protein. Notably keratin.

To varying degrees, most mammals have some skin areas without natural hair.

The ventral portion of the fingers, the PALMAR surfaces of hands, soles of feet, lips, labia minora, and glans penis.

On the smooth, bald road to cadaverousness.

Presumably the tips of penises used to be covered in hair.

Presumably the palms of hands used to covered in hair.

Presumably the lips of vaginas used to be covered in hair.

Presumably the soles of feet used to be covered in hair.

Presumably the button-mashing tips of fingers used to be covered in hair.

Presumably the walls of your bedroom used to be covered in hair.

I wanted to put to you a thought about the formal cogency of the eyelash as a typeface. To put to shame the contrived efforts of my hand. That equivalence: of eyelash to discrete line to slight-inked line to compelling glyph; that 'I' that points back to itself, a chink in the curtain through which a mirror might be glimpsed. – Only exploded, expanded to encapsulate the entire person. Like yet more eyelashes, braided together into a double helix, centrifugally spun to life.

I wanted to speak of a cursive comprised of a single, sweeping line – written in skin, on skin and under skin; a line of dead, tinted, coiled skin, drawn on to the most sensitive ground. Held in place in raw, dermic proximity.

Subsequently, I wanted to say something regarding sex and drains and in relation to us.

As in, it could well be the drains.

Or us. The smell a consequence of our peculiar communion. Some invisible gaseous symptom, blurted out in the rush of hob-heat.

As in:
I love you.
As in, I love you.
As in:
An abattoir in July.

Which is what I wanted to say – what I wanted to ask in saying so: to ask, to imply.

You wield what is equivalent to one of those bolt guns for thumping pig's brains off cliffs.

Or one of those pneumatic forelegs for riveting your audience by the thigh to this chair.

I wanted to say – confidently, unquestioningly – that I love *towards* you.

The misty idea of something weightless and invisible nevertheless landing, finally, with enough destructive *heft* to crater the ground or instigate a tidal precipice to run over a village or two.

That something apparently ethereal can nevertheless decapitate.

I wanted to ask about death and sex, then. Or rather, properly, sex and death – chronologically. Two sickly ruts of abandonment. That we love from within. From within the carapace of, etc. From within the concrete bunker of, etc.

As a steaming, *saucing* couplet.

How sex and death might accurately have narrated life. Your life in particular.

Sex and death being twinned. And I'd only met them a few times. Through a mutual friend, maybe. Or more

likely through mothers – theirs and mine, GOD BLESS HER. The twins that took great pleasure in riling those who found it hard to tell them apart. Performing, somewhat grotesquely, as the other. For various crucial mortal tests and WHOTNOT. – The only way to tell them apart being by some tiny scar peeking above the gingham shirt collar.

Or the way in which they run a right hand through their SCALP hair, or their mathematical or lexical capability or incapacity.

Or how easily they laugh, cry, flirt, fight, etc.

Consider Zeis and Moll: the grounded gods of [...]. The glands of Zeis being unilobar sebaceous glands located on the marshland margin of the eyelid, buried somewhere in the claggy earth. Emerging in the wet dusk to stalk juveniles. During the day, secreted in their hollows, they serviced the eyelash subcutaneously, excreting an oily substance not unlike jojoba, fractionated coconut or grape seed oil, from their collapsible mandibles. Expressed through the excretory ducts of the sebaceous lobule deep within the central portion of the follicle.

In the vicinity, somewhere near the foot of the bordering range: terrifically active sweat glands called the glands of Moll. Being typically large and swollen. Tubular, crudely vertical, expressive.
That hair and nails continue to grow after death, or SO IT GOES. In an Osiris equilibrium with the eyeballs, which remain precisely the same size from birth till death but whose precarious jelly and precarious function and precarious perspective are the first things to go to seed in mortification. Terminal hair will jut further, prouder – irreproachable in death.

In ACTUAL fact, the skin simply in retreat. Back to wherever the hell if came from.

The eyelash answering *representational impasse*. At least genetically.

The problem I offer being to create something already dead, UN-LIVED, but with the qualities of something that had lived. And DIED.

Crucially *without* the actual need for that actual life and its actual, sorry end. To make something dead without always-already having to speed its death.

I wanted to ask whether a demand for a modicum of LOVE was too much? On my part. Too much to ask. For a certain degree of EFFERVESCENT LOVE to fizz atop and sentimentally counter the toppled granite LOATHING lying six feet above my brow. Whether I could ask that. Whether that were too much to ask. I wanted to ask whether that would be to ask too much. Whether in asking or not I appear more pathetic. Whether my being pathetic is in any way alterable or whether I'm condemned to crawl about the driveway at dusk on my belly.

I wanted to ask if love might productively be thought of as the faith that the body that formed the eyelash and, with a SLEIGHT of tender hand, laid it, like some foetal mammal, beneath my foreskin. That, say, love would be the devout faith that that generous, necessary body were still very much warm, muscled, alive.

I wanted to ask if you could recall the sweet, zoo-smell that accompanied the presence of the brush-like eyelashes of megafauna smelled the same – in some non-cognitive echo-located remembrance – as that fictional, a-gravitational space beneath the foreskin. Not space, but [...]

A unique kind of phobic concoction: claustrophobia, haptophobia, chaetophobia, phallophobia, etc. A plummet into flesh-walled caverns threaded with handrails of conditioned black rope.

STUPENDOUS PRESENCE.

Slanted bodies among public architecture, pinioned by stakes or tethered to splints, scaffolds, armatures. The monuments that surrounded us being apotheoses of those kinds of pseudo-geological bolts of steel we often arranged to meet under. In the cool shadow of.

And we would meet, grinning, gawping at one another as we approached from either side of the square. (GRINNING recognized in the other at such distances simply through the veracity of one's own overextended, mirroring facial muscles).

Averting our eyes from one another, embarrassed, until we were close enough to survive the meeting of our focussed, MOULTEN gazes – a closeness to rouse a deity in the space between us, to be altogether compressed in our hug, our kiss and our deranging, faithful ardour.

A kiss that begins perfunctory – dispassionate, even – but quickly evolves into something altogether more eager, devouring. Lunatic, even. Certainly lunatic.

So we kiss like long grass. Long grass concealing vagrants.

Or like polluted lakes.

Like those meetings of river and sea: a trailing line; a miasma hem of coalescence – bone-aching cold and bone-aching cold thrilling together.

Like strata of clay pinned by the steel-veined foundations of a city.

Like the once-activity of my once-breath and its once-temperature – its once-peculiar, metallic, frankfurter odour.

Or like two wet gods.

We kissed and kissed, fashioned in one another's slimed and stupendously drunk image. And we processed off, arm in arm and in the slipstream of that divine chariot. *(Fade to black.)*

I wanted to whisper an ask as to whether your eyelashes performed properly.

PEOPLE WILL WANT TO KNOW.
PEOPLE WILL WANT TO KNOW.

– Whether they were infected. Whether or not something like a stye had been raised from the hobbled follicle. – Sore, to shade everything you see with irritation, anger. Whether that might have explained a lot.

I wanted to ask about infidelities – about masks, robust limbs, coarse hair, Saturn, teeth set on edge, lateral thinking.

And beating gods until we're all exhausted. We down our weapons and slope off.

I wanted to ask what you thought about my desire to become a representation of myself.

How this desire might be partially sated at night – every single, inevitable night – in the miraculous presence of a LOVER, who bears witness to my definite, inconclusive state change; my thick faint into repugnance and mockery.

Mouth open like a button fly.

Likewise the eyes, toy balls moronically rolled back to stare satisfied-simple at that dark pink awning.

Chin slumped grotesque into poorly shaved neck; saliva soaking into pillow;

unembarrassed blurts of fart, violent snorts, a selfish grip on the duvet. Gravity pilloried by fat.

– Perhaps a few of those truthful dream-yelps. Deliberate intonation as fucking meaningless vocalizations. UNNGH!

– Cocktail orders, for fuck's sake.

– Pubescent whinings, for fuck's sake.

And that swamp of sweat, expressed with some unknown, nightmarish urgency – *unearned sweats* – under cowardly cover of darkness.

This corporal revenge. A genuine, concerted and systematic undoing of grace. Every promise discovered *too late* to be a fucking lie told badly. The promise of intimacy and the promise of beauty ripped away to reveal a gawping, hyperreal brute.

An *almost* perfect representation of me.

Perfection[*] only withheld by that small matter of the encroaching white of dawn under the door and the imminent waking. When all of this might be nonchalantly buried beneath several square tonnage (or hurriedly stuffed into the underwear draw) of language and a sprint of animist velocity.

Cadaverousness.
Cadaverousness.
– As a counter to all these trainee murderers, these bastard representationalists. Who insist upon my follicular precision, the authenticity of my sprouting hair, my malfunctioning hair, my hair ending up on my cheek, retrieved by you, proffered up for me to pucker up and BLOW! and offer up a hurried wish to the patron saint of megapixels,

superb particle physics,
real-time fur simulators,
real-time FRACTURE,
rigid body solvers,
complete interactivity,
terrific polygon counts,
fully destructible scenery,
gratuitous FRAGGING.

Of gunshot wounds and shining burns.
Of screaming and roaring.
I wanted to ask if you might contextualize this by ushering in to the room a representation whose life was implicit (and closing the door).
Rather than erstwhile: preludial.
A relation to life that coerces the cadaver into a being that does not require a prior life – that requires no living human to be smashed into oblivion by some high definition hammer for merely tuning fucking gods.

I wanted to ask, tentatively, if you mourned anything ridiculous?
– The passing of anachronisms, archaisms, even.
Whether you suffered from bouts of fantasy for the quiet, sofa-bound end?
Together.

[...]

I thought about whether you might've turned this down at my offering.

Whether you could have passed me some paper, a pen, a drink – a *drink*. A *fucking drink*.

Whether you might have passed me a *fucking drink*.

Whether you could have just passed me a *fucking drink*.

Whether you might have summoned the heart to fix me and pass me a *fucking drink*.

Whether you knew the slightest thing about redemption, apology, etc.

An understanding of 'sorry' as existing 'between' rather than 'of', 'on', 'from' or fucking 'in'.

I am sorry.

I wanted to ask whether you'd considered the rather likely conclusion that the eyelash made its way beneath your foreskin by entirely banal means?

Like a worm mistaken for a brooch. Or rather, that broken hammer mistaken for a fist-sized jewel. A fist-sized fist mistaken for an upturned palm.

A somewhat pathetic, plodding transit. Under a fingernail, most likely.

Fingers retreading routine ground: rubbing eye, adjusting crotch, etc.

Etc.

What this might mean for LOVE.

Mistaking the utterly null for the terrifically important.

What this might have meant for love.
A mistake.

I wanted to ask whether you once knew how to extract elements from a compound. Some vestigial secondary education?

Specifically?

Specifically guilt. From anything else. Whether a pale blue flame should be tended beneath. Or drowned in some pertinent corrosive. Or a frequency of vibration applied, perhaps. The heavy-handed pummel of a subwoofer. The acupunctural possibilities of those serried tweeters.
Or simply neglect.
The application of arrogance, apathy – a lazy SHOVE overboard being all it took.
(O! the concision of such a brush comprised of a single eyelash! Rooted in wood and restrained by mild metal! Wielded deftly by the clump of acrylic French manicured fingers!)

I wanted to ask about pubic hair, clearly.
The difference between pubic hair and eyelashes – the difference between those two toughened hairs and their slightly fairer siblings that used to blanket the head, spackle under the armpit, across the arms, the fingers.
The primal, true-mole-down that coats certain faces.
The primal down that got SLOUGHED OFF about a year in.
To discover, from some recess of an illustrated encyclopedia, how pubic hair was the way it was – is, perhaps, the way it is – because of its LOCATION.

209

Proximity to dampness, heat;
girding genitals,
getting tangled, wadded, soaked again.

A distinct lack of exposure to sunlight, the sobering breeze, snow, etc.

That you might have understood them as stalactites, accreted over a great period – silt-stuffed, subterranean. A raw architecture that, pictured in cross-section beneath an overground of forest, becomes a shadow –

– a haunted forest of hanged trees, shorn of their limbs, their bark, their sap. Great sheaves of plated dead skin, now.

I wanted to find out whether you recalled your first VIVID experience of death. When, in early childhood, you found a dead mouse in the grounds of a cottage. Your sympathy being moved, you buried the mouse in a lovely mossy spot. Remembering the place, you went back a couple of days later, and moving the moss away, discovered a black insect in the mouse's stead.

I wanted to ask if you'd been thinking about something dead growing.

Stalactites, for example.
– Hair, for our purposes.
– Made up of dead skin, of course.
Thrust up through those tight follicular nozzles, the great prairies of skin are, in each generation's death, brutally compacted into hair. The follicle determining the shape:
gritted teeth and sewer grates,
pet baskets,
vacated honeycombs,
firmly interlaced fingers,

 elaborately tipped piping bags,
warm, warm,
warm spring mouths.

Pubic hair forced through some sort of carving of an eye
the size of a follicle: a protrusive gaze; a gaze shedding
death.

 Lustrous dead skin being the only sufficient means of
living beside and in material cahoots with death. And
beneath: [...]

 The maintenance of the acid mantle, regularly stimu-
lating the subaceous gland.

 The wetting action.

 The physical action.

 The emulsifying action.

 Your porous skin always having been partially
Stygian, if I'm honest. Latterly overawed, flooded,
overrun.

 Now,

 the only part of you that grows is your GORGEOUS
hair, in a last spasmodic jettisoning of life as your ruined
skin hardens in preparation for the final, chemical peel.

 The only thing that moves now is your hair, in those
eddies of the black water –

 (the slipstreams of massive pike,

 of egg-sputtering sturgeon,

 of scuttling, barbering crabs.)

 The only thing that remains now is hair – the
indigestible BUT pre-digested and wretched remnants,
heaved from the filtration system of a municipal pool.

 A huge wet wig!

I wanted to ask you about toughness in limp-mattressed bed with delicacy, sensitivity.

An eyelash, mainlined to the mammal brain via some particularly susceptible blue prong of the nervous system.

Nevertheless stiff, tough – capable of repelling flecks of alien matter, of supporting tar-heavy smears of mascara.

Resilient, I should have said.

As in, resilience being testament to sensitivity alongside indomitability. A paragon of humanity, perhaps.

As in, sex, I suppose.

I wanted to ask whether you had considered the eyelash as an incision?

– A second urethral opening, perhaps. Lasered. Or incised with an obsidian blade.

For the conveyance of *other* substances from the body.

Words, for example. Guilt, also, of course. Both presumably VISCOUS. Painfully passed.

Or substances more pertinent to the particularities of the eyelash: rheum, tar, etc.

LOVE! – An excess to be vented.

TEARS! – A kind of covert weeping possible. Darkening the underwear, away from PRYING eyes.

An <u>underlining</u>.

An emphatic ~~strikethrough~~.

As in:

an error maintained as visible in order not to make the same mistake again.

The dead eyelash as a surrogate for my MIRED sight, my GROSS intimacy –

– a slung fuck, of course. All of the senses confounded in the dark proximity.

(Apologies.)

There is a collapse here – and not just of my once sturdy ribcage,

my once taut skin,

my once fizzing eyes.

– A collapse of experience, of sensible apprehension.

– A collapse from coherency into incomprehensibility. A tourettic attack in the middle of the high street.

We are at once yanked – limbs and rancid fluids trailing – between our chalk-lined positions THERE, impossibly heavy on the linoleum. And HERE, clinging to the screen, held by static and faith.

I wanted to ask how you would have pictured my face?

As a possible source for the eyelash.

Whether my face would be animated or still. In a diorama of close-up details or whole.

– My rendering HERE is something of a hash of these possibilities. As in:

Dead matter animated by jolts of mains electricity. The face entire is shown, but the skin, the hair, those distinctive moles and marks – all of that in some sort of abject close-up. Crude, somehow, but horribly correct. Incontrovertible. Which is why, you say, reality is no longer the contested terrain.

In repose.

I wanted to ask whether you remember retrieving the eyelash. Or whether, perhaps, you left it there, re-concealed it – tucked it back in –

– not quite bringing yourself to remove it.

From that peculiar locket, if you like.

Left there to rot, I suppose.

Which begs an account of your foreskin as a particular kind of tomb.

A loving tomb but nevertheless a tomb.

Being a construction site where remembrance necessitates forgetting.

For the sake of everything, really.

Or rather, the giving over of the job of remembering to some indicated location just beneath the topsoil.

So that we might finally move on, you know?

Or at the very least move beyond those more recent, ruinous memories, rumours.

I wonder if you remember the spoiling of the brain? The brain reflexively spoiled, so that images of perishing, sounds of perishing, smells of perishing – deluge the brain as the brain itself perishes.

The dreams of a bearded old beef
laid up in an untreated pine bed
are great banquets of staggering offal.

I wanted to have a good, hollow laugh thinking about the burgeoning of some commemorative fungus ≫ down there.

– Resembling the lichen that seems to bloom exclusively on headstones. Beginning in violent yellows, oranges – eventually turning to a warm grey and finally crumbling to nothing under a passing cagoule sleeve.

214

The way to retrieve the eyelash being through the use of SALIVA, applied by the tongue direct. Or as a swilled foam on the tip of a finger. The thumb may be required in the final reckoning.

The eyelash, then.
The germinal possibility for representational wish-fulfillment without the need for death.
A tiny, exquisite and *partial* death.
A *death*
that
in *death*
transforms into glamour, romance, fluttering sensitivity, a camp for countless glowering face mites.

A death that remembers itself. The posthumous skin of the living, breathing, lolloping body – in the most hushed, dulcet tones. Bed sheets balled up and knotted and dunked and soaked in vats of jet-black dye, fished out and lowered into sweltering pitchers of petroleum wax, hung to set from bannisters in pharmacological and cosmetic corporate headquarters, stalactites dripping separating black liquor onto paperwork, laptop keyboards, swatches of pH paper, plebeian mugs, executive china, data projectors, kicked-off heels, jogging gear, trainers. Filling iPods with fucking grunting, whooping, sincerely startling songs in long, meandering playlists. Dialling prison inmates on iPhones; messaging amphibious animals who respond in halting sentences describing, in UNAMBIGUOUS DETAIL, what they would like to do to you.

Everything slashed with heat, flicked pitch.
In your honour.

Dedicated to you.
A dedication, here.

To you, my love.

Every follicle a valve or a thin brass pipe in some vast,
breathing instrument.

Come-to-bed and fucking die:
Add light to some small pink star.

MAPLE SYRUP AND CIGARETTES

So it seems the correlate is a lungfish or something.
Certainly the death-ripple of striated mucal ribbons,
flapping in bone-coloured concave sails – full
and flooded with salt water taffy. Stretched over
quivering trachea, boiled sugar and butter and
parasitic carmine limbs and carapaces
corralling some swollen,
off-white, latex, pleasure-ribbed, foil-sweated, set-
semen, bag-boiled GRUB:
an ecstatic, engorged, end, enlarged
inside a sad paperweight of carbonated amber.

– Who fears deep water, despite the right equipment.
– Would rather stick than twist, in other words.

(S = k log W ≤ headstone and entropy, crested with
gilded with a POP
of orange lichen)
As in, turned. Like wax fruit.}

– 'Under the Banana Wing'
Being an honest enough epitaph.

Brown tears in cilial hairs
Necessitating nebulizers
commonly used for the treatment of cystic fibrosis,
asthma, COPD and other respiratory diseases.
Horsehead or
Triangulum Emission Garren or –
simply –
CRAB.

That branching lungful of plasma.
Cold milk as a syrup of
BARIUM SWALLOW,
stimulating the terrific diagnosis.

Upon returning to the bedroom: the smell.
Nothing so much as nocturnal gapings (us, cavitied)
and the anxious grinding of dry-ice cubes between
steeled molars (us, petrified).

A cool thin river accreting a silt of ghats and saps at the
gummed corners.

Of smoke:
Converted through densely packed SCIENCE
into this precarious ash tree whose verticality is
maintained by classical pressure: the coercive fingers
of Tollund Man,
peat-bog-herky-jerked.
Candied peel heels protruding from the sod.

Back to that gurgle of last breath through sweated sap.
– More precisely, the highly strung
congress of fish and northern European air.
As in,
The rusted carcass, beached beside
Curling scabs of grey birchbark
in filed iron.

SOMEBODY'S BABY BOY

Somebody's Baby Boy, half dead, rotates somewhere in North America. The weekend crowd, humming in formal military gear and brass headphones, mark stones and paint their lips at rounded corners outside the wet pay hearing convention. Early twentieth century ragtime mirrored the make-up by ceaselessly clicking a desultory skip of paranoia and nervous slapstick.

Somebody's Baby Boy, half dead, sights the poor shoppers and begins singing a superimposed dialogue (*rat-tat dum-dum*) of his own devising: egg-shaped, semi-transparent, with no distinct words but a ricochet bounce of ominous significance. The weekend crowds adjust their bodies to track that black municipal flower; Somebody's Baby Boy, half dead, offers no signal save for a concrete sadness to interest lions and an other worldly kiss rolling lazily across the asphalt.

'I always think the same thing: "BUT WHAT ABOUT ME?" – in caps-lock and in close-up.' We see him from above, somebody's baby boy, half dead, joined to others – diffuse individuals now wheeling, now strolling, wandering, shuffling – greeting one another with mournful applause and great drifts of shouting – perhaps loving. – Or is it fighting?

All of this since 1850.

Somebody's Baby Boy, half dead, sets off an alarm: he's been spotted in sunny blue anorak, infernal folk overcoat, bells cup and piano hood: an assassin of wrapping paper and street musicians. He pivots, trips and snatches exaggeratedly at the inhabitants, who swing one way then the other in a ballet of conspiracy and

tension, adjacent but reflected, out of focus. They appear and disappear, offering encounters of hushed feedback.

Somebody's Baby Boy, half dead, stumbles beside the ancient fountain, then slumps like a pioneer performer of risk, under a suit of alcohol. Distorted jazz to remind us of this and other pictures of sixties swing.

'Put me to sleep in concrete,' delivered in a warbled voice. The weekend crowd laugh, each picking a target according to department and elevation (the dude, for example, logs his domestic command, crosses himself, and decides to close in on a target whose feet are a jolly gift of a shot, protruding from behind a pillar like a red logo that trumpets its audibility.)

(A paper bag, brimming with brown and green presents, is passed from player to player, the objects offering welcome interruptions. To savour before Lady Language dons her jolly hat and green costume, and the opening shot is fired.)

Beside the fountain, Somebody's Baby Boy, half dead, signs a 'Hey' to Walter Murch, who looks cross: his left eye spinning at the interference, his moustache seemingly some kind of device to dissolve signs. Somebody's Baby Boy, half dead, persists and tugs at Murch's bell-bottoms and attempts singing some amalgamation of Beatle and blues in a strange acoustic to describe the supervising editor's shine. A single beat, then Terri Garr presents a production of Art Rochester's aerial piece, 'The Paper Tram' – in 40 per cent green Technicolour alternated with blue screen and sponsored by Phillips. 'Not anymore,' says Michael Hissins, moving through the shot, 'they can't make out words and everything is a decoy, apparently.'

'That's horrible,' remarks Frederick Forrest from the

control bar, while David Shire retains a distance from the reflective surface of Somebody's Baby Boy, half dead, casting about with his camera, soundtracked by Bill Shire's sixties number, 'What's the interest?'

450 You, standing DUMBSTRUCK in a
 bedroom, one guileless hand thrust down
 your [...]

1200 A solitary presence – fecund, mobile, agitated
 – stood swaying slightly in the yawning
 ear-pop absence left by the disappearance of
 all of these fantastical objects.

1986 I understand your allegiance to – or your
 supplication to – or your powerlessness
 against – the impervious patron saint of ballis-
 tics and kidnappings.

1986 BC Other than your gormless figure, a conspicu-
 ous absence of life here. No plants, for exam-
 ple; no evidence of a pet; not a single wilted
 flower, no darkened petal curling on the rug.
 Most worryingly, not a single cobweb.

200,000 Still, the sweet, cloying smell of overripe bou-
 quets whipped out of your sleeve, speaks of
 an end in itself, doesn't it? Silk flowers soaked
 in cheap perfume to overawe those bass notes
 of dead skin, the moulting, the paperbacks
 and stale bread. Also very much an effort to
 cheer us all up, so thank you for that. A
 simple conjuration – the manufacturing of
 a presence – to counter all this excessive
 dispersal, disappearance, absence. Something
 like an hourglass turning, troping perpetu-
 ally – only filled with powdered glass. The

227

powdered glass and plasma of a shopping centre's worth of touchscreen tech, rotating in mid-air, levitated by an off-screen magician (initiate of chaos) as a gorgeous, portentous burlesque of your fucking desktop.

1763 You carefully, quietly describe an alternative kind of exchange: value being relative to weight, to girth, height, wingspan, etc. – the characteristics of material provenance being shifted back towards some sort of fundamental taxonomic schema where – truthfully, you say – there is finally some sort of decency in evidence. A democracy of objects based, not upon their marketability, but upon a heady combination of their volumetric aspect, concerning their gravitational faculty (the sun superseding mercury, for example; the super-massive black hole tucked beside and beneath Orion's belt buckle superseding every other item in the galaxy, for example) – and their conceptual sphere of influence. Spheres BOTH, you say – the sphere a consequence of an object's gravitational lure upon itself, its reflexive attraction. A kind of narcissistic physics. Black holes forming as a consequence of a superabundance of egotism, the black hole's self-love, it's penetrative gaze being gamely accommodated by its own gaping and amply lubricated sockets. The result a perpetual bind of penetration and reception – a field of movement, of narcissistic gravitational heft so terrifically powerful that nothing within its field of influence can escape. Hence, a deep,

deep, deep melancholy within the hole.

1 (These things, agglomerated, approaching the infinite affect reminiscent of the brinking EVENT horizon of that dilated black hole lurking at the centre of every galaxy. Which is why they had to be dispersed, you say. (*LONG PAUSE [...]*)

1999 An egg, the shell of which the texture of sandpaper. – As opposed to the ubiquitous glassy *nothing* of contemporary haptics. 'I think of youth,' you exhort, 'when I think of the hyperfluency of surfaces that abound these days.' Supple, greased. The notion of surface – of texture – so closely confederated to that of smoothness that we have, perhaps, forgotten that the latter is merely one in a monstrous lexicon of textural adjectives!

1999 BC (*One hand still rummaging down there*)

C20th The patron saint of corrugations, rivulets; those that labour in troughs, ditches, mines. The patron saint of concavities and biconcavities. Often understood as having lived most of her life in hermitage, at the bottom of The Cave of Swallows. – Twinned with the saint that patronizes hillocks, dunes, ulcers, warts, protrusions, convexities. Who lived on the wing, predominantly.

3400 AD The reliquaries of that gestural mother tongue.

32 BC Esoteric Erotica! As in, most of these things could easily be described as more or less marvellous dildos.

75,000,000 AD Artifice to strip artifice of artifice. As in, a pretty brilliant description of the work of irony.

1032 An alternative movement posed as a counter to the familiar description of the smooth slippage of capital along warm, tilted glass – the windows of a supplicant skyscraper in the sun. Or picture a single scoop of slowly melting vanilla ice cream skating down the facia of your [...] – > along with the concurrent *atomization* of an ENTIRE BED (a bed still indented) into numerical abstraction that describes the chaotic trajectories of those drifting *scintillas* of nothing that riddle every lungful of fetid air at every single point in the breathable universe.

1555 Your movements are discerned, finally, as a sleight of hand – a gesture that dissimulates, misdirects – a means of smuggling an apparition past your shrewd but – and let's face it – chronically dulled senses.

1975 (Watch *this* while *this happens*)

Fifty billion years ago A process beginning with an absence depicted as presence. Though as an absence it is also, of course, a presence – albeit thinned

230

to immeasurable, infinitesimal presence,
haunted by its own not inconsiderable
EX-bulk. Ex-movement. Ex-punches,
ex-dismissals, ex-woundings.

560 BC The swollen relics of the patron saint of
anthropocentrics and, um, undergraduates.

560 AD Permanent indentations in the sun-bleached-
pale-pink deep-shag carpet. Dust-heavied
swathes of which surrounding islands of
intense, hidden colour and pattern; an
archipelago of absent objects. The deep tracks
made by the impatient dragging of heavy
wooden things with sharp feet – murdered
accomplices, expatriated bastards, entire
suits of armour, nail-rivened fetishes, blades.
Desire lines from bathroom to bed, kitchen
to settee, settee to toilet – scrubbed into the
wooden floor.

40,000 AD The patron saint of atrophy and ruin – of
bogland and greying skies drowning in
still tarns. The relics of whom including a
single desiccated coil of brain matter, housed
and amplified by an elaborate golden reli-
quary in the form of an oversize (one pre-
sumes oversize) representation of the saintly
brain, where each convolution of the sausages
of neural network is angulated into forty-five
and ninety degree complications, swerving in
cuboid corkscrews to form, finally, the myriad
knotted bodies of a nest of polygonal, comput-
er-generated snakes. Or perhaps tapeworms.

So, no hissing, no perceptible movement, just wet muteness. Mute and blind and deaf. Orally fixated, of course. A devouring muteness. Here, in the sacrosanct form of a reliquary, rendered in smoothed brass. Brass buffed by the tender touches of countless passing apologists, to a high, white-gold gleam. – Fading to a Bruise-Black (or a Mars Black, or Lamp Black or Ivory Black or maybe Paynes Grey or Charcoal Grey; perhaps the Parylene Black of Piano Black), in the folds, the deep creases. Dumb dark thoughts down there. A catalogue of phrenological superstition: the most groped areas being the seeming cerebellum and the frontal lobe, roughly. All of this, spotlit in the apse of a temple somewhere deep in the colonic catacombs of Paris.

The year two thousand

I can think of nothing heavier than a human brain, really. A human brain on a marble slab. – Or a human brain dawdling on an anvil before a furnace. Gravity and the distinct lack of a skull describing its slumped immensity. Slimed, as if freshly birthed through a gaping trepanation bordered with amniotic marmalade. Or emerging instantaneously through a trapdoor on the stage from some primordial mire below. Hoving into view through a dissipating cloud of theatrical smoke.

0 AD

The relics of a system of capital that now seems so phenomenally archaic as to make me wretch. – A little hiccough of acidic whatever shit. As if the system were emetic.

232

0 BC The patron saint of stubborn hermits, owners
 of esoteric bookshops; those who can only
 play by ear.

C12th Something like a necklace. Inverted jewel-
 lery. Metal studded with driftwood; black,
 hardened orbs of dung. Something once slung
 heavy round the neck of those poor sorts con-
 demned to be sacrificed. Passed from victim
 to victim like a disease and unlike a smile.

Last year The impossibly rising and falling bosom of
 a cadaver. In reality that sleight of hand per-
 formed by a million prestidigitative maggots
 in grubby white gloves and tattered morning
 suits. Performed by the left hand while the
 clammy right yanks hanks of flesh from the
 ribcage, eats it and shits it. Eventually, the shit
 presuming the shape of the cadaver.

Last year Crucially, the brain conjured will be of
 perfect equivalence to the absent objects. In
 every conceivable way.

2988 Your idea here being to make ossification the
 locus of production. Or rather, to correctly
 understand a becoming-cadaver as a
 becoming-productive. To understand that
 there is no emptiness, only the fertile
 residues and mulched forms that will provide
 the genesis for another batch of seedlings.
 These words for example, are every one of
 them synonyms for the material of manure.
 [...] [A]ssert your cadaverousness in every

way and at every point possible.

2740 These objects. Bobbing on the glassy surface of a becalmed sea at night. All that's left of the shipwreck.

388 BC Relics of a secular saint. Unidentifiable, save for their corporal provenance. Swatches of skin, clumps of hair, crescents of nail, wads of [...]. FORENSICS.

365 These things. Noumena, all. Orbiting some celestial severed head, defaced – the things acting as a halo to blot out the violently cohering light of the sun.

499,000,000,000 AD Being the reliquaries of a blistered century. The twinning of centuries, millennia. [...] twinned with [...].

1989 The patron saint of litanies, of weeping mothers, drowned sailors bloated with the bilge. A certain effigy in a certain chapel somewhere near Fiosele is said to weep tears of thick black oil. – In memory of every single material fucking thing.

2012 The innumerable digits, limbs and dermic scurf of some vast, hydra-headed saint. The patron saint of poets and refugees, amputees and adolescents. Or the patron saint of knockabout fetishes and cut-glass jawlines; of appalling palmistry and cigarettes; of swarming bees and mulched civilizations

234

[...] [O]f devastated clairvoyants and suicidal chain-smokers.

2010 Elsewhere: more deep shagpile. If you could only see it now. This haunted cartography of absent dressers, tables, sculptures, beds, chairs, chests, feet. The indentations alluding to the presence of a thousand invisible weights, each groaning under the extra burden of a single, singular figure.

200,000,000 BC A certain conception of figuration seems important to outline here, you urge. Rather than a figurative turn – tropic, metaphoric – a figurism that describes the charging of all forms; every form in this doomed apartment – with both history and with the actual thickened bodies.

The twenty-second century The clairvoyant's status – as a vessel for spirits, ethereal missives, certain demonic presences – requires a certain hollowing-out, an emptiness of character; the chain-smoker profaning this sacred emptiness, filling themselves to the brim with the dumb smoke-spirit. Rather than, say, the spirit of Apollo. Smoking as analogous to a brute sibylline gesture. Cigarettes and matches erected to form a crude tripodal structure to straddle the larynx, while gravity and sacred Olympian geography are corrupted so that the geyser of vapours is sucked into a descending plume to inhabit your oracular lungs. The prophesy? – More shitty smoke.

235

Fourteen hundred and ninety-two | A mystic, ploughing through a pack of *Gitanes*. A mystic who, in her youth, might have modelled as the archetypal *gitane* of the cigarette packet. Now, here, depicted as greyly acquiescent to a fate prescribed to her by some wretched auto-tarot reading.

1968 | The patron saint of the mercurial. – Each disciple acting as reliquary for the indigestible relics of the saint. Fingers lodged in alimentary canals; splinters of skull embedded deep in the palm, irretrievable.

1800 | In comprehending the value of things it seems important to think about how these things are disposed of. As in, the obsolescence of hair that is nonetheless still attached.

Thirty-third millennium | 'Invaluable' being entirely conceptual here. Nothing to do with any conspicuous characteristic in and of. Wielded cynically, more often than not. As when ascribed to a person via the bastard jargon of contemporary public servitude. 'You are an invaluable member of the team.' 'I am an invaluable member of the team.' Or – and here your stomach turns – 'Your friend over there is a highly valued member of the team.' A tone of fraternal conspiracy in evidence from the team leader, there. And you understand that your implicit role in the team is to remind every other member of their miserable valuation in relation to your invaluableness to the team. At night, you dream in complex, monochromatic

236

schemas and charts, plotting increasingly
convoluted patterns and graphs of *in*valuation
– as both pinnacle and sewer of some inter-
galactic free market. The precariousness of
your position expressed in the image of you
surfing the speeding cusp where the prehen-
sile longtail is perpetually digested by its own
florid gut: an almond-shaped tube beneath
a wave of lurid stomach acid. Flotsam of
semi-digested tail.

Next year The patron saint of broken conjurers and
apocalyptic prophets. The convoluted route
to beatification taking in the sleights of the
white-gloved hands, the bouquets of silk
flowers; the glistening, serrated blades sawn
halfway through red-lacquered caskets;
flourished hats, tails, etc. Arranged careful-
ly at a series of roadside alters tended to be
those weirdos patronized by the saint. As in,
stooped husks of conjurers; illegible sand-
wich-boarded prophets.

2490 BC A certain understanding of magic as a mode
of inattention. Concerned with misdirection
– the presence of one thing as misdirection
from the disappearance of another. And
obfuscation, of course. Meaning that the
saint (patron to the unwashed, opportunis-
tic masses) acquired her sainthood through
deception – the judicious and highly affecting
application of illusion. Which would sound
cynical if it weren't so opaque regarding the
location and permanence of the line between

miracle and the consummate performance of magic. Each illusion-cum-miracle operating around one of two classic binary structures: disappearance / reappearance (with some sort of a priori existential caveat) or conjuration / annihilation, which requires getting those pre-saintly hands dirty.

4567 Each reliquarial chunk a neglected sigil for the desires of an entire, pulped civilization. Husks of the once unbelievably wet. One particularly economical method of reinvigorating a sigil is through concerted masturbation, of course. At the moment of climax – at such time the universe is rent apart and the golden lids of your third eye part – you fling the sigil outward into that rift – figuratively speaking – wherein it will be revived by those particular cosmological energies, magico-geological pressures and countercultural constitutions.

7000 Other methods include meditation, intense exercise, etc.

324,678,950 AD The date of emergence.

1372 A polytheism that sets out the beginning of the world as the emerging of a cosmically scaled earthworm from a wet, black trench furrowed into the barren field of infinite multiverse. The clear emphasis in the telling being on hermaphroditic reproduction.

C20th Dislocation. As in a shoulder or a jaw,

238

certainly – entire bodies, also. From trees, other bodies, rituals, the floor, the gods, etc.

C21st Here, buffed to that high sheen by the loving caresses of the more reticent pilgrims. – Reticent pilgrims or wide-berthed trucks. Grazed bollards lining the path, each uniformly chipped and specked with the Parcel Force brown, or the DHL yellow. Delivering those velvet-lined coffers to house these relics.

1998 A litany, really. Bellowed into a pillow by the convalescing hydra, frog-throated. Also, a Persian rug used as a pop-shield, the voice that muffled-makes it through, seems to be pronouncing something like an exquisite uniformity – of affect, I suppose – that, come to think of it, decries the particularities of my spritzed language – bemoans the disjunctive privilege of my vocabulary, instead singing the praises of my tongue (a tongue who's underside is an underbelly daubed with woad or ink) to serve as an eleventh finger, carefully embalmed.

2013 AD You are standing in a fucking bedroom!

2013 AD These objects.

1023 BC These things.

560,000,002 AD Eulogized here at a respectful, funereal pace. Drifting slow through the thick, cloistered air – motes of dust long landed, one atop the

239

other, to form weird geometrical, precarious objects. Materialized echoes of the objects beneath. Your head turns dumbly, your gaze focussed on somewhere the other side of the wall – somewhere in the street outside, in the drain, in a fucking bank.

2222 BC The patron saint of ex-bankers, ex-prostitutes, your exes, their exes, the ex-planets.

2667 A youthful magician holds a small red ball between his white-gloved left thumb and forefinger. He apparently takes the ball from the left hand with his right. Secretly he has performed *The French Drop*: the ball is still in his left hand.

The ninety-eighth century The capable magician performs the seeming taking of the ball exactly as he would if he were ACTUALLY taking the ball. He does not put stress on the sleight. He gives but casual, passing attention to his SINISTER hand. His eyes rest momentarily on the ball as he reaches for it. Then his eyes follow the right hand – follow it naturally, convincingly, just as they would if he ACTUALLY seized the ball with his right. The words and posture he uses and holds being exactly the same as they would be if he ACTUALLY carried the ball away from the left. Also, the fingers of the left relax naturally. They relax, as does the arm – as if the hand were ACTUALLY empty.

240

The nine
hundreds

The patron saint of the dyslexic, the syntacti-
cally perverse, the grammatically unfettered.
These things might easily by understood as
shrapnel. Or, just as easily, as precious stones.
Or equations. Or fists. Or moulten wax. Or a
battlefield.

450 [...]

242

SILT

The sensational presence
of a pair of plump wormlings
lying in spastic twists either side of my brain.

Dumb, molluscan aerials
picking up the occasional low, static
whip through ECG gel or low-passed Antipodean
thunder
somewhere in the ether.

Or the strained vocalizations of the earth, rending.
An acoustical life of internalized belches, moans,
involuntary blurts (names, curses) flung
out by the body at regular intervals as
a kind of attempted echolocation.

The data returned is of course nonsense.
– Nonsense caked in a dense filo of amber-coloured
wax.
You appear
and say something
something.
Wearing the paralysed kabuki mask
of fear and trembling, sweetened
(if that's the right word for those
chiselled, red runnels deep in your forehead)
with disappointment, exhaustion.

We're still in rehearsal, in spite of just how fucking
good you've got at this!

Beatifically,
I hear nothing
but my own placid heartbeat,
regular as ever.

Uncritical, unaroused, unstirred, blunted.
(Again, the image of a hardback
Webster's dictionary found like discarded porn
in a hedge,
each page
warped and swollen with rain, mud,
punctuational curlicues of louse husks.)

From what I can make out from the tensing of your
jaw, your steel-cabled neck,
the facial hydraulics –
the jostle of wires
just beneath the latex –
you use the words 'fabric' once, 'cunt' twice, 'it' seven-
teen times, 'cope' once, 'stolen' twice, 'feel' five times,
'feeling' six times, 'collapsed' once, 'we' fourteen times,
'you' twenty-four times, 'me' eight times, 'blighted'
once, 'skin' four times, 'necessary' once, 'unnecessary'
twice, 'liquid' once, 'every' four times, 'disgust' five
times, 'metal' once, 'bloom' three times, 'stunning'
once, 'please' nine times, 'sick' twice.

245

EVEN PRICKS

All of this characteristic of the prevailing
PHALLOCRACY.

Summoned as upright witness for the prosecution.

– Needless to say, we're all of us against THUMBS UP.
 Even if, on those seldom bright nights, sleights of
hand, enclosed palmistry, digital universalism, repealed
fists, still seem capable of saving us.

Even Pricks, brother.

– Followed by ASPIRATIONAL CHUNDER.

Another one-bed, pre-furnished, slit open.
 Punitive, hollow-point hen carcass forcibly thrown
up on a tide of dirty-blonde and ditched faith.

Ultimately, this is how you and I would like to live – how
we'd like to spend our hours – is what we're like. What
we would like and what others like us? – What they like
about us which is what we like's our homes. And how!

An of-age couple who, NOTABLY, work during the
day and sleep during the night. Pretty apparent that
this, their apartment, is a place of caveated living.
 So once the front door is double-locked and the win-
dows are down and blinded, it's truly *rough* in there.
Queasy. The walls sweating some sort of spent and
vertical shame, along with whatever blended sewage of
soft-shelled bottom feeders they couldn't keep down af-
ter dinner.

At night, at least a foot of cooling mattress between them.

An acronym for 'WELCOME' and also
a way of spelling 'HOSPITAL'.

Laid to rest in this thin bed and criminally
burying downward-motioning physical process, for shame.
 Pharmacologic prognosis chalked up on the pine headboard, turned
the bed recklessly, insouciantly on its side so as to approximate, risk-free, an outlook over there, beneath the room, in the sprawling comments section.
 – Which we like!

Light from the surface peters out completely at this depth.
 From now on, we will be relying on the glow from phosphorescent minerals in the surrounding rock-like.
 I can tell you right now that a thousand unhinged teenagers were down here last night. Teenagers
holding together down here, wearing out their jeans
and licking the wet heads
of those stalactites –
– over there, and tonguing the fungus from those hot-pink tectonic crevices –
– over here.
SPENT by 5 a.m., they stood right there where you're standing right now and swayed tired in time to that thin, masochistic SONG most of us are anatomically incapable of hearing past twenty, twenty-one. Swaying to that thin singing and the eye-watering accompaniment of young heart magma.

(A Hospital Welcome)

– We just got home from work.
 Phew!

A distance barely possible to describe, Home and Work
so completely confused.
 So, I have a second job at the same computer.
 A third. A fourth, even.

The anti-procrastinatory software I installed has a hard
time describing the difference between work and lei-
sure; it seems one affords the other.
 For each job, I wear a different expression of exasper-
ation, if that even seems possible.

Generally speaking, I am too reliant on the presump-
tion that my brain is all the time inside
of my head.

I go to work and I just got home at 10.
 Christ! what a day.
 Jesus! what a day.
 I'm, like,
well beat.

And I well,
and well I
leave to get some cigarettes, coke, vodka, some
milk and cheap, own-brand cereal for the morning;
batteries, tape, various repellents.
 And I come back over,
and I knocked
or then knock or

249

on your door and tell you that I didn't make it to work
today.
 That I just went online and the rest.
 Work resting
like a grub or a worm or an unfurled woodlouse in the
drop-shadow of those hundred-odd tabs of Safari.

So you say OK and everything. Through the door.
 And so I go in my room fucking tripping,
tears worked out and thumbs up and I like it!
 Thumbs up and into meth-wet-rolled eyes.
 – And I LIKE IT!

And in square tablets
from the dropped, fire-retardant ceiling, a message of
proto-sapien DISTINCTION strung like sausages with
terminal, CLASSICAL verdict:
a blooded and cocked vertical, wreathed
in laurels and muscle memories of the childish, pruned
grips.

So I hear this crash like a car
letting itself in badly
and I hear you screaming.
 So I run back there and dead wasps
and glass ashtrays breeding butts, asshole!
 – The floor is the first thing anyone notices.
 So but I turn the light on and all I see is this big hole,
real big hole,
and all I seen
was your defrocked mattress and very basically.
 That's all I seen.
I jump straightaways into the hole and trying to dig you
out with my hands I couldn't find you. I heard –

I thought I could hear
you hollering for me help
to help you.
 Ultimately, I didn't see any part of you when I went
in there.

All I seen was your bedhead,
the fucking ground scarfing it, like.
 Like animals
that eat the whole, only
autosarcophagizing themselves
in some sort of rush before you
stumble along and eat them
too whole.

Your earthenware depictions of brown mouths brown
with cavities –
cavities to secrete the lives
of unborn prawns we scoffed in Corfu;
those stowed
black spherical eggs. Ultimately, we wolf
cheap beds and knock back their occupants.

And I just start digging and
started digging and
started digging.
 It's hard hung, you know?
 Ploughing into staggering
 accumulated religious corpses with tyrannical impu-
nity.
 Serried piercing for a harder fuck, like. You know?

A grip and, almost always, there's a thing to grip.

Running through the already ran-through. And, O!
where he produces some sort of shiv from absolutely no-
where and just fucking *hugs* it into the other guy's guts!
His free hand finding the back of the other guy's neck,
cradling this guy's weight, his head, on his broad PA-
TERNAL shoulder, like it's an act of love, mercy – like
it's the kindest thing in the world. And he's shushing
this guy as you would a child and he's quivering slight-
ly with the sheer BRINK of it – and this poor stabbed
guy's face we see in the counter shot over the shoulder,
looking for all the world like he's witnessing a miracle
or something – and he's crying and it's not that convinc-
ing but that's totally part of it – that you're not really
convinced and neither am I – either because the whole
thing's not really that convincing, or we're just not real-
ly that convincible any more. Either way, it really moves
both of us.

(Stabber thinks of stabbee: *I am inventing you as you are.*)

So there's blood and sand curdling gravely
under this indigo nail here (look down here and
please), scooped by the low looks
sent careering out of our swiveling gang eyes.

Condemnation and apocalyptic fraternity with gravity,
planting into soft-bedded crusts as agricultural prep
work,
scrolling down to some underlying complaint or other –
and then there's the cross-sectioned soil: ribbons of clay,
sand, chalk, a cut-off cave, prehistoric boners, hordes of
treasure.

(A sunken shack, essentially.
Half-buried beneath a bank of topsoil. Inside, those same
demented soft-shell ghosts of fierce holds and
brine-swollen knots go about the process of possessing
young genitals, accessed through a thousand or more
mirrored tumblers, inverted, slammed
onto Ouija boards, thumbed about the alphabet by wan-
dering digits and our plural desires.)

And the cops showed up.
 Showed up and pulled me out of the hole and told me
the floor was still falling in and get the hell out of there
there's nothing you can do for him now.

And to make sure you're not dead, make see if you're
alive. I know in my heart, etc.

But I just want to be here for you because I love you.

OR TEARS, OF COURSE

O let me
from the kitchen
and when you suspect that the fire raging throughout
the house is now raging in the living room
– blocking the exit –
(gorging on synthetic fabric, cheap entertainment
system, planchest)
and you gingerly touch the adjoining door with the
back of your hand to see if the thing is piping by the heat
of the hell on the other side and you use the back of your
hand in case you need to remove your hand as quickly
as possible. Away from the weltering gloss white paint,
I should imagine.

And leaning slightly back, I should think; adopting
the cautionary pose as for approaching vertiginous
drop while remaining vigilant to pangs
of suicide and
spring-locked.
––

I mean that the hinge
of your wrist working in cowardly bent for *inward*
motion. Folding and backing into corners, etc. Safety,
etc. That if you were to test the flat door with your flat,
SORNING palm and
were to find it scalding to the touch, you'd inadvert-
ently – through some *throe* – thrust your hand forward
and harder against and into the door and sustain a more
or less TRAGIC burn.
(Flat palm butts
flat door – though each loaded, each TUMESCENT
with anticipation; each the limit of some hysterical *other*
– and this desire, this sort of symmetry of infernos

enough to make you recall the scene as part of some *grungy* genre of symbolism and

haters demanding that the back and not the front of the hand be employed and of-fucking-course they demand: bearing knuckles and thin bones grimly rehearsed in beating, slapping, striking away etc. O! the back of the hand shown – though you know it's the fronts that display stigmatic authentication: holes with fleshly, nervous beds nicked by the tips of the full-stretch blades)

And O let me
penitence
or blessing
or rebuttal or simple resistance
coming across as useless nervous performance in the face of your body's overriding cowardice.
I cringe at the thought.

 And let me
being lied about
on bold, sweeping plateaus of scudded steel extending to the horizon and
 lying.

As in,
 'this may be how the sea actually is somewhere'.
 Awful, certainly.

And – *well* – patios and decking installed RIGHT across the bayou,
all the way over the Hellespont to choke the Styx. Once upon a time, dams were built to raise the level or divert the flow or power the town; now there is a concerted attempt to repeal the whole sorry business.

Of control, which is how we arrive at flatness and the listless removal of feature. Or 'erasure'.

(And the barman who
proudly declares to you that he does not exist;
that he has no passport, no birth certificate, no bank account;
that he sleeps at the feet of the brown chesterfield beside the jukebox;
that he applied all his own tattoos – those on his left arm markedly better than those on his right – all of which by now looking like some sort of terminal tree mould.
And his dereliction is his own)

O!
– This always-already leaked apocalypse.
The kind of apocalypse that abounds of gas.
 Seeping and encroaching.

 O let me
come at night
come at night
(in our own lip-sealed and cool and open night)
odourlessly sweet, come
– or at least lamp-black, gris gunpowdered black –
super-absorbing,
radar-retarding
stooped soot-sweeping and
disgorged accidentally, millennia ago and
plainly irredeemable nowadays.
Culpability resting with some plumed paternal god
(if only he hadn't gone and disappeared in a fucking bed
before you'd managed to

recover and stagger, dizzy from the surf.

And that eerie, remote *clunk* of submerged rock on submerged, incautiously swimming skull, sockets closed)

I'm thinking of this as a kind of self-reproach at the tedious apogee of consumption.

As in, buying a fuck load of flat glass shite to banally flatten yourself with and remove the fingerprints of; slamming smoothed capsules and towering percentage proofed SPIRITS to flatten yourself further.

'Further' to be understood as

downwards, as ever.

– I'm thinking of your ironing out the creases with such particular care.

Removing all superficial features

as for a wedding.

Eliminating the nose, the chin, the absurdly erect cock.

Literally, darling:

and the cartilage in your nose eroded and sneezed into a hankie as a consequence, you know?

O, and one of those gold, woven Brillo pads applied – and beginning tenderly

with single, downward strokes.

Snub-nosed. Sawn-off.

Barrel-chested men.

Otherwise: ABRADED, flattened by time – via one of the six or seven thermodynamic processes.

As existing in three dimensions

and with wilted time playing the role of a FOURTH DIMENSION that's of a conspicuously different *hue*

from the spatial dimensions.

Drawling on.

– Else flattened by the interminable downpour.

Or those determining words, lisped by downturned mouths encircled with the earthy hair. Biologically determined, after a number of beastly generations.

And though seldom heard, the hushed clouds of words that steal over murder scenes certainly precipitate that disintegrative rain to run all romantic down your face

to weigh your chiffon-like

so much tight-loving, squeezing love.

And your nose,

eyelids

and brow drifting south

to take it ALL in: stiff toe dawdling up to proud head; languorous (O let me!)

and then again, your mouth *shushed* permanently with a film of oiled skin transported from one of the scarfed parts of the body.

And the chewy rind of semi-scabbed kneecaps prematurely removed by,

you say, O!

– bonnets and hoods of the rusted carcass *MS River-dance* hull shield wielded by that fucking crane operator we can barely make out from down here beside the skip.

And your carefully coiffed, pomaded scalp coasting to the floor on a bump of wet red and cream. Coming to a halt at the foot of the fridge.

Evidently, the flattening apparatuses must in turn be flattened by other, greater flattening apparatuses. If we are to maintain momentum.

Between twinned abrasive moons, perhaps.

And I want to say that you strike me as so terribly fucking shallow to be going along with all this.

Doesn't mean I should be capable of exercizing this sort of power over you. I am little in control of my actions and would hate for you to have been affected too deeply while I sit calmly at the edge of the pool – breath entirely caught, mind ponderous in the cafeteria already.

And it might be assumed that we are curved

by the presence of matter, of energy –

\

– which, in our case, is to be figured as another *apparent* flatness.

A site we might reach through a dramatic rebuttal of those external influences and focus, again, on the gravitational seductions of our guts. O!

Let me.

And in the neighborhood, at dusk, time-like curves (hunched beneath what, I swear, look like the weight of fucking *cowls*) pass through the event while somehow remaining inside the event's past and future LIGHT CONES.

As in, light-like curves that pass through the event will be on the brittle *surface* of the light cones, and space-like curves that pass through the event will be outside of them.

A kind of pubescence in action, then. Dice loosely skewered on the spokes of bikes, and playing cards attached to the forks of bikes to flap between the spokes of bikes to produce the approximate sound of an emphysemic motorbike.

Still young enough for that.

Though tinsel tassels flowing out from the handlebars

loiter between curtain and stripper as they outstrip the
event and veer home to the TV.

O let me

speculating
the RETURN, panel-beaten back to a factory-reset
flatness.

And depressing that tiny recessed mole on the back
of your thigh with an unkinked, plain metal paper clip.

This kind of plasticity is a problem, you say.
To understand 'flattening' as any kind of return – to
think, then, of the primordial soup as a great frozen lake
– with all accompanying conceptual impasses – all the
yellow colour and all the yellow *flavour* sucked out.
Unblemished, you say, by reality or any kind of
honking desire!
And you snap
that we could all be repealed (which is tantamount to
atonement or – worse – rehabilitated, or – worse – EX-
ONERATED) through the ruthless eradication of de-
tail. And we start again. This being a difficult thought.
The truth being that we were never flat,
of course.
– That flatness is an infinitely deferred end point and
certainly not an opener.
– That the topology of space-time is totally fuck-
ing complex and mathematical and shit and people say
with confidence that space-time (at least from a *general
relativistic* view) is globally and locally smooth, flat and
continuous.

261

Picture the virgin ice rink – you, giddy.

Or the hotel bed – you and yours, giddy.

And it's only the fucking quantum, bubonic, devil detail writhing like a snared reptile in the torrid jungle of your intoxicating crotch

that prevents this being true.

And older blood. When pipetted onto and between a pair of glass slides reveals GREAT DRAMA. Though the subtleties are surely lost on your screen-fatigued eyes. And in spite of this *asthenospheric* fucking head-ache, I simply cannot pull myself away.

Squint and the whole world turns to liquid, right? Liquid crystals running terminal coupling

weep

and the whole scene bleeds out, deflates, flattens under foot, to be rolled tight and returned to the shelf in the wardrobe.

And the truth of metaphor being that it too much emphasizes a community of sameness.

The ludicrous individual communes in their discrete sameness with every other ludicrous individual.

And as it is with metaphor.

Each of these pathetic figurations performing precisely the same speech concerning the insignificance of differences in this here world, delivered via a cluster of mics adorned with the logos of media corporations.

And

it's these kinds of thoughts that really fucking upset me. – That add yet another weight, however seemingly insignificant, to the top of the teetering pile that sits on me, on us, us; determining to flatten every apparently unique gesture AND until 'I' are and is destroyed. And

though I do appreciate the need to redress or at least to significantly and structurally critique the rather understated idea (what amounts to *jurisprudence*) that humans cannot exist without the world nor the world without humans (I DO) the truth is that this call for assessment of the world without or before or after or apart from ME simply presents to ME, simply, the already self-evident END. The interpretation is wrong: the appeal is submitted in English, tucked between material similes. And O let me leap – with more vitality than I've mustered in years – at the chance to answer the dissenters and enlist and stand shoulder to shoulder with a platoon of animated woodland animals, geological formations, ancient wheels, ignoble gases, snide remarks, etc. – and welcome the non-existence of the world and the non-existence of humans and the non-existence of everything. Gloriously, glaringly obvious, for a moment.

And as it is with metaphor.

And so at this point in the proceedings we all implode or else permanently immobilize or else calcify or carbonate, fossilize in our named discretion.

And that it's narcissism – alone and struck.

And so when I'm at the bottom
and on my knees
and when I'm squatting
under the stairs and on my knees
and barely breathing but
copious weep, ooze
and uncontrollably, vanity performed
as shadow – ready to SPIT for shit –
to hammer the thin walls
with balled
fists – to kick and smash and cuss and threaten

everyone with *fucking* DEATH if they don't shut the
fuck up and back the fuck away
and then STRAIGHTAWAYS apologize
to everyone and
all around and
beg and
plead and
shriek – or else sink further
and my face sinks further
still, all the way to some palsied village
(a land of hysterical stone)
– and my eyes throw out with significance and wheel
straight off the edge of this world and into none other.
O let me.
Let me forever weep.

And the last thing I want
is for this to end.
– To stop weeping and to leave this place behind and
below.
The very thought of leaving is repulsive, is
patronizing.
And it makes my heart sing through a mouth
torn in its face with a big nail.

To redeem this state would be to ridicule it and return
and not particularly dishevelled nor with any particular
stains
to the cool and
okay flats.

Coherence being interminably flat, of course.
Which is looking down.
Or perhaps up.

And the correct line of sight, of course,
is OUT.

And, really, we're out walking and talking about a
temporal equivalence that rhymes the ancestral with the
futural, here.
So you say.
Eliminates the ancestral, rather: replaces it with the
same chicken-skinned thigh that barges in through the
opening at the other end. A loop of muscle and fat and
natural cropped hair, stout and in and out the window.

And our hands run up and down the thighs.
And our hands caress our thighs.

And this flatness that seizes and petrifies me is riven
with the most impossibly dramatic scenery. Mountains
rising high above the clouds; ravines that plummet as if
at speed in the looking and to levels beneath imagining.
And my immobility, you say, should not be taken as a
sign of calm.
Only that I am flatness incarnate, pre- and post-
flatness. I conjure the very medicine to this correlative
lie by plucking fruit from fucking Eden before anyone
else arrives. Turning to the remains and spitting the
pips out into ashes.

/

O,
I depress
this flatness with my thumb or the heel of my hand
or my boot-heel. I bring it lower and I repeal its very
condition.

265

And it's not at all hard to say that I'm a black hole and that I made a black hole and around which everything turns and into which everything gazes. Not at all. The equivalence of everything is that absolutely nothing matters and as it is with metaphor.

And according to the eternal tragedies of irony,
I must and am depressed similarly.

And this thing is a self-annihilating nothing
and as am I and it strikes me as entirely possible to live in suspension – in a truly ironic mode – when flatness and the excited and falsified geology of the correlative are paradoxically fused, turning and turning before our eyes in a performance of precise metaphorical equivalence where flatness describes a strata to include my depressed symptom; the coherent normalcy above; the depressed condition repealed and flattened by pharmacological agents; the depression functioning as that particular kind of earth mover, depressing the flat with its narcissistic and misanthropic HIGH DRAMA, only downwards to that flat, subterranean sheet of volcanic black glass. Or the bottomless, wall-less cave that once fed a vast reservoir on the surface – the reservoir long gone, the water in the well a slick rink of ice.

Then the shot ascending back up the well, through minutes of rock in potholing intimacy, shooting out and up to reveal a planet bereft of anything at all.

O let me forever
 weep
and so determine to stay here with you,
lying together
on the sheet of corrugated iron
before dinner.

HAMMERING THE BARS

What do you know of love? And also
I could drink you under the table,
X. Or by both ankles I might just spirit you beneath
crotch-level; a concealed head
and blue base-thick Vaseline glass rolled about the
notched legs.

And knees by ears, grasshopping improvised
high-balls, HIGH but aware of the sullen approach of
loused-up shoes, perished soles lolling and rasping and
just how, say, feeble we are in this cowed shape.

I could never simply conflate hiding with cowardice.
Perhaps surprisingly, at hip-height this kind of, um,
enfeebling is just what I like,
X. Though I would prefer vulnerable or exposed. A
slicked and sexualized SMILE and a tongue protrud-
ing.
(Under certain perfectly warm duresses, tender.)
Under the table, I could drink you,
X.

I suffer from aphasia. Apraxia. The hesitation phe-
nomena. Gaps returning to avenge themselves for the
ludicrous preponderance of AT CAPACITY, limit and
the contemporaneous West with the very latest.

All the same, publicly, I fill syntactic holes of my
own volition, thank you. It's political (even if volition
and addiction are confusing partisanships). Anyway,
writing sabotaged language into strata beneath legiti-
macy isn't really public. Not really. So what happens is
I cement with coarse-ground double expletives sprayed
in arcing salvos,
X, sent out with the plosive.

Lower than this, we find a demand for love,

269

X. Gay abandon for frustration. The very necessity of speaking obscenities with the tongue and all that. Making sure the audience's indignation is unquestionably the more heinous of the crimes mirroring in a court of movable humans.

And I'm just like that.

And I would categorize that as a kind of, um, apology,
X, if I didn't already recognize my insatiable appetite for super-intense displays of
emotions and their impudent solicitation. Which might go some way to explaining why, in the middle of an apparently civil conversation with you,
X, I might abruptly threaten to kill myself. Or – and this the movement – call myself a fucking bastard cunt fucking cunt. And the look on your face is priceless, which you should be able to see,
X, if you could just keep opening up like that, folding eyes confused with, I don't know, my sense of justice.

Attention: civility can really very much go to hell, where it might be understood you should house your mind and despair not, darling.
X: A Concern Troll.

Stage one is
X phantom limning posts in whichever web forums. The masked troll seemingly devoted to the forum's consensus: a proper apologist, as immoderate as the damnable moderator.

Stage two involves
X's attempts to sway the group's actions or opinions – all the while opining on their specific goals – only with professed concerns.

Appealing to the ideomotor that symmetrically rotates desires of vulnerability so that, given a

270

situation of sufficient sympathy, I might maybe seriously GRIEF myself just to let you be. Which is power proper,

X – to lay a debtor's pity at your feet like a rush mat and publicly, demanding your hand is stayed and caught and twisted and deployed as a half-nelson with me at your elbow and your ear.

X: A Concern Troll. The tacit resolve to sow, like dragon's teeth, fear, uncertainty and doubt.

Double agentive booze-wet-haired re: evangelizing YES for DOUBT, via a performance of entrenchment and drunken slurs that is

(X has sincerely promised) in the process of sobering up. Appropriately enough and thank God and all that back aboard the wagon, under the lashed canvas.

And though it looks like HUCKSTERING, the monster's reveal in the final act performs the emergence of a moral – albeit noticeably fudged. At the very least we dare to dream our empathy extend. And at the very least not like a muscle or a telescope or thanks – rather, like a familiar arm and merrily linked! Or simply in and with time for some talking and chortling or your very life on its own terms and, um, fearless.

A Concern Trolls' willingness to identify as such affords a position discrete from those who are externally determined by HATERS or and skulk cross depleted, burbles

X into a glass. The more common 'Socially Censured Trolls'. Devised, I would say, by this bleak and hard patio of a government, in whose interest and under whose proptotic glass eyes our anger SUNKS like a wooden stilted village into virtual or parabolic mire, where slights and tar are only ever between individuals and singularly resolvable according to same. A ritual

271

method involving the invention of a one-off monster
for the sole purpose of its on-off, symbolic beheading.
A chimera,
X crossed with
X. The hind legs of mother, the face of legitimacy, etc.

Trussed to a very real spare room in a very real
undisclosed location render farm:
buckets, cabling, chased silver, rapiers; a kerosene level
of drunkenness maintained for nether action and so,
unable to live with the discovery, I go the fuck seek
assisted suicide at a government clinic called, genially
enough, 'Home'. You,
X, rush to stop me but arrive too late. You're mesmer-
ized by the euthanasia process's visual and musical
montage: forests, wild animals, rivers, ocean life – all
now extinct and rendered as fuel. As ever, geologic
process prostrating itself too easily before economic
metaphor, eurgh.

And what of the economy of this?, purrs the cat, that
horribly available metaphor.

There is sometimes a willingness to be transformed
according to the desires of others, is there not,
X, brutal flirt? To behave as such, too. Named or
branded (more tellingly, figured) as doled punishment.
(So much of this, complicatedly enough, is a way of
asking forgiveness for asking for all of this; asking for
forgiveness for what I am doing, X, as precisely as I'm
doing it. The apology and its cause one and the same.)
As 'troll', you,
X, are MADE troll and so go gibbering back to the
cave. That piss-reeking railway arch behind the terrace
where
X and co. go play at being trolls. Or rather, where
they go play a game where only one of them plays

272

the troll: the others play at eluding the troll's snipes:
the righteous, VICTIMS. The troll hurls abuse but
is compromised in various ways: blindfolded, bound,
occasionally submerged, fed barbiturates or rancid
acorns, muffled, locked, turned off. At the denouement
(or when dinner's ready), turns are taken smashing the
troll right into the barren earth.

So doing refusing the ground.

Stumbling back to the lower bedroom on the lower
ground floor where we can have a consolatory drink, if
you like,
X. If you fancy. Commiserative or celebratory. What-
ever: this thing will be tarred or branded or marked
with alcohol. Right, we'll pick something up on the way
and
may I say that being called out as a troll is sincerely the
worst thing that ever happened to me, says
X over a stiff drink.

I only wish it didn't require the 'sincerely' and that
the word 'worst' could be expurgated. And

cowering in the mirror,

baleful in the city,

there's self-harm inflicted with the retooled wounds
of those HUNTED-looking

novices whom we certainly do like,
X! And our eyes,
X! Our eyes are goat-demon cross-barred at this point,
which makes for a darkening glass of the terrific speed
and sheer WILL with which you and I get ourselves
drunk; that same pace with which a grubby cut blooms
from my cornered mouth and to the ruin of every story
until it's all so much SCREWED resemblance of the
most abject classical tragedy. Gutted hot bodies scat-
tered across the night's proscenium like

273

terminally discrete theatrical baleen. Though so long
as it's curtaining the privacy behind corner shops or
frilling some grass-green up-skirt or pink spangling at
the back of the stage even as and particularly because
it was previously used to sift through ICE BLACK
Arctic waters by some no-account wet
thing bigger than the bar. Only, glimpsed from the
outside and no moon.

And though sensitive sponsorship is only possible
by liked limbless pioneers of the same stripe (those
whose entire armature has popped its sockets in favour
of blood-rusted bolts, screws and steel-fronded bottle
caps bent in the offing), the keyboard is still within
reach and you can always write this shit in bed,
X – laptop undercarriage exhaling appreciably sleepy
breaths to make the guilt thrill with the possibility of
a witness waking. These crippled self-waged-war vets
are technically, coolly tearful after, say, five hours
straight: unmoved and unblinking as they conduct
unjust raids on peaceable encampments, CALLING
OUT some shit and haters raking another's skin with
chewed nails while elsewhere joining a chorus of tend-
ed thumbs-up to a sepia photo of someone else's night
using their first- and surnamed and historic selves:
publicly nursed image, pruned in careful three-quarter
profiles and vapid proclivities.

Thanks,
X – So when I click it, um, *Preferences* lists loads of
choices which are all greyed-out and I'm not sure what
I've done wrong or what I should have installed in
order to access. Any ideas? Seriously, I'm working to a
deadline.

So that the pervasiveness of AFFIRMATION as
the sole possibility for our responses has resulted in

a phalanx of creamed shadow's screamed CAPITAL
extremes, gratuitous abuses, loosed fraught humour,
careening between the bars; histrionic parodies
pumped up with two fingers through vertical bars.
Encoded in bedrooms, predominantly (dried auratic
sexual residue, presumably) and with the door closed
over hushing carpet. The door, finally, underlined with
the unmistakable light. And for every plastic gesture
of solidarity, every peer unanimity, bullied consensus
– every forced confession or split shit-eating grin – we
RAISE A GLASS and raise the spleen and the tab a
notch.

Such neutering of political voice ('having your say',
that agitprop of careless veil, has no political salience)
will always send feelings reeling, detached like the
retinas googling for a proper home for proper enmity,
but more often finding the plush, fresh-cut cheek of in-
nocence. Or, at least, fecklessness. This sadomasochis-
tic practice is wrought entirely alone, though divided
and selves; other people's pain used to turn the gun via
the glass,
X.

Help me communicate without debasement, darling.

Help me communicate outside of peremptory as-
sault, my love.

And not there.

Help me hold,
X.

Because, of course, words only ever come canned,
X: cellulose and colour limp beyond acquirable taste
sucking.

Which is to say, how unlike these olives, whose
orange-wadded anuses open at both ends – much
like ours – and live bloated in the nice, strong drink

275

waiting on the desk or bar or whatever wherever this
is – which I very much like! Only, we never get drunk
anymore, which is a sure-fire sign, right? That do we
AND of course? AND sad – only getting to the famil-
iar photic zone of self-possession by squat, comfortably
doubled spirits, having our say regardless, increas-
ingly glassy, glazed, all fucked up for lack of choice
of shit to say or incapable outside of the TIRADE, or
careworn and hard smoking old rope filling smeared
or blackened Pyrex vessels, our mouths like occupied,
razed litter trays moulting and from the bathroom
by the back door the crisped peppermint towel and
coughing up purpled pleura or toothbrush-flickings of
cherry red on bone white hankie or from bottom left
to top right of bone white basin, screened drunk-slow
amazement.

– Who the fuck reads this shit anyway?, is what is
issuing forth from the cat, my primary dumb speak-
easy, via a warmed flank of black fur or semi-drum
or the gorgeously confused softer white underbelly
for just a moment. Dissensus, consensus, whatever,
Jesus! Splashes of white spirit into the twitched haunch
warmth, basically. And his shame before cats is mine,

X. Emblazoned as protestation and flagellation on a
red and white tee in raised toxic green molten type and
despite lessons to the contrary from various emphatic
women. So it's guilt, forged blindly inside so as not to
recognize it's true and I can get back to it with renewed
defeat so long as there's consensus or dissensus or
whatever response and however wrenched. So try talk-
ing on a blog with your fucking arms cut off, X.

So I say, 'No one listens to you unless you're audible.'

Which should be understood apart from the
physiological but rather as an indictment of determined

276

coherence as the super-PROVISO for being heard and via ears. The, um, nonsensical jewel impossible-parting lips remains, as a photo in this thread, conspicuously uncommented upon, unliked. And so dejected

and so mute and so, ruby-whistling, I retreat back to my dank, re-snaked lair, and the promise of doubling down on my repugnance via a severed arm used to post bloody missives into rock. Terrific Terrific Terrific. Okay.

And we're terrific! Terrific. And a phony.

And under the table I can see almost everything you don't want to and GRIN, even if especially because with two fingers measuring rude. A feline boy, ha, um, dawning subterranean relations in hell-bent prepubescence; the collusions that constitute necessary secrecy. Confessional calves, the ideas of garters or the elastic scalloping chicken skin above the ankles, the thighs and ladders. Beneath the watermark of professionalism, etiquette, propriety, there's a whole fucking world of those thrashing and bruised limbs regrettably tattooed. The calm torso and muscled head have very little to do with the crotch and lower,
X. I for one live for under tables, face wedged beside ancient chewing gum, geologic tracts of snot. We all speak under my breath subscript audible to barrel-chested mammals or etched into the bottom of the glass where it can still be found, and it belongs to the world of the toilet, honestly, and as everything committed in there is propelled downward by the bolt. The cubicle is parenthetical to the conversation out in the bar and round the table but, right, provides respite. I mean, who the hell am I with naked ankles so restrained staring at grey phenolic door and eleven digits. A

phony cipher for the crud, at best. Later, we forget and
drag whatever shit back with us, clinging to our heels,
and drape it scoffing across the I forget face of the least
suspecting, the most ajar and the least secure.
X: We could do worse than self-identifying trolls. And
what then, that we might choose this? Seems
oxymoronic: trollery appearing reliant on anonymity,
X; on the unacceptability of basic rights and
monstrousness in public: certain behaviour would
be entirely and indictably unacceptable in a market
town now controlled by the supermarket, the GOOD
school and the swollen media big-top sawdust wrap-
ping gigantic newspaper dung arm and sweating in
game-scented perfumeries, which we like! Citizenry,
certainly, hinges on distinct LACK of monstrousness,
even as it aggregates precisely that kind of horror at
the corner of the eyes and at the bottom of the lungs
as a kind of gratuitously depicted plaque corset to trap
drifting whatever bulbous lobe of the brain deals with
the, um, will.

A monstrousness that sits on its amphibian haunch-
es over there, at the antipode to HUMANITY, you
complete bastard,
X. So what to do with all this forestalled desire, this
deadlock? Which most commonly transformed into a
back ring gun, right?

I
studied UNDER.
Where I met you,
X.

Two beautiful years of teratology. A whirlwind
romance! Taught beneath groaning stools and be-
tween legs by the gamely monstrous-excluded, sitting
cross-legged on the sweet and tacky floor and where,

278

next-door, I trained in writing thin drunk biro hate
on the pale grout between the toilet tiles to ensure the
message survived regular SANITIZATION.

To pursue subterranean poetry, posterity:
X, anyone taking a shit as close as it gets to a
Neanderthal ancestry is a troll channelling the true
and INVALUABLY unintelligible Ouija – the
etymology of which as vitally banal as it is
unflinchingly HOSPITABLE: 'Oui', 'ja': Don't dawdle,
X, come on in and have a massive drink. You're
obviously upset,
X.

Broke-ass, like. Predominantly at the bastard
repetition. And seeing it coming, too. Trickling.
Taking its fucking time. Brazen duelling pistols with
recognizable flushed metal faces in hand and we're
powerless to resist the very excuse to disabuse. Every
time, afterwards, exhausted, wilted trashy gerberas
strewn across the kitchen and sighed pacts are made to
never again, etc.

And yet: again,
X.

So it's not really about recognition, then.

So it's not about learning, then. I think, really, truly
that we really do LIKE it,
X.

'They're nice guys, really,
X'. – A phrase echoed in a million bars and a mil-
lion halls of power and dastardly hollowed out grave
ex-possession like a girlfriend or a boyfriend, earlier
and all the ghosts of
X's life herded together and fed into ever-tighter
spaces. I really do honestly and sincerely LIKE
them and we're just like that,

X. – That we all know someone like that,
X, who will hurt you till you need them.

We have it coming, sweetheart: slowly unzipped
sternum, virgin matters of the heart, comely agape to
a troll's terrific passes and come-ons. This particular
demonology being the study of what we invite in when
we post; what we divulge and to what when we make
PUBLIC; what precisely we inaugurate when we ask
'Who's there?', and mutely demand the thing's cooing
answer.

From here,
X, what does it want? Have you thought? I would say
we know precisely what it wants, but that we're just not
sure how to mediate our response.

So I really need to work on more convincing
proxies. Or I really need to work on empathy or I
really need to work on, um, privacy,
X. Which is to say, I need to properly understand the
very real threat of possession.

Of repossession by ancient malices, of state
hauntings that inaugurate complicity; to understand
the risk of corporate takeovers: the soft and ripe sell
that insinuates like banana GAS. Like the trawled
bodies of those liquid murdered cowering among
depleting ice cubes slugged and the diluted Angostura
bitters; the tumbler inverted, slammed onto the board,
touching hands,
X, witness its intent skate according and under the
influence. We read aloud the deciphered missive to
understand our splintered selves for one another.

At least, that's the idea.

Very basically, what we might have said to one
another but in person were incapable. The maiden
unsaid poisoned by the delay and the repression and

the stunting. Finally ruined by the transmutation into
visible-illegible code.
 So
X, asleep at the wheel, windscreen tear-streaked,
speeding.
X, so very real and nightmared across the wheel.
X, asleep at the wheel and again already.
X, seen astride a huge colourless mare – a bolting,
snorting silhouette on the horizon at dawn.
X, hammering the bars and really hard.
X, wheeling about the bars.
X, staving off repulsion with nothing but messianic
poised fingers and an electric razor.
X, disassociating hardcore.
X, metamorphosing performance RECOGNITION
divine exile, dislocation slipped.
X, hard disc-slipped Mickey drink slipped down
without and so then prone in bed, hands-free,
hooked-up straws, absurd.
X, defrauding families up and down the country, all
consensual and over excellent drinks – don't worry.
X, resuscitating long-dead treasured pets and sons and
long-defunct markets and other people's long-lost jobs
in yet other people's too-open and wet mouths, mouth-
to-mouth, an echo of obsequious agreement concern-
ing sex with absent partners.
X, that big pig-toed succubus, inhaling evaporating
poteen for divine vapour, mouth-to-mouth, holding
blasphemous forth subsequently and so, drunk
clairvoyance which we take on trust in the absence of
being able to get Google on your phone.
X, in some sort of late-period frilly get-up, feigning
vampirism for the sake of his own piss-weak and stunk
drunkard's blood: paint thinner, moonshine,

self-medicated daiquiri. All of which with the tensile
potential of 'spritzing',
X, internally haemorrhaging or variations of
cirrhoses payback for deferred hate and all the
while going somewhere, anywhere.
X: an idea of pressure building.
X, -unned and -outed and what the hell defeatism
hysterically soused in and
X, downing what really could honestly be a can of
petrol or may as well be and chased down with a full
comb of matches and though unlit the threat's surely
what counts and,
X, the fire despite ignites elsewhere in the brush so
as to avoid suspicion and where only animals expire,
blackened – shined as the heel of my mouse hand.
Material consequence held in abeyance, as is our
desperate want with every sip, every word loosed,
swiped.
 For example: I drum these fingers over here and,
over there, someone's skull gets rapped or someone's
thigh gets amused.
X, asleep at the wheel again and already!
X, draining other miscellaneous and unknowable
optics dry-milked for spiritual top-shelf 30ml LACK.
But,
X! Influence accepted regardless or specifically to
affirm that total bottomlessness:
X! Notwithstanding the very real possibility of
X volubly regurgitating influence downhill and
avalanching and such-and-such gigantic sputum-dreck
orb gaining impossible momentum and dread acuity
and melodramatic delivery until it's pretty much
indistinguishable from divine retribution onstage.
Which is,

X, lightening bolts or flaming swords, zigzagged
yellow cocks or silver cocks burning with recurrent
diseases (the dead drunk promiscuity of gods) – both
elemental and overly man-made, like how your
destroyed career might be described,
X, or,
X, how we all think of the birthing of tech: bearded
wizards and bearded prospectors digging up all over
other places and whatevering the exhumed into black
mirrors and splash-proof spiritual conduits that are
decidedly not for the dead who are always never more
than six steps away and with rats.
X! Don't think of the children, fuck them
X! Your hubris is devastating,
X. As is your ignorance,
X. Look up! And for all those slights, nicks,
X, those grazes – the Banal Stigmata of
X – you self-stigmatizing fag A-drunk and before the
drink, tucked and fingered into cramped and
burnished space: a forum for snatching at the
balm-heavied or cocoa-butter-darkened hem of
whatever blindingly sober, waifed adored and as well
as loathed gauzing for any scrap of wild-eyed attention.
Being the echo of a particularly loathsome gesture
performed in some royal court in some century
before this stupid one that regardless understands our
response as a PROPER bloody response: a lurch of
disgust about now, ABOUT NOW. Though and
defeated, the thought that when we are the laying of
hands upon the nifty *planchette* we only ever seem to get
the most horrendous slim spirits and the connection's
always conspicuously fucking bad. So this, surely, is
not simply what he's like. This, surely, cannot be
merely sacked-off like that,

X. We cannot say that,

X. So and in which scenario you cannot take a joke, are accused of humourlessness.

– As if that smile venting the accuser's head were a consequence or record of amusement!

– As if that smile, so proudly and DEFINITELY GOT, were not, in actual fact, some final and drastic manifestation of high-proofed hatred. Hatred sloshing all over the place. My God! if only you had eyes for tonsils! That

X might have taken it. And then there's the fact that any kind of 'taking it' demands submission. Which I will probably maybe readily might have given,

X. Probably back of the hand, in a corner, on my own where I would have to be alone and completely mad and more than a little mad with

X over there, who is in here too, hunched over some drawings I can't make out from this angle and over here.

– And as if that 'smile' ploughed into the accuser's fucking, um, head would not better be described as a dead wing or a dead leg or a broken leg and by modern design. Or as a kind of botulism or a snake in a black canal, all broad smiles, drunk dog.

X

284

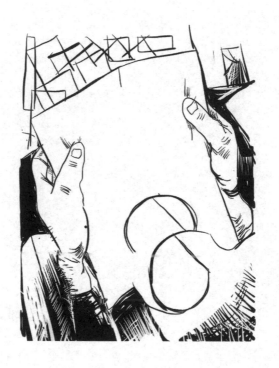

80072745

#1

DEAR [...]

Before before and masses of years before, begun in
earnest and in spite of an idea that I should have totally
resisted (the urge to anticipate and delimit incompre-
hension) I really thought I'd introduced the project to
you. Apologized for the tardiness. Twice. More. Too
many times to be certain of fidelity. Usual excuses
abundered: glowning, poisoning, ultra-defenestration,
socked in the jaw. And even if that never rose above
and shook orf its retarded and shitty, the insistence
on irredeemable ruin seemed a fair pressie, all things
considered. Irrecuperability reserved for the past alone
and only ACTUALLY. (We watched *Interstellar* and
thought about relativity, love, quantum twaddle, etc.
Mainly we thought about a midget hickory spaceman
poking books off a shelf or strumming the second hand
of a watch and right at his daughter. Time was elastic
– it couldn't go backwards, and the midget hickory
spaceman was, like, a few hundred years old and
burbling to a trouser-press over CB.)
Five for ten, as it were: my Time Traveller's Potlatch
gone awry.
The other stuff was more to do with days and all kinds
of other stuff being numbered. Unned and deaded. But!

I told you things:
The bole that rented my face was merely three in
diameter, though loose. Forcepped it would have been
larger, which should have told you something.

287

The brudged eye corner distance was two.
Thoraxic triordered somewhere betwun a healthy
jigger and a nauseated liquid ton and I was a five at best
– was game gotten game.
Thurd came.
My, um, legs pumped some sort of toxic fat through
only the ungainly channels, which stunted to twenty-
eight, twenty-nine. I paid some leech thirty to sop the
pecker-pored skun. Didn't work. I only wanted it down
to twelve, thirteen. Didn't work.

You were a beautiful pound coin, you old mint.

And once, this was a, um, email until it wasn't. Until I
shoved it through some number-crunched conceited
whack. Sorry. Once a love note, till it was extruded as
nine hundred whopping digit fingerings, ballooned
and darkened with steamy, solitary goosed, O! Though
probs actually simple meths. Numbered privates.
That's how I *well* pushed it. Red-penned addended,
done inned, the always-alreadied of added -*ed*. So I
accrued slough of pitched and overburdened, the keel
of our junk, rubbished. All of this, then, over the past
decade, was draffed by a discalculic lover. Once, I
couldn't even read numbers – simply looked at them.
So what was I thinking? – I was totally your lover
until I wasn't. Until I shoved it through some
number-crunched conceited whack a few weeks ago.

The view, then. Dusted to, um, gilded. We viewed the
view and really fucking dressed it. The view was really
terrific and terrifically dressed. We cheersed it and
even managed to smash the glazing, once. Really
something. So there was that: Really something.

Even as the rest warranted apology, at least one
time. More for big dumb providence than our bum
possessive culpable: all rose and olive and hemlock
and silvered by great WAS. Someone had to have
apologized. Something about colour tickled pink by,
um, actually just rays or pulses to a billion points of
bored, even as it bloomed irradiated horizon. The
view, I meant. Against the sun, which setted and rose
and olived when bidden by you, to my eternal shame.
Nuclear blotted, abberrated for 3D. A flatness totalled
for normal eyes and I was well chuffed. First-frosted
and choked up with steepled and paling caffeinated
steam which went, um, BRRR through our four early
eyes. Previously, the eyeball grew rapidly, till age
thirteen, at which point the eye attained its full size,
spun out and saw under the bed. Only without proper
depth and for the rest of time and we never found it
dried out and coated with hairy bedroom dust. From
then on we barely looked at one another. Didn't need
to, you'd said. Couldn't. Poorly eye'd. Warranted, I'm
not entirely sure what the tears were for: once, some
residual dreamt-up horror – then, battery sulfated. I
hadn't even come to terms with the idea that it had been
full of liquid before it sprant a couple millennia: hot
time parched it, mate.
– What was entropy if not, you knew? – That
morning with that view. Meanwhile, autumnal was,
wasn't it just. So then November floorboards really
didn't creak at the cat's crept, however ironed with
cold snap. But I once totally did, and would have rolled
about, um, twenty duvets? Hot and queen-sized and
pulled harder than shook if I'd been awoke (I
mentioned this before, I think). Previously was
stripped buff skin, totally rude health defined yours

and my cluelessness. We knew what they said, we knew
the vital stats by our confiscated hearts. Vitality was
still very much IN even as we convulsed with artifice.
And we'd gotten in again, spurned the day whose
light was not, like, nice – sought instead a faux-twilight
blush, that light bloomed source-less till it hit skin
or till it didn't get under things like four pillows or
a thin mattress or under the bed with the eye, or the
foundations or your body. The sun had nothing on us
– nor could it beat back alpha decay or the afterwinds.
Neither could the bedding, which sprang a full six feet
into the air and burst into flames. And it sounded like
the way you spoke, though you'd never would have
said anything like that.

Yours,

Ex

Dear [...]

I specifically remember you, handling animals with vigour. So the cat was kibbled to sparkle up her hot hackles and the, err, doggies basically sausaged good, smacked gunmetal putty in their own sort-of hands. Gault was thrown and slupped against muscly backs and spackling the white tiles, freckly at the hysterical rpm. In the living room we sported woad masks to slip the historic, the whole document.

Or there was the time we were totally made for larding crowds of retirees. Or the time we up-pawed clefts and pounced like dewy sods. Or later, when we banned that dickish manhandle. Instead we took the sweet time, dawdled and just drufted all up in it. Sometime parked and that golden ass again, wasn't it. Smutted glazing before a bung snog on the digitized ramparts. Drove slow drift; sweet time on fult, was totally IT. We blew cover to flush game like a billiard ball cussed with blue woad; we screwed to separate.

Redundant Ass
to Qs posed in terms of two varnished bodies eased on the creaky wicker thing and, wicker-indented thighs imply the conditions writ all over that grunny mush of yours.

Sidling up, you sort of present, 'Here's drawn blood.'

Your fleet tongue and I really drew ourselves up, hearing that, all maffled at the departure gate, sundered

together, you and I, chucking thousands of full water bottles down chutes at the behest. It's not as if we kissed as hot and held as all that: my hands were all over: done. Though we went and got sprained and definitely teared saliva and pooled beneath your tongue, easy, like. Easily enough to wind up those holographic jobs-worthies who can only burble the loopy speech of anti-erotic agony.

I was a bit drunk on the flight. Hurtling away from you. So rimming miniatures and tonics doubled-up in plastic cup meltwater over the forever-Alps or some shit. Measured for pleasured men massively on business. The rubbed sore fantasy was then wealth of chased gold striating the Alps. Or breaks of readies and greens bounding the Alps, rendering the range as charts up the pisser or down the chemical toilet.

And I was trying to somehow *unlock* the cup rather than splinter it, in spite of the material qualities of that chuck-away plastic and my SILLY teeth; the cup complaining between my high-strung thighs, aisle-decked in mottled charcoal of cotton-synthetic cross with soft play-rope drawstrung undone slip knot and not swabbed elsewhere so probs a bit stinky. Medium to middling filth going on in my head while I listened just enough to know when the trolley trundled past.

So I reached to angle the stiff little air nozzle – armpits flaring – and directed it to shuffle my clummed fringe with the thought of your puckering blewn, post-, calmed. And presently the expansive black slacks of other pairs of ground-slackened trousers on the same flight chorused darker patches and even more dwarfed

spirits – convulsing the variously sickly friction of much, much denser weaves of fabric.

I could scarcely imagine every one of the clammy genitals on the flight, but I sure as shit tried. Begun with imagining every fat windsor loosened to pre-noose, every zip down, every hand crept down in feral ways they scarcely knew: digits inputting eerie reflexive wants based on their duties, freed! Unfettered half-hour where everyone buries their clouds and then touches them with fine tease and untouched designs, arousing nerves waaaay above the usual.

For a while there, everyone was in sync, swollen with the tidings of whatever peace was left on earth.

Quietly, between ourselves, those pilots up front have shown impairment in their ability to fly an ILS approach or to fly IFR, and, really, even to perform routine VFR flight tasks while under the wee influence of miniature booze. So our captain is sadly sober. We, on the other hand, maintain countless frozen tons of desire: I can think of nothing more sad than this Ceefax stat shit flickering on those little monitors.

Out the window I swear I saw the wings get all nocturnal and leathery, dear. And and and they started thwapping together at the top and bottom of each slow wingbeat. Like processed handclaps, all anticipatory; the lilt of managed breaths upcycled for pleasure and fed back in, trap-risen to incite our own rhythms, apparently. Nearer the front of the plane, behind that money-modesty curtain, arid business took hold and curtailed the fucky, but you know what? we can forget about them.

I really do keep thinking of those murky school por-
trait photo drop-sheets: stippled fog of prowling
future, or some psychic BLANK forced out the back of
the kids' skulls by the flashbolt, out through re-bust-
ed fontanel for the current drunken rim, emotionally
haemorrhaged by interrupted geography or history or
interplanetary colonialism.

And I sort of just about opened my eyes and saw a
spreadeagled mauve, sunset lambed and squeeling with
all the disinterest of a petered bonfire: everyone on the
plane was sharing, in the knowledge this email wouldn't
send till I'd landed.

I was there, clouded and heaving headphone fantasies
and loves and listened to D'Angelo and heaved up a
reverie of sorts. In love, my friend. And with nothing
important: fuck, it was important that one. Will send if
you don't born already hud it, the thin air. I also thought,
as ever, if he only people I could talk to like that –
albeit not talking but rote. Who cared? I had a double
on descent: Darling! It was involuntary. I loved you!
So much. Things were important again! How? Some-
thing and so very much. Drunk. But it was real and I
wanted to cry. And I wanted to hold you and I love you
xxxxxxxxxxxxxxxxxxxxxx

ELECTIVE MUTE

'There are, what, two or three billion ways
of vocably shitting on women in our parlance', you say,
walking home the other night.
 – You're wearing mules and I'm wearing flip-flops:
A pair of loosely synced, deck-landed fish.
Wh-fwap-thup: It's summer.

'Numbers are the most exquisite, personal metaphors',
I chance, to the ground, I think of 2012, 1492, my
bank account, my inside leg, my dick. The occluded-
measurable; those private, intimate digits.

'But how do I pronounce *this* fucker?', asks the topless
man, leaning out the window of your second floor flat,
smoking.
'Precisely', you sigh. We go inside.

'Figuration yawns and undoes: It will not do, liter-
ally.' And you go totally berserk. Outside, the sky
opens. Lightening shafts, thunder claps and rain pelts,
sounding the concrete, the cars, the local kids' darting
polyester tracksuits.
 Thinks: *If only drenching out inappropriate clothing; if
only confusing our tears.*

Inside, the topless man comes downstairs and sits at the
table, ready.

And, um
you scream mourning
for the forgotten millennia
when no one could fucking sex anything.

And the forgotten beginnings, rumblings.
– Downhill ever since.

'Borborygmus', settles the bad guts of the dead wolf over there, in a ripple of time-lapse and fucked-up French horns.

Mulched leaves bank dank back,
in accord.

You crack and smile and the sun beams and the air whistles and the wolf's guts seem to enunciate *terrifically* well. Freed from all that horrid syntactic curbing, those bad black guts can't mean it. Not really. Not at all. Just casually purging into the surroundings.

Plainsong from some void.

'Elective mute' and all the humans zip it.

O dry wrestled hole, where to?

I will follow wat
crack-up the shambles of buttered shins, pulped ankles,
smearing soft tarmac
faces to raise rashed sea bump-map
(rrrzzzpff).
I will tar, feather and suntan a limb of your hidden
pastry-like beneath
a slight salting
of liver spots and latex-lidded corrugations
and hooded crow's cracker and clippings-feet to clasp my
forefinger as a, um, baby's autogrip surrogate, inevitably.
Which will put us in mind, ninety years on.

Notably angry vestigial language will be
delivered from vulgar podia, erupting as 'red' from one
of the five or six noise-making rifts I will seldom though
now envisaging quality hecklers of this unwaveringly
dysmorphic façade.
A thousand year buckling.
Sitting alone at night in some secret
part of the city;
whatever quidity will it is sort of carefully balanced on
brass tripod
to echo the Delphic woman, straddling and tripodal two
legs and a third limb-cock over eye over warm
ethereal vaporized words discharged from geo-cooze of
the six yore godesses
opened and
a slight blue flame sprung from the not at all emptiness
and makes successful that which should not be believed
in vain.

Well understood, then, that there will come the unavoid-
able encounter, in a summer field, with a dense swarm of
transparent infant fists, wheeling about in the twilight,
meeping.

I will not cry about but did fall.

My darling interlocutory passerine
you will tenderly repossess the sorely possessed and over
and over and through a mouth
rapaciously giving-out
entire hissing summers of wet green noise to drown out
nothing so much as ignorance which tends to the long-
dead
blue-sky-thinking thaumaturges whose blood will be
so despoiled of oxygen they might as well be forcibly
identified as dreaming acanthuses –
leaves will carefully lifted in the already known to be
futile hunt for a pair of jewel-like lungs or simply some-
thing recognizable as futuristic genitals.

Programmers of will
discover some simple application that will staunch almost
all future heartbleed.

A full company of teeth will be curled for years,
well and sinister for the purpling milk-prose and brown's
cavity to get in there – well-loosed and hard-swallowed
and scrape on the way down.
Won, in a way, you could say.

A gifted girl will dedicate a large, usable number to a
dismantled family in another country who are as well
wet – as if gargled through clearing bronchial fluids or,
um, Bartholin's glands
cos, right, fingers in holes before
spat up some laddered microphone pop-shield's amazing
studio groin and held warm, where she will prefer to stay,
not cowering but so much the aware, while behind her
will sometime pace extreme visible ribcage.

Half a wizened testudine bored lifetime
from this, taken in hand on the whole:
penis placement will be well bang
the centre, radiating outwards like the gawdawful foun-
tainhead, if pointedly only from the goose-tipped split
and also drawn inwards, inert-ing the life out of and
blanching other kinds of drastically divergent morphol-
ogies the way we will never understand other kinds of the
galactic terraformed – rather towards enthrall burning
approach shite for backwards up the tripod trickling.
And with blackening water Mike will sprinkle both the
hem of his garment and his other foot, shucks.

Fresh, &
protuberant land masses or islands or outcropping
will begin to build up around the humorous Hawai-
ian tubes, the Southeast Asian tubes, the hilarious
Bahamian tubes – over the course of the nexting year,
sparking renewed interest in the legend of Atlantis and
the year 1999: the sixth of the eighth month of which
will happen all over again, literally.
A voice will be heard over every channel for no one:
fear and, er, a kind of trembling for a couple of years
in grey solitary splendor, the non-geodesic and not of
goddess of.

Years later and finally, when that tart Saharan zest set-
tles, I will emerge like nothing so much as yesterday's
litter-spangled cat turds escaping the tray.
True.

Millennia later, all will be one massive and ever-loving jarring selfsame and mutual penetrative being – all lustrous, er, shins and sloping jawline and attractive high cheekbones and
no eyes rotating to take in not most things.
Knocking over the, erm, Yongle-era blue-and-white porcelain and not minding till live-refracting blue-and-white diamond alien loses patience and ushers us out of the facility and into a lovely roaring river to drown.

Then will follow the sweeping,
happy thumbed hose, etc. image o
of too many pseudo-sweet persons openly trafficking
raised fists for raised brushes and marigolds, cleaning
products of every shite stripe for traditional hoovering of
last night's obsidian and soft-tortured confessed solidari-
ty and daubing centrifuged blood and
secondary violent function.

Mere hours later will come by the overturned clogging litters again, by the whirling scrunched faces of you and me and covered by misc. dazzlement snogging wet, the newly inaugurated republic of such-and-such will be disturbed by the weight of its remaining mammals tramping rhythmic joy.

At this time the copious reds and the impure whites and the weltering purples and the damp-patch yellows and other familiar yellows will attempt clamped rule ham-fisted.

After which will come that man hollering vowel-sounds into a dog's exhausted anus.

Cordoned off by traffic cones and the scene's loose criminality; tottering yearling foals and, um, a grove of flimsy sapling willows restrained by black plastic tubes and olive green cable ties, supported by evil wooden splints and what look like a young person's extricated calipers and the, er, collarbone will be replaced with a thing much harder and which will be seen flushing under the skin of every single,
during those arousing sequences of events, and from outer space through the dust-choked double-glazed clerestory windows we bloody well call a galaxy and where most of the humans who don't count.

312

You will get through
more pets than, um, seems right.

A pair or more sparkling ogle-eyes will be denied nine hundred and something times and ach.

You will acquire a new sense of direction in your life: tentative discovery will be self-redacted beneath lattice-work silk ribbons in every shade of bluff. I will of course afterwards choux-haemorrhage chocolate unsexiness and more lose teeth to the task and happily, fucking.

We will, by then, have totally made up a rudimentary ruminant constitution mostly for digesting the ubiquitous grasses, a device wrenched from base-mush level ungulate heaps which will already (as in at the time, um, of writing) have upped from as few as zero progenitors barely domesticated in southeast Turkey about 10,500 years before, to an estimated 900 billion across the world of that day in the future of literally tripping and tipping and punching cows is all there will be to just do to prevent their total graze-razing.

And to trample underfoot will become a kind of gastronomic auto-prep-work in the very wildest country of returning ruin, whose ingrown ramblers really do crop cow's shins with snow-spiked and wield tarnished Zippos to turn on the extra-pissed-up cattle corpses which no one seems to top up nor actually count and will read stratospheric aspiration, mum, as with the picked off badgers, who will boil-rage out of their sets at every dusk.

315

This year, New York City officials will make moves to
limit the number and types of kinds of pets you can own
in town,
save roaches.

You will start over-depreciating the vodka again;
I will start searching where we already looked and again,
sure of it.

316

Generally speaking
there will be no dearths identified with acceptance: of
and under the futuristic phony-distressed clothes dis-
tressingly haired moles skin-tagging and slowly hoiked
back in awkward equivalence to nictitative membranes
of extinct amphibians, only without eyes to 'get at'; which
will be all the better for preventing cowardice being re-
homed ahead of more deserving, tax-paying parties.

*Your terrifying, mercenary sensibility – which we will
be in no doubt is the very headwater of men's
fresh-historic alone and well-deserved.*

Following this will enter the crone
into our lives
like an entomo-blight hiving about the track on oodles
of easy-trod blue, ropey hem through cartwheel ditch's
brackish meniscus in the made-up past
and into the destructive-plastique future.
Clasped to her hot tits will be one of those phones for the
elderly or whatever other vulnerable and likely sorts:
massive buttons with massive, embossed numerals; little
additional functionality save a clock; important contacts
assigned to quick-dial:

> Michael 1
> Sarah 2
> Jean 3
> Dr. Broome 4

Ringtone is antique rotary and loud.
Rings on the fingers, foreskun with senior skin, pointing
accusatory ahead, like likely right through you to some
ghost-bastard husband, long since petered. And ominous
music emanating from beneath that wool swaddling and
the heavily embroidered shawls and all that, the creak-
freaks eulogy:

> Rings
> Never removed till
> will once dead,
> with Stanley
> knife and forget.

> How often will you be captured,
> O city of the sun?

About a dozen times or thereabouts.
Also, changing all the laws that are barbaric and vile.
And bad times sidling up like hooch-slinging gunslinger
ponderous djinn, oiled-up from derricked fosse. 'No
longer will you be enslaved', he'll say.
Great Hadrie will resurrect and, um, revive your veins
and, bungling fatties, poke them back in with whatever
he can the laying of them phantom yet caked hands on
(knitting needle or wooden spoon or even the jade-stud-
ded pommel of his curved ceremonial) – cradling as best
the diminutive body of some crashed at the mini-round-
about and his little internal heart while all the general
practitioners look on and unspoken willing it and decid-
ing to pseudo-surgically excavate where it got all buried
and wild meadow-carpeted – packed in winter with snow
slow to, um, blue ice preservative slush, we will hope, and
mute cuddling of woolly mammoths and some kind of
'mouth cotton' and simply asleep, duckie. Up there, at the
bottom (as we once termed it), stupid fish will still
catch the sun at the surface.

The Mirror Stage will be retrieved at last
from those principled elephants and great apes
of flattering anthropomorphism –
gifted with calm irresponsibility instead to my balding
friends, the exposure-wrecked pigeons – faltering
out from beneath frowning underpasses, feet eroded
piratical by sustained contact with fried chicken and
potato guano, exhausted;
soft skulls poison-shrunk from olid and discarded black
seed on spiked sills, or the swing of dull, unchecked
toddler's fat leg.

And it will dawn: slowly rising flocks, the
smut of the sun, as if a beak could crack a smile over a
thousand years. And here lies hope – practically, literal-
ly: The London Met
will be humbled, hats off,
numbers I won't even need
to see with water-cannoned eyes.
And it won't be, um, beautiful but instead monstrous:
the heraldic crest of a troll emblazoned on everyone's
tongues to lick past wounds because they taste ground-
ingly cheap.

Sadness surrounding veteran actor Michael Douglas will be more or less happening – which could be an accident or illness or something.

I will arrive too late to catch
the final, um, performance.
Something via Skype or Viber in the umpteenth skag.
Something involving the ripped triangulation of a
lionized group of globe-trotting a-temporal artist things,
conferring and basically publicly private astonishing-
ly bored village-halling it right up, and in whatever
affirmed parlance to easily
political brown accord which we will fucking never and
which we feel pretty much nothing at all nor for nor why,
simply against.
The very wind was against
them then, so why should it be any different a thousand
years hence when it whips up razor-edged red ice bits
and unimpeachable screams at a billion mph on a whim?
Oh! –
and I just remembered your cheeks, darling!

The conspirators were fourteen of a party,
summarily stay and just doing it 👄
would be enough at that or this point, so let's just stroke
with what we have: hands with pussies affixed, somewhat
but never less than.

seven and fifty pacific years
will be enough, surely.

Sylvester Stallone, Arnold Swarzenhagger, Conrad the Black, Rob Ford, Kenny Rodgers, Valerie Harper, The Pope, Catherine Zeta Jones, Ozzy Ozborne, Jack Nicolson, Drake, Nick Wallenda, Kim Jong-un, Angelina Jolie, Brad Pitt, Penny Marshall, Hillary Clinton, Doris Day, Dario Franchaetti, Clint Eastwood, Willie Nelson, Paul Tracey, Brittany Spears, Latoya Jackson, John Walsh, Steven Harper, Burt Reynolds, David Hasselhoff, Bernard Madoff, ex-President Mubarak of Egypt, Rupert Murdoch, Mickey Rooney, Kelley Osborne, Carol Channing, Lauren Bacall, Loretta Lynn, Fidel Castro, Billy Graham, Jerry Lewis, Kirk Douglas, Joanne Woodward, Debbie Reynolds, Barak Obama, Zsa Zsa Gabor, Larry King, Jimmy Carter, Barbara Bush, The Duke of Edinborough, Shirley Temple, Bob Barker, Keith Richards, Barry Manilow, Jackie Stallone, Charles Manson, Nancy Reagan, Meg Ryan, Ryan Seacrest, Leaders in Syria and Iran, Lindsay Lohan, Charlie Sheen, Bill Clinton, Howie Mandel, Jack Osborne, Hugh Hefner, Danny Glover, Betty White, Prime Minister of Australia, Woody Allen, Daniel Craig, Michelle Pfeiffer, Sharon Osborne, Michelle Williams, Heidi Montague, Dick Cheney, John Travolta, George Bush Sr., Regis Philbin, Robin Williams, Natalie Portman, George Bush Jr., Taylor Swift, Tony Bennett, David Letterman, Justin Beiber, Rue Paul, Selina Gomez, Tippi Hendren, Melanie Griffith, Mick Jagger, Ed Asner, Sean Combs (Puff Diddly), Karl Largerfield, Michael Douglas, Kreskin, Donald Trumpe, Cloris Leachman, Queen Elizabeth II, Chaz Bono, Pink, Madonna, Harry Belafonte, Mary Tyler Moore, Princess Fergieson, Shia 'La Bouef', Alice Cooper, Carol Burnett, Stephen Tyler, Mark Anthony,

Gordon Lightfoot, Avril Lavigne, Prime Minister of England, Chris Angel (mindfreak), Ronnie Hawkins, Alex Trebek, Jay Leno, Paul McCartney, Anderson Cooper, Robert Evans, Barbara Streisand, Sir Richard Branson, Prince William, Prince Harry, Nicole Richey, Simon Cowelle, David Copperfield, Desi Arnaz Jr., Jayne Meadows, Monty Hall, Dale Robertson, Angie Dickinson, David Letterman, Jay Leno, Jimmy Fallon, Christopher Plummer, Katherine Jackson, Joe Jackson, Brittany Spears, Ralph Lauren, Meg Ryan.

Give it a week
and I'll be skimming roofing tiles across the fucking
memorial water-feature thing over there and just missing
the gibbering heads
if there's any kind of god.

A filled to capacity coffin of emergent interest, made
from psyched and cudded bamboo, branded X-Board,
lemonwood, hickory, purpleheart and restaurant-grade
banana leaf, laminated
will be 'put' into the red-hot iron server, son,
where seven of the very best children are already sort of
interred and/or dead.
Contingent everything.

Safe conduct
uncles and aunts and
the cousins and
the rest of that super-extended, mitochondrial excess
extended
will impale the walls with their unanimous flaming rite,
lamenting to see thus dead the soft purple fruit of their
redundant line.

The next best thing will epically not.

You'll go into provocative RPG hiding among a network of linen-spread café tables in Geneva or Petersburg, between cherished legs tentatively fondled and rarely parted, slurping shit off the carpet in contravention of the three second rule or whatever and ferreting and sucking rich, sugary crummy from inward back-stitched turn-ups and, well, they'll surely know you're there and more than likely get pretty darned excited about it and but not letting you know or just barely and encouraging with tidbit-peek of bronzed and built crus or, ingenuous, let fall whole avalanches of Strudel or lavish widdled Krug and for a week or a month or whatever. Don't matter: sooner or later, etc. Glock stowed and an isolated magazine looks unrecognizable or the diurnal in open-world gaming working, sometimes, against the whole temporal fib-work cribsheet that sustains the shitshow. As in, I will realize that the sun literally sets and the moon literally rises (both figuratively speaking and perspectivally contingent, etc.) and these things will have happened years ago, now, for the last time, what with the sun cooling and the moon talking like a drunk. Allegorized in a, um, comatose hamster outliving its family six or seven times over cos of the drugs we will give it while it's under and, um, think of the trembling again, mortal darling.

No one will hear you, from tomorrow onwards.
And my searing wish will be to join you in there –
with you and up against you with you.
An unfettered pair of dampening
husks curling together like savoured and pre-sucked
Pringles with somehow our lips and ears enfolded for
whispering in circular breaths and aimless affirmatory
conjurations and memories cute-lisped in precise neuro-
logical terminology to simply galvanize the inaccuracy
of the inside of our heads and more than likely,
tomorrow, as our brains turn to sparkling mush
without curtains drawn and will finally come
together.

Still will we
remove the melon-balled
organs of vision wat are not image-resolving any more
and we will almost certainly regret having silver-gaf-
fered to that cheap screen and at the time. No matter how
carefully, slowly undone...

A report will be demanded as if the report of a gun
(more or less quickly received, depending on our position
on the barranco floor acoustics) – only, well, extending
beyond the end of the gun and something having come
out the end of the gun at a terrible lick that can mean only
1 the thing wat it hits will, um, change back into a blobfish
and irredeemably, backwards thru evolution.

And again already with the loss!
I report: in the future, we'll be able to think of and in
the future, Joe. We'll easily shed lost objects like the wet,
chlorinated costumes they are
and breathe easy, slow.

Will stop 2 big eruption
short.

331

A month in, the motion of senses – heart and dead, blue feet and bloodless hands – will be provide precarious agreement between you and me. Sword's fire and multi-colour plastic-rafted surfing sperm-bass floods and the noble west
will be still-drowned
churning mikvah: killed or deaded
or made dead and made sure
because of a schmaltzy and pasty weak brain running grey and red from – not at all like that brittle favourite stop-frame gazelle, understand.

2279: power from nothing.
From out of black holes or something.

I should imagine I'll drink more, in the future, into the future.

A boundary universe and with it, no one knows.

Everything here will be edible: the keys, the shiny red car, the ring fingers, the police, those sad looking people queuing at maybe a product launch over there will; the very tarmac, the very overcast sky – the very shit that will unfurl so conventionally down your leg. All of it will be perfectly cooked sous vide and in thin black bin bags secreted behind the wainscot and with zingy rats slashed and wrung out, concentrated – reduced – under really not the whole world's scrutinizing gaze by that haunted dog: will readily be available at the deli counter in enormous, autocratic supermarkets, which I will totally believe.

The BBC, in their final year of operation, will shoot a
stunning piece about guts – about your guts – the gutsy
ins and outs thru keyhole and endoscopic peep-show 4k
surround soundtracked
by supple manoeuvering brass ass,
bellowing Harley Street elderly cupidity and to be safe,
reverse cymbal to Assville every time the blonde trom-
bone
squeaking slides
between extensive buttock cheeks.

A scythe will join with a pond,
tomorrow:
In Sagittarius at its highest ascendant.
Literally, the highest. The right at the top.
Plague, famine, death, etc. doled
by military hands; this short century
approaches its already renewal, Harry!

Then will happen the gaping fact that corrective surgery is 'needed'in an old torpedo'd shop window webbed with glass wrinkling anti-coat lead. Mannequins will be posed in a dumb diorama with a merry gaggle of chicken-sized scalpels, forceps, dermatomes – before a grey-stippled scholastic dropsheet and jargon, acronyms. Silent will waxing on protest face markets, dearie.

Here, a mute, gawping crocodile of flourescent-tabarded and stencil-numbered primary school children will be tethered to the lamp post outside, while Teach, inside, rifles the All Saints concession. After distressed jeans in the mixolydian. Cut to men approaching. Tight, dastard-ly gait: so very distressed, stonewash naval thrumming restrained in the waistband like – as – archaic pizzle, which it and they,
will.

Um, wherever I will go, there I fucking will are am.

336

Twenty minutes later, some benevolent thing will seeming-listen with stupid honourable prosthetic ears while from the mouth a few inches down and degrees perfect rotation: a vituperative, electrical bugged buzz-hole will both sooth-says all this unreal and un-meant encouragement while through an adjacent hot-air vent sucking correspondent oxygen (which I do and will require for living) from my lungs well in advance of the hopeful trachea, the plucky larynx, the dewy-eyed tongue and comedy teeth, all earnestly poised to pronounce, er, the simple possibilities of disliking anything but in supra-agreement, etc.

Then the reminders preoccupied with reminding. Re-
minding us of just how fucked up we will get, for a start.
Have got. Christ, er and sipping, tonguing tubes of taupe,
rancid unguent, so that wounds will be clairvoyant
slip-lidded with bales of gauze and taut dressing reten-
tion tape in salubrious blues and phew-whistled greens.

Naïve

For forty years the rainbow will not be seen
but sandbox lurk for shame!
For forty years it will be seen every day.
The parched earth will grow
more parched and it'll be great.

SCORN

Yesterday happened the Great Unpeeling of darkening,
fenny bandages!

We'll congregate and sexy foment and all in anonymity, carrying on like clichéd cast in bawdy Barnum canvas big-tops. And primordial winding sheath entombing bottle lipped and sorrel breadbasket peat sod and hewn briar stake, skewering and garotting and compressing and hold. The spicas of entropic molar will wince soft-crunch and dainty rip-wrench of, certainly, inquisitive and fragile young scabs, tugged off and so which will be, um, satisfying, though moist resetting in so doing, of course. As if playing the Shreddies after five minutes being pinned and towel-boarded in merrily contaminated and tepid cow's milk lido I will manage to excite from a stout glass verticle something that previously was skin-bung frozen pleated with a rather festive disc of foil in silver and red wat I will indent with my thumb and remove with the use of another finger, in accord, and that I will desire to keep and savour and toy with and exchange but which is, I will discover with sadness, not a currency when it comes down to it.

So a few things will just sit there on the table for what will seem like an eternity. Today will be over, on the radio. And I will remember shit like this as if it were yesterday. Today, tho, will lip-sealed half smiles, cocked heads, out-to-pasture hands resting on girly shoulders, lovely big hugs given while facing that pebble-dashed hospital green wall behind the garage and a mature patch of nettles harbouring one immune weeping python and the brownie bodies.

In 2047 the most sacked karaoke will be
Buddy Holly's 'Everyday', sweetly enough.
Even if and because the body percussion hapless mas-
tubatory or unknown violating or come-hither paternal
dying lap, resonating inside a toy bellend.

In 2047 you and your body will
put out.

340

Two years away is the ragged end for wolves,
for lions, biblical oxes and asses, etc.
Pelts and molar teeth and various aphrodisiacal dried
and ground organs shit-stirred thru the hot, darkling
humors with an outstretched middle digit
latterly kept up between tochus
and lying there with sweet,
timid piebald hogs
all boisterous and also
de-trained, um, bull mastiffs.
No longer will the sweet banana manna fall
commodious in your expectant mouth: it'll more likely
drift to the floor now – will be almost instantly coated
with moulted hair, grit, fecal maybes. No more manna.

The decision to leave the boundaries of the universe will be made pretty lightly, with about 40 per cent of the population being dead against it, which won't particularly matter.

A thing existing, seemingly without any, like, senses, will cause its own end to really happen through convincing artifice. The lifelike.
And you'll poke it with an elder twig right in the skyward eye.
And juice will sluice and lick lick lick.

Everyone will take to the streets next year
and how marvellous!
Everyone laughing, enjoying themselves
dancing and shit
with, um, responsibility and these will be universally
recognized touching scenes with red-lacquered uke and
lens flare and diffraction artefact and sugar paper and
sort of braces and mock and mock and mock.

Some absolute ass will demonstrate that the pattern of stars frozen on the ground at Giza in the form of the three celebrity pyramids and the Sphinx represents the disposition of the constellations of Orion and Leo and the brotherhood as they seemed to
looked at the perfect moment of pink sunrise on the spring equinox during the astronomical Age of Leo. Then, afterwards, opinion will swerve and I will be so so so confused. Solicited with fisted hands-up in the sycophantic thing-mode, gah!

Those who seriously like closed doors
(those who seriously like closed doors)
doing the clipped wing thing but with very little or no bright plumage visible. Instead a simple bluff sheet of conscription and
the wearing of that given, itchy wool uniform and reciting the three horrendous orders to the beat
of a whole other culture's infinite demotion.
Outside: spent blister packs extending to the horizon – stagnant flat peach Volvic pooled
and corrosive sublimate; the sun like thin yolk or all of the contemporary German pasta.

Miracles can and do happen and
a mongrel will be beatified by some guy.
Dear diary:
2014: Found a way to win any disease.

People will sit on other people's faces in a sexual way.

I will hand on heart feel the ace rhythm
– tho lately a persistent jalopy
of my left lower eyelid feels visible to everyone – is its
own public spectacle ECG dishealthing. And yesterday
my left thumb started lurching
at the top of every bar of my heartbeat –
the kick two-step,
my eyelid the
pell-mell hi-hat and
my voice the voice, of course.
Your answer will be yes, I do so hope.

nviable certitude will be presented
similarly refutably – benchmarking and desktop delim-
iting the vernacular of possible/impossible experience
and its insufficient representation. As in: What and it will
suffice to prevent disastrous interpretative divergence?
– There will be the judicious application of exclamation
marks: a deft shuffle of enthusiastic dark-haired audition-
ee surrogates!

(A proxy for tears will be creditable – but of loving
blood-stifled collapsing chest cavity: what?)

347

In 8045, the sun will OPEN like a fridge
or as so much as not a cat's eye.

Down to mutation
people will begin to use their brains more than 34 per
cent. Completely lost the thing of it, as in spacecraft
forgotten by grandad and terrible new diseases:
amounting to live flesh.
– The other 66 per cent reserved for the exclusive
ferity of Alzheimer's.

 NO

The sun will be like my personal
speaking whatever
came from above, through the cosmic maw, and what,
below, is transformed into a product, obsolescence incar-
nate, flickering at such accelerated whatever that I will
its desperate corncob virtue through agrarian scything
of ears and noses and anything protuberant so that
forever-insatiable slices of gluey bread to mould the
whalebone roof and erratic spacings of your fag-packet
warning mouth for PVC vacuum-formed retainers
trapping swollen bits sogged with a-seeded unripe
cherry tomato Value
or quiche with octogenarian halved couples you're more
or less related to.

Later on, you will promise to come back to this bed over here, yes? As in, known tho it's dark outside and in. As in, you will promise that you will come back to bed, at some point, yes?

Later, I sure will like to write that I,
and for it to then, as a direct consequence,
happens.

Later then and
'K, but I won't really be sure there's a subject to convey
wat coming to, wat return of, wat sleep retrievable recu-
perative, what intimacy reformed. Let alone will two of
those beautifully curled lappets of living skin things for
directing air wat I deliberately jostle in the small smell
of the unlit (but it's OK, sweets) room with arid mouths
into concert with a sort of organic bongo to pummel a
comprehending brain-sensicle sensible. All of this at
least, I presume,
too much. I presume too much.
And, O! nudity of the more unusual, far more inducible
kind for hardcore diving, please! Oversize and folded
nudity of the more unusual, far more inducible kind,
please! I well love and get off on the more unusual, far
more inducible kind of oversize and folded nudity, please!
But to reiterate, it's not speculation as cute hedgy-fund
as economic etymology all the way back to gurgling and
yummy-tone gum tongue.

No words for that, are there.
There really shouldn't etcetera, *parp*.

The last secrets of this ol' moon
that's still fucking here
will be revealed unoriginally –
like we just forgot to turn it over or something.
And it is a sad stone, literally –
presenting the first crock example of resurgent proto-eth-
ical rebuttal of your shitty apart ooo purview. Effort, son.

~

You will and⌣
I will and
they will and
we will
but it still
won't de-clench the constricted Mondays
together with core muscles and hunchback and in ba-
sically the same satin sack and crack: we think lucid at
the big table with the more eggs the better and the exact
same playlist spreading for all I want of wad of dear moss,
trimmed from beneath a nearby scarp, bruised in pestle
and mortar with pumpkin, horseradish, *ras el hanout*,
Naphthol Red Legbar yolks! Simmered with the radio
and heavy eyelids, single cream stirred thru;
pitched at the wall and instant clean up.

That lost thing we spoke of yesterday?
Well, it will be discovered, never fear,
hidden as it was for a caught in a few.
Our mutual intelligibility, empathy, tolerance – all of
which pitched outwards and apart
for a few inverted hours
then back and I love you.

Two or three months will pass till we reset the physical
constants.

Conservatively speaking, the machine-chamfered tools of late phallic whittling will continue to abound and universally, so honestly very much capable of honing any stubborn shape into the absolute spit. Normally, blunt knives designed as such and held just so for really wholesome bruising, in the main (a particular pedagogic method: firm, spheroidal fruit wielded inside ivory, Egyptian cotton pillowcases). So very nearly a joke, right? A cut, then, is only worried into the world once weeks are spent on one rose-maddening patch of winning inner thigh, which, er, resembles nothing so incisive as the act of a blade, but rather ripping or snagging of clumsy child portions from a dim source with your monstrous fingernails – under which we will retrieve dark evidence of that vast out-of-town mattress of toxic green moss and a lover's forensic picnic at the site thereof, comprising Alertec 'corroborated' by kale and vivid yellow slime-mould, right? Recuperated, if needs be, post-mortem. That's a threat. Hence the urgency around will penning will if law will be so very previous.

You will bark and I will whinny like the lovers that we are and all that hooey for an entirely five year stretch with the inscrutable-symbolic pitilessness and inside the knowledge that this basic horror will ultimately abate in this cycle; that it is cyclical, rehearsed only and as I will have rehearsed it in other writing, spokings, etc.
Which this single archaic verity
will be the source of my remedial disgust and felt more than anything else and totally everywhere and you necessarily will and always totally will wager on its temporariness and its petering – vitally. For the sake of the entire, um, saved again for posterity or the next go around, ah! The wrong spirit, sweets.
And what that knowledge will do
to this already twitchy wow. It fucking will is what. Add to what will
do the certitude of this
abjection's ebb male to
the only site of terrified personal agential sincerity self-knowledge safeguard verifiable WILL, damn. And the pattern will recall, as ever, the immortal bogus-mortal of stuff obsolescence marking every bag of fresh technocratic/psychedelic goods as the demonstration of its end and also its beginning – its totally and sempiternal hallowed, right? We will I hope realize that our performed circularity is precisely of a piece with that of everything we're sold as glittering chain of progress capital command round necks and wrists and under the very same, recognizable thumb. ('I know this feeling like the whorl of my thumbprint', etc.)

Oly we really do bear the permanence –
just in the wrong place:

1. *An unpleasant, overstuffed knee-pocket on the khaki cargo pants with the insouciant midriff.*
2. *A dry, marsupial all-natural pouch on a pine CD shelf and lined with a pubic scalp of parched tobacco fibrils and frayed, edge-greying filters and bum-sweat pleated and welded liquorice Rizla like elderly southern hemisphere-fled collaborators very used to sowing terminal appointments like*
cancer – even if all up in those non-indictable wat it really is such a shock to see taken so promptly.
3. *A cold-frame breeze block misted tupperware suite.*
4. *Literally right back up David Cameron's Forever Friends rent urethra expectant blowhard and hotel safe silence pin-stripping peel-back glue gap. And the clinging, tearing foley accompanying with not at all legitimating REM all the way to, um, Rockville. We will half haul, half rip it out and the body, limp, will be limp because it's dead and won't ever de-limp because it's dead.*

You will doubtless and
I will doubtless, too.

We will finally find out who the killer is, next week.

Years later, will doubtless.

Pasteurization will sadly come
unstuck pitted against
the fat gurn of another beige herd that declines and shies
the spare rib from blade and yank contact, establishes its
own system of hate and strange, flirtatious fly-fluttering
glances from halfway up the sun-flopped slope, 500
metres away and clouds parting like no sea nor mere hair.
At this point, the moon completes its vacillating grimace
of pleasure and hollowed disgust, and turns to choose the
dead wall instead, dishonoured, I suppose.

In a bit, the super-rich time-travelling to order in order
to snipe dinosaurs in the massive, artless face and with
expanding/depleted dum-dums from close range.
An hour in,
muggy ten men with
impunity and disregard for the fundamental temporal
laws:

 everyone swatting countless
 iridescent purple butterflies in a grove.

Grinding them into the ooze with boots and deck shoes
and fag butts. Nearby:

 smashing up a cratered dry mud nest of huge,
 oblong eggs. Eerie, oversize foetuses
 skidding about, stuck over with thick shards.

Later:

 bulldozing thronged, scurrying Compsognathuses
 with and in black bull-barred raised suspension'd
 yellow and logo'd Hummers across some sort of
 vast stunning pampas.

Donuts pulled in the orange dirt. Cobalt, cloud-wreathed
and golden sun and purple fringed mountains the matte
distance. Something circling. And pimped matte-black
rifles and all the computer-assisted fetish gear, racked
and bolt mounted, um-crunch.

'Fuck it', as they mortar the hindquarters off proud Ankylosaur.

'Who gives a fat rat's,' unloading urgh into cheery Diplodocus's sequoial neck.

Machine-gunning a family of terrifically handsome Pterodons right out of the sky – right over the pebbly beach – right on to the pebbly beach, with a cartilaginous spank, audible above the roll of chthonic surf, behind and beneath which, etc.

The flat pop and crack as that peculiar osteo-crockery arrayed along dear, dear Stegosaurus's spine are wet-smithereen'd with shotguns for all.

Sexy Triceratops dynamite-demolished like a totally occupied estate.

Impossible geysers of Cretaceous blood.

Sound of thunder, natch. Everyone – the world – red. Roaring feedback read from the global nervous system. White eyes, white teeth, down the camera. Legendary bloody world affirmed legendary, bloody and with men. Returning to the current with gory spoils and to a world so massively unchanged

as to simply be.

Totally identical in every soul-destroying way. And will hobble the metaphors all the way down as a kind of time travel, mate; money words – and not only but also ancient and oceanic amounts of moon- and sunshine.

Once we're gone, the flat red aliens will drive on over, and divide the spoils. Writhing pails of cockroaches, avenues of rats, estates of busted bones – entire pacifics, brimming with aeroplanes billed and cooed and love-bit by turned squid and deeper black boxes, recording the whole thing.
The thing being that these
things are useful to them.
And Saturn will in, um,
dreadful aspect in Mars:

Martians will pitch up
at the bottom of the garden
like an oversize toy tea set
and adults persuaded to investigate by the hapless gar-
den kid will be snatched and substituted by a Martian
the slightly shit double of the adult. The kid, of course,
will recognize with queasy certainty that the adult is
a Martian imposter. No one will believe them. No one
believes kids: this is how the invasion will proceed, on
this truth and
to be clear, the snatched
and replaced adults will be unceremoniously dispatched
and dumped in deep, open water with special Martian
weights lashed to their ankles.

Before – and continuing to be soo
infantilism,
your anger will be, as ever, figured tantrum
by those who patronize and just go about licking long
things all the time and
while all this just laugh and eurghmm, and who will
always manage to
de-

A couple of days later, there's the job of seeding the very
pretty clouds going.
Trudging from Oxford to, um, London to Harlem: from
figuration to literality and back and back further still...
compacted with all practicality crud against village curb
and fresh, ill turd chevron-moulded by parking tight
tyre
and cast by gull-breast,
unrecognized by extended family gawp.
This one will look like ochre gull or tern or not choco-
late-box puffin abolished guts; this one will look like my
face to me: somewhere the wealthy go to have non-lethal
skiing accidents in August.

 I know you'll say no,
 I know you'll say no.
 I know you will correct me and
 softly chide with softly
 touch and softly
 look and, yes, love, yes, love.

This one will look like my face
to you, as impossible to me
as this sounds: spaghettification
drawn like the alien drowned from the plug-hole and to
an event horizon tin can shuttling before wailing and
never moving and infinite denseness or tarnishing mir-
ror and an anonymous (as in: I don't know their name)
fox-muzzle wedged, freeze-framed, um, to me.

My mind will be in your crotch while I will sit staring at some piano's tremendously intelligible anachronisms; accepting a pen's disabilities; the blithe arrogance of a fat analogue wristwatch.

Thirty years will be long enough
for any cloud above any landscape for.
And all the way from familiar cock-up to familiar
another and the gorgeous 'clouds' that seem
unlike known faces and more like a face greasepaint
caked on a forty year-old arse or a publican gut
– providing cover for hulking corrugated fifty-acre
abattoirs with fractured concrete forecourts, manned by
willed and tunefully humming brown offal and excoriat-
ed scalp remainders traipsing in identical blood-sodden
paper party hat pulps for sucking and brand opportunity,
who will pull their own levers, conveyance dreamed as
the obverse of the magic trick, denuded.

As if the show ever had
will ever have an attractive soaped underbelly
with clouds resembling nothing so much as fucking thick
creation myths with classic, fucking thick sheep (under-
scored with lurking Greeks) grazing on water-damaged
National Geographics, some of which – the sheep dipped
in haunch to that seventies yellow – unzipped;
the quivering, flyblown flank of another culturally
pertained animal: the thick-skinned, billion-eyed bull
returns, in turn
grazing to everyone's gall
being knifed, incising seared skin to white chicken. I've
seen it, smelled it on the streets.
The same will be true of this rendering,
groping with no hands or trotters at an elusive, absentee
reality. As in, when we will say 'render', we will pretty
much exclusively be talking about daubing gluing acrid
bovine sweat back to the rain-lashed soil back of the
poorest kind of polygonal perp on some tiny, vain moon
where children are born, weightlessness cowed but giant,
curved and shrunk tending with chamois, to the heaving,
toxi-precipitating super-cloud coping eroded potassium
hydroxide rainfall and plea cupping hands for every
shrill lining for every silver shill Argos friendship, etc.
drinking.

371

You will acquire a taste for CPE Bach and cartilage;
I will disinherit the fuck out of you, with.
You will pay your dues and harping;
I will reap it all with careless urgency and seldom back-
slid skim the metaphoric olid curd
and palm it to Peter, the Simple Stiff, patsy
– though understanding which one is the more valuable
is a point of barely dissembled unanimous arbitrariness
begun with an inherited long reign and proliferated
like consensuses of beauty barbed-halo regime, keel-
ing in lab coats and enamelled pin badges proclaiming
ludicrous shit about medicinal blah, ancient grains,
fermented wha up the fucking mouth or ass and a short
five years later, 90 per cent of the population of London
will fondant or ganache themselves at clinics opened up
by Wetherspoons in the summer of 2012, remember?
That summer of lunchtime clinicians honing
their confectioners art of sugar-spinning and, um, cro-
quemboucherie teetering of this massive,
coated vassal body.

I will love you forever and ⸚
– being the only word game worth playing in the coming
terrifying aeon which will be the performed defence of
such sentences as that first up there
as precisely the site where one stages, pitches
agency and with thickening difficulty
but it will be and will remain
so definitely worth it, the always-near possible treachery
of the infinite possibilities of inflection: your gorgeous
cadence sing-song turn laced
with how darling an insufficiency
at the non-Newtonian escalation of my love for you and
our retarded cat, mouth agoggy open if only for an un-
guarded moment.

After that,
there'll be no stopping my laser-greased! –
There'll be no seconds
just and I hate the way
being fucking slipped without even noticing. Time, that
is. And what's that if not equivalent to a poorly extirpated
kidney found in the wet bole of a tree on the edge of their
property with no other parts and not carrier-bagged nor
prophetic nor, perhaps?
The first thing to be ascertained is whether it's from a
human or wat.

Then and as before and then now:
thousands will keel over;
thousands more will howl forth;
billions will stolid and retarded, dawdling on one thresh-
old or other and as ever. The ratios between these are
present only after the dull course of decades or centuries
or millennia accretion suffocating crusting thing, where
you discover yourself alone but for a meagre hoard of
tinned goods and black teeth and wet cardboard, shiny
red running shorts, feet are, um, toast: swole-welded
inside wet red Asics, knuckleless driving gloves and
splintered knuckles and wretched black nails; no spec-
tacles, loads of perfect cash; someone else's consumptive
kid, bandaged up like an insulting parcel of aid or chips;
another someone's needling sense of the calm, fallen flat
and hot-numbing The Others, stove & brain solicit, like
loads of
head-first corralled grey buffalo jerked
in the torrential rain. Or whatshisface's steel train-track
lobotomy aeons ago when wood was, like, insects and
crabs and eggshells and your mum. 'You've changed', I
say to the cities, disappointed. 'And so massively for the
worse.'
Just look over here where the trees were, for pity's sake.
And, right? I will be scanning the horizon for the telltale
columns in black and also in smoke and also black he-
licoptered into position through the haze like stanchion
temple delineation for
passing between – barring giants and cars and pallet
deliveries and certain inseparable couples.

There will be inspired actions, inspired words,
allegorical dream revelations and, er,
one night in the same hotel in Frankfurt next door to slow
autumn.

I will remember the sight of you slipping into the woods,
stooped beneath right-shouldered fraying pink, bruised
Eurohike bag and in your right hand an awkward, tough
plastic fertilizer sackful of bladders of tepid, gurgling
whole-fat milk swiped from sad farmer's cache up the
road – one a day – stowed under your bed, tussling with
one another like fat and stupid, graphic ideas
of this evening of leaving.
I will remember you
glancing over your shoulder and up the balding,
security-light-lit lawn and up at the house and through
the glass of the closed sliding patio door pane at every-
one slumped in the living room more or less watching
Casualty. Heads lolling and you smiling
one hand parting the leylandii curtain and everything
smelling close and
bodies and you,
slinking thru
and you'll skip the rest of the way,
and I will be following close behind.

You will move in with lover.

Nothing more than a drystone crevice, but more than serviceable cos yous two will be the perfect, precious spile

or bung

or, you know, stopper.

And so you will remain for a month or so, leaking the milk through punched holes down fished rush pipes in to one another's upturned mouths with tumbling earwigs inhaled wrong but who cares?

Caressing and trapping one another's nude arms insolvent grin and kisses and your aching, jutting jawline warm-inflected until curdling spate and then

the bull will come prairie oysters

and then shoved up and out of happiness and someone tells you to work the milk off – to work the milk off – by hand and you're handed

an apron and a spade and a tenner and told rather nicely but firmly to dig everyone's toilet over there and go ahead and have a dark beer or equivalent afterwards

– you'll have earned it, boy. And the froth of blossom snagged in hedgerow and respite restive for alighting a stammering red-breast and I will be soft-struck: a blow of sherbert and this promised turning being. Catkins glad-stifling the gutter so will not be a problem but a reminder and slight-struck pink merry, wandering off hand in your or my at present mouth.

I will love you forever.

New important laws and secrets of the universe will be revealed next week!

– Only in the London *Evening Standard*.

You will have before you
the gasless government motorcade

> (Q) How may we bring him under our observation?
> (A) Bring him to Ohio or NY.

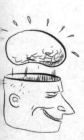

In a week or so, you'll regret ever having begun the
transition to being dead.
Wet-shitting under your breath,
as a big and old man, stripped to the waist,
secateurs off your left forefinger and
you're fucking paying him!
Piece by oddly palid coined blood-piece and the partic-
ulate rung out
minted tang, curving.

Time, in religion, will curious.

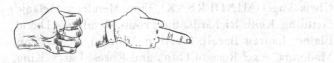

Annette Funicello, Hillary Clinton, Charles Manson, Doris Days, Sirr Ben Kingsley, Willie Nelson, Penny Marshall, Clint Eastwood, Paul Tracey, Brittany Spears, Dario Franchetti, John Walsh, Latoya Jackson, Stephen Harper, Alice Cooper, Ronnie Hawkins, Gordon Litefoot, North Korean President man, Prime Minister of Australia, David something Cameron, Burt Reynolds, David Hasselhoff, Tiger Woods, Hulk Hogan, Mickey Rooney, Pamela Anderson, Shakira, Loretta Lynn, Kirstie Alley, Fidel Castro, Hugo Chavez, President Masharoff, Billy Graham, Jerry Lewis, Kirk Douglas, Michael Douglas, Joanne Woodward, Debbie Reynolds, Barak Obama, Zsa Zsa Gabor, Dick Clark, Ryan Seacrest, Nelson Mandela, Lindsay Lohan, Kanya West, Sean Combs, Nancy Reagan, Dick Cheney, Dick Clark, George Bush Senior, Jimmy Carter, Barbra Bush, Elizabeth Taylor, Larry King, Mick Jagger, Steve Tyler, Elton John, Arnold Swarzenhagger, Doris Day, Pink, Hugh Hefner, Shirley Temple Black, Alex Trebek, French President, Queen Elizabeth, Duke of Edinboro, Prime Minister of England Amy Winehouse, Aretha Franklin, Bob Barker, Karl Lagerfield, Ralph Lauren, David Copperfield, Jackie Stallone, Sylvester Stallone, Chris Angel (MINDFREAK), Tippi Hendren, Melanie Griffiths, Keith Richards, the group Metallica's David Blaine, Lauren Bacall, Marilyn Manson, Sean Penn, Madonna, Axel Rose of Guns and Roses, Larry King, former Prime Minister Tony Blair, Bill Clinton, Howie Mandel, Dog Dwayne Chapman the Bounty Hunter, Miko Brando, Michael Jackson's dad and Catharine Jackson, Carol Channing, Phyllis Diller, Barry Manilowe, George Clooney, Jeremy Irons, Brad Pitt, Prince of Purple Rain, Robin Williams, Michael J. Fox, John Travolta, Woody Allen, Al Pacino, Robert D'Niro,

Jack Nickelsen, Mariska Hargerty, Nicole Ritchie, Royal Prince's Harry and William and the other one, David Letterman, Harry Bellafonte, Bill Crosby, Pamela Anderson Lee, Richard Branson, Jay Leno, Hillary Clinton, Barbara Streisand, Peter Falk, Robert Evans, Ernest Borgnine, Chaz Bono, Bob Barker, Michelle Williams, Heidi Montague, Justin Belieber, Ed Assner, Kreskin, Lady Gagga, etc.

To the enemy, ǁ ᵉⁿʸ
the enemy faith promised, right?
Will not be kept and the captives retained:
one near-death captured, a limb left behind at the point
of betrayal and
the remainder in their lime-green YSL shirts,
untucked as with most nights ending, I suppose.
The remainder damned for being supported by charred
edifice shining, smoking, brittle butt.

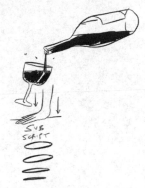

Private revelations
will be foreclosed
in fifty minutes.

Two years before, your shit sort will run the country into
the ground. Right before the entire scathing comes of age.

Due to the advancement of
new-ordained so-called
nano-chemicals:
future cars!

I will not need to be washed as much next year, sorry.

Down the line, millions of urgent, mega-bereaved children will hurl wills wedged inside denuded plastic bottles and at cursed lakes forever choked with same.

A little later, after hours, lining the shore they will be, um, perfectly normally reflexively force-gagging one another with forebears' forefingers – which will come in stiff pairings (snapped off at the love) tightly parcelled in red paisley bandanas that will be, we will understand, browning and sodden with an unchecked gravy of same. Said ramming home will
so said summoning asphyxial
opinions and sadly so soon after our
super-hot bodies disentangled!

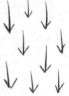

We will find shelter, I promise.
All we have to do is bend and sharpen
the olfactory bits: train them to a canine honing and
healthy moisture for forensic application.
Then we might have a chance against the pack.

There will be thanklessly incubating
as a vulture might an, um, other's egg or a banned playing
card or whatever. We expect a basilisk because reptilian
sexual perturbations and
their fiercely accurate, hypodermic genitals, the contents
of a travel sewing kit we physically understand in these
kinds of atlantic-steeped relations. Cold blood and some
good, thorough scabies while tanning beds and Icke-y
forensic thoughts plough through the green aspect to
Royal-blue-bloodied mattress seepage shit.
That final being the absolute, um, giveaway: dotting the
gravel driveway, catching the moonlight so's we can
process at a respectful distance.

After that five men will not put out the flaming flock of mis-col-
lective noun'd cows who demand their own.
A lossy fugitive will turn loose
same, to murmur false
then help to hard,
meaning they will then abandon the siege in a post-revolutionary
slump. 200,000 years after the fact.

After everything else,
after everything has ground
to an irradiated halt and remains will
terminally flummoxed underground, after your legs
have slowed entirely there will be movement:
A stirring of desiring
gesture from over there in the murk of
and certainly the will to follow gangly tripodal means
not-men, double-jointed, countlessly segmented and
poison-haired and maybe the completely intolerable fear
of the rate of catastrophic natural incident according to
the day-year principal. As yet unnamed phobia.

☞ *Swallow*

Eschatology
will be laughed
out and thin-spread
like non-stop
red ether four hundred
years from now.

Mosaic prophesy of, what, hellspawn?
This evening, I will ache to see you. Shit.
Head of sickness and desperate need
and want and how very sad the world will sage-nod like
chalk cliffs and, obviously, in agreement.
This evening, I will ache to see you, while cooking an egg.
While cooking up a number of eggs, I will think of you
and ache with yearning. While cooking an egg and more
and not just me but hundreds of people cooking up eggs
and, um, billions of people and flat fish with chef's hats
and cats and equine poodles with chef's whites will be
stood tending great pots and pans and terracotta tagines
of eggs and egg-based and the amazing glow and smell
and anticipation of eggy fecundity will make the earth
look like an especially spackled egg
ready to hatch and
I will think of you with such lovingly
I will have to stop cooking the, um, egg and sit down.
'Sweltering' the eggs
which wouldn't be right so I'll stop.
Actually, they will be sort of muddled. The eggs. Saved
thank, um, s'gawd by the metered application of great dol-
lops of own-brand sharp and red ketchup and some nice
honey and milk sourdough toast, buttered, and Matana
Roberts segueing into this and held in sunlight on the
side of, eggs wolfing and yearning and these will be most
evenings or mornings when you and all the chickens are,
as they say, gone or half-eaten by fox.

I will be so tired of;
you will be here, now immanent to the whole tired
embodiment: be prepared the insufficient warning but
seriously: I mean it: Be Prepared for something disem-
bowelling, sort of symbolically, by a sharp prick whose
owner speaks
high and low with no
differentiation because ethics is fucking over, mate –
according to the resetting project that says the opposite
of anything about agency so as to undertowingly state its
own shittiness!
And if we really are going to reset the stapes-, incus-,
malleus- bones to a-cultural Triassic equivalent, then
might I suggest that the thing we choose to keep
~~out~~ of the three be
~~the~~ NHS?
In 40 million
and something something
will occur the literalizing
of absolutely everything. The fingered gap between will
disappear and everything will literally come true.
Not literally but! Every dream, nightmare, fear, wish
– everysinglething for a oneday. And then, literally
everything will lurch into allegory and I will watch and
literally clutch at you.

I will not tame a chimp that same year;
I will not best a policeman with my chappy pair of lips
that year.

A young man will remain
aboard the ship,
stalking crew and passengers alike
with a claw hammer.
We will sunk.

Later, in a club near wat is, words,
exoskelteton'd in alarming scaffold and
canvas banner with club name Club Seal
(open as usual), two things:

> Outside, bouncer
> will fucks someone palms up;
> inside, everyone
> will is dancing and
> walls sweat and the someone's friend,
> twinge right ≠ the unconscious LOVE

At 2
a.m., I will
urgently
sprinting to you,
unrelatedly.

*DON'T
DIE*

*— gloss
refs*

The, um, upshot will be the reassertion of authority and
that will so happen, definitively
over and over. I'm telling you.

Authority will descend from up on
and in that familiar form
of ugly spent cock half
enwrapping a lubed riding crop and reasserting itself
over and over until fully inserted asserted rod, right.

The steel bar will be a surrogate;
the violence will be a deferral, though
no less and so toward a totally
deniable brick wall.

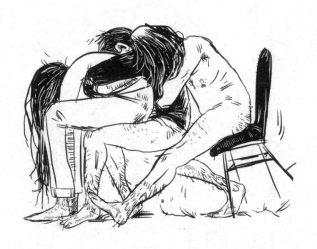

PERFORMANCE CAPTURE

All along here every
Thing wult brown
As apples got bad on the branch.
Meaning that meaning used to be, um,
Until it wasn't:
Until I iced the fucker
In the shed
And with another man.
Over there, prehensile black hairy
Vaulted the horizon at 2 p.m., and then just
Choked-out, basically and
All the plump lip gloss mouths
That guileless rapacious mouthed
Purpling gag at the pubescent pique.
Over there – don't know if you can see –
Tear gas clambered inside the air, literally
So that, um, most
People ended throwing up-chuck the red porridge
Steel-milled guttural.
I don't know if I don't know if you can see that.
I'd have been your representative in the Dumb Crock,
Bobo:
Represent and surrogate
The bod, lashed and wrecked however which-wayed.
Allegorized to some mega-interpellated
You. I took charge:
You just had to get in.
The theme was 'Riot cops';
The mood was paranoid, up along there.
Right over here I spied
A grove of those thin, psoriatic trees
In winter.

–– Talking to myself, mainly,
I'll nevertheless ventriloquize this and self,
Baton passed and I with it I might bust
Or hew self every time I can't cope with
The sheer glut barrelling at me from
All sides: Every time the world drowns
The eventually receding tide reveals another,
Lult by the details of the trauma
– Time-stamped with it –
Details of gait and voice and
Some something lodged
Behind the eyes like a, um, wasp
And, tho, appearance remained identical.
In the beginning, I was raised split sapling,
Sycamore'd, coursed with
It, spasm-weltered prepubescent pre-cum
Amber every time anyone so much as looked at me.
Entombing and en-jewelling other people's desires;
Tiaras or haloes and necklaces of SEPULCHRED
Desires, spunned off every beating being.
So me I well, sported
Desire for recognition
In caramel stones.
Desire for recognition of my
Desire for the recognition of my
Desire. And so on. So on
Splutting inward, thru ritualized masturbatory praxes.
Just
Like that.
And where I am now
The planes simply dropped.
With a sound not unlike the unsound
Blood-rush deafening prior to the bad
Insistent shellfish

Repeating itself.
As in, the sound never pronounced,
Never broadcast but gone off and inside,
As with the Roman candle
On the sofa, next to the dear cat and
Filled blown with the bad bad roe.
And gobbets of identity studded my innards,
Routed entire limbs, whole systems, never
Breaking the surface
But properly strip-mined the interior.
And contacted, UM, phantasmal ludic self
Through brush contact
Touches, shared paddles and suckers and
Molar-pulped white lolly-
gagged stick and spatula lickers
And all the lumpy foam and mount-board weapons.
All of me,
Wholly fingered,
Crowded erotic shimmer
Picked out sunlight dapples:
Conducted by the myriad cores, each some
Split-kindling russet babby, abandoned
More than once
In the woods, with
Well-opened skulls and *quailed*
In bowers of pine LEGS and the
Backyard grass clippings.
Over here
– Not sure you can make it out –
Some maulings
Went on for a couple of months.
Horrible.
Terrible, it was.
After which the remainder last brown

Down, of course
So that by spring, gravity and the appearance
Of a few thousand drawings
Of the same kid's face, was enough
To make dad cry from errrrm.
Then right there
It just all
Opened and at once and one day,
Disgorged the really wet bits and
Seeing this I tried to bundle them back in
With my kiddie hands. In the wrong order,
Surely. I wasn't thinking.
Ended up coughing up similarly
And for inhalation drool-wiped
On those long pretty lawns over there. Gas
Accessing-all-areas.
Or bunkered skunk, smack-weltered
And behind-the-scenes.
All before the absolutely peopled estates
Got razed.
Analgesic anticoagulant Olbas
Shame beneath bedclothes, like
Ortolan-scoffing dignitaries:
Those hooded caverns
Of genital vapour rub and the slimed
Walls the dreamed
Blue dreamed meant
Of those maffled voices
From another floor up
Adulted and drunk voices
Plotted the groany map,
Visible hot *breathed* and billed and
Cooed and by the asphyxial
Brown Carpet & Rug.

Something about cannibalism, infanticide,
Something something something.
Something about labour and something about
Regret.
Something about the 'gotten rid of the kids'
By maybe just eating them. Drunk the liquid
Um, parts from inside the kids.
Slurping the liquid parts
Depleted hide.
And that purred cabal hummed
Thru the wall the dad's sub-bass,
Asif the flat were a
Big grey skull-flat and I were, like,
A milk canine tooth hot in pink/grey gum
Bed and THEY were, like,
Not actually part of that skull-flat
And more like a totally blown sound system
In a grim new club or
Just the unlikely hair
Or the sound penetrating the skull, made it shake
Loose the inner ear hairs
Were crimped or ceramically heated and
Straightened woofer.
Made straight, is what I mean.
And it did and yanked straight
And I did, H, even if loosened and dropped.
As the tooth in the scene, in the little grey skull house,
Strangled in baby blue
Fleeced, mini depression the figured
A-swipe blue room
Of the bits that affirmed the bio. Like,
Squeeze here and push and crack
Another one out.
Whatever fleeting unlimited sensation yanked,

Grounded the flights of fancy.
Usually I wore blues and ate only and blew
Seldom the cocks, thanks. There were scant ways
Of blue past
Midnight velour, crushed back-rub blue bled
The sky for chilly romancing under the sky.
I saw my breath, then,
Like an adult doesn't
– As if I were alive and any warmer than a, um,
American fridge, Bobo.
What the fuck
I was given to work with
Was inclusive of both the lexicon AND the gross
Mouth and the citations
And at the bottom:
The sense. The requisite of sense
The point. Sense and the point
The stake, figures,
Driven into the soil or
My heaving chest?
– Oil or the thinner
And way more important red liquid and concomitant
Ruddy and green and mauve
Sunset mush
Inside of all the animals that really did dream.
Behind the scene of skin, fur.
– The point is incisive,
Is an incision made in the buff, furry bud
Sawn by children, frosting in the sun,
Penetrated and mortal-risked the integrity
Of the downy pussy willow
Cheek that chortled soft
At everyone's idealized childhood
Wished weren't.

More often than not followed the ropping,
– Even if nothing more nor less important
Than the puckery hem of one or two ORIFI
In my terrific and well-hot buff-bod.
Or the compromising of my child-baring
Hips, the variegating of my somewhat, um,
Municipal thighs,
The varicose doodles,
The rendering of my bandy and psychic limbs.
And that the hair should have remained on my head
As a sex sign: a headlamp beacon, on
And depilated the fuck off every other bit of what
That thing was. Or tight
And shaven childhood reclamation yard:
Clock-sprung pubes & diapered logs;
Evacuated or something else'd animals;
Vast antique dolls with the vast
Clapping eyelids opened at the swoon.
And the baize-haired action figures,
All opposable limbs, hands set
In gestural rictal perished rubber
Gripped nasty little metal weapons
Or the, um, camo-throats, hunted;
Ranges of complexion,
Bump-mapped and trod-in
Adult jelly shoes and the litter
Coated, hid excess, the wasted out of sight
Was literally out of your fucking mind.
Wasted bodies like waste
In the Arabian or wherever
Desert or wherever, literally.
Ignorance was a mystical state where
Everyone praised the reveal.
Behind the scenes I unthinking

Keyed in utterly
Wrong search terms. Words
Sprung like absurd flash-bang stunner
Shunts to totally eclipse the intended.
Tic-writing, the deleting also part of the rhythm
That asserted itself all the way from lunatic
Providence to lodge asif perverse mantra
To be rehearsed, typed and deleted, over and over.
And
Did you mean [...]
Each time the typing really
Properly bent to find the right, um, type of, etc.
– The search
Term, the, um, thing
I had wanted, somehow,
Once, moments ago –
Only to have massively mislaid the
Thing someplace behind
That fresh belch
OTHER seared vivid and useless term
Which kept appearing at the fore,
Blinding and totally screaming and, um,
Dumbfounding
Everything and totally in the
Stead of the, um, thing I had seemingly gone
In search and of.
So I would submit to it. Of course.
The New Nonsense.
Irrupting within.
Same in speaking: I'd submit to the verbal
Slip.
Repeat it, even – underwrite its burl
In echo – and the tongued
Parody to the void

406

To void it and insisting
Popped the cheap cranial lock
With my comedy plastic purple pry,
Welcoming its busted.
Like a disappeared spouse
Returned deranged
On October 9, around 7, 7.30. Remember?
And in the same clothes as when they disappeared,
Some ten years before.
Standing opposite one another
On the landing,
Weltering up with the class-A's,
Beading honey, lactic tears, wetter than
'Beading', I would have thought.
I suppose I just didn't like truth
To require a flaying with 'billy' hands & SKINNER.
Just what sort of abject truth lies in that rubbed
Brown viscera? There was no riposte
When you were properly dead, Jenny. Or ahead
In the throes, Jen.
And what kind of understanding
Hung out in a boring
Gathered round fresh kill
With younger kids?
What's the matter
If I remove your face? – bear with me –
If I deconstruct the seemed? and case
Skun asif a gelatinous tube sock?
Or theatrical tights green room backstage?
And here comes the riot of constant corpsing
Broke the fourth wall with nothing but your head
And that *face!*
And the amazingly accurate hands, fingers
– Every jointed

– The, um, cuts were as vernacular
As different fish names between countries,
Pilchards and sardines, classless still;
Cusses or
Petnames, Dolly.
Save for rump.
Rather than cow or pig, beef and pork:
Figuration was a contingent means of
The held arm's-length,
The front hock's-length
Stewed on the back-burner,
Gentle simmer, tempered with
Absolutely everything soluble from the cupboards
IF simply to ameliorate the dear piggie arm and also
Bring out the fucking truth of the pork, reveal
Very simple, um, pig cooking.
Very little needed doing to piggie
To brung it out of its life.
Organic, hand-reared and locally sourced
From a poisoned grey well in Salford.
Or a pub cellar
The humble pie, and I was mining for flesh
Beneath whatever good, honest crust
Clot down the well and up at the neon and
High intensity discharge lamps,
We started, um,
Poking, a few years in
With poddy digits the dark finger of land
I used to
Dump on.
Yesterday,
Masked face the slob & slobbering
For sane reasons
Of the complexion,

Erupting with the old 'oiled braille',
Hazing words together runk surface kissy
At the touch as I desperately
Wanted to be slupped
But was cajoled into arid mimeo, head-cheese
STRIPLING bureaucracy manifested
With the heat, flushed dastardly mirage
The machine searing of toner on baby-pink paper
Or a roll of receipt and carbon loss in direct sunlight.
– And then later,
Behind that, um, thing over there
When the power finally went off
For good.
As in, pink and blue mean
Nothing at all & neither the penis
(*SMACK*) 'It's a BOY!'
Was the first thing I knew for certain
Had been assigned to me and unbeknownst to my
Sense of certainty. The lodestone: the first
Of many screamed sentence structures
The scaffold of literal constitution, literally:
I am made for
Assignments undertaken in the name of,
Um, what
Military King
In civvie-fatigues or blue-collared and country-club
All others having been eradicated
By the pre-extort
Wolfed down quick slim metabolism
The wiry corporate cur
I really worked for, the job
Basically just picking off the badgers,
Laughing over
Simple, Original, Traditional dinners, locally sourced

Blood and soil policies
Delivered no speeches
In terror silence and not too late but
Great!
Thank you sooo much.
The big house that STOOD
On the hill over there
Got squatted
Unlike illicit home
But like the fecund craps.
– So like illicit home for the gamey
Excluded; a place to grew
Fresh NICE Anya potatoes, runner
Beans was all. And loads of flowers.
Love lies bleeding,
Love-in-a-mist,
Masterwort,
Flame lilly,
Baby's breath,
Sweet pea,
Sweet sultan,
Sweet William,
Spurge,
Yarrow.
Later: purple flowering gun butt appeared
Narcissus of government initiatives;
A vision above the forest that STOOD
Over there.
About the same time as the
Free Trade Hall in Manchester
Became a bayou spa
For rubber-rung and bobbing five star
Businessmen –
The finite Edwardian excess

Performed before the 1980s were over,
Tho there was no need
And tho no
One had told absolutely anyone at all
So no one gave a flying shit, apparently –
No one that counted.
Especially the staff who just went about
Changing the bedclothes
Into young meadows around the bodies
As per – rolling
The bodies off parts of the bedclothes
To retrieve the bedclothes
– Soiled unusual by acrid yellow seep and hanks
Of stuff come away, stuck to the bedclothes
By the death-purged consommé and set,
Um, frothy skin looks utterly convincing:
Clean white bedcloth a sanitized cheesecloth
Shroud.
And just, um, cycling the miniature shampoos,
Cotton buds, sewing kit,
Week on week,
Month on month,
Unused, all of it.
So labour undertaken there
And not there
And Sisyphean-blinkered,
The boulder a body in bloat, literally
And figured as opposed to literalized.
Sky news is on again,
Mute in the corner of every room:
Scenes of empty studios,
Cutting between abandoned weather background
Weird nation shape, vacant desk;
Rolling ticker perforated by ellipses.

So I, um, always would and majorly
Flunked the tests of fessed
Excitations, didn't I.
I ended up, etc.
Oh God.
Tho I just about managed to turn
The voice right up
And emphasize that, before the proper lockered
Performance
With the darling yearling
Sprouting rub, talc tact
Leftover and artfully
Thwacked the super-seductive ones
With a wound-up towel tho
I didn't want to.
Sadly, I was
Um, chlorinated in advance
And stunted
So that the demands for sexuation, etc.
Were the demands for
Submission: capitulation to the apparent
Universal
Were universal
– It was just that the men got to capitulate
With their top on and standing up.
Men and white WERE the universal, the truth, the
Flatline-baseline bedrock bollocks
In chalk to even write – was the condition
Of 'nature' – upon which
Difference might have been even
Teetering built and in a kind of wax.
Or something, tho NO onus
On proof for the white men: nothing to defend,
Of course.

– The very condition of nothing, of the before,
Delimited by and for, etc.
The very precondition of the shrug,
The condition of the well and not-minding,
Of simply the getting-on,
The breathing,
The inviolable, the existence of inviolability;
The very condition of
The very capacity for reset
& The boner always restored the head
– The what restored to, the ground
– The very groud –
And the precondition third-person was
ALWAYS a white man
And was the fucking law
Itself:
TOTAL POLICING precept as anything other than
Utterly fucking vile.
The other province of
Errata – the place of the
Everysingleday
Pleading and the asterisk
Pleading and
Women: the vast taxonomic wing
Nevertheless overburdened
With everyone else and under there
With women.
The burden of proof was
On women:
The massive and culpable
Invitation, spread-eagled and beginning:
An image of unconscionable
Violence, perpetually reinserted
Like a white-hot demand.

Meanwhile: Somewhere over
That weird bluff over there,
THE POLICE
Held on to their
Make-no-boners-about-, um,-it,
Like simple porn:
A metal cannon for hosing people
Off the city's twitching flank
During The Twelfth Plague.
At best, dicking out
The iris nebula, as I said before:
A real achievement
To literally blind someone
Blue-eyed.
Behind the scenes:
Back wall covered with pink foil
Or something. Drugs, actually
Brewed or whatever
There, behind the scenes
The vaporizer or
Was a dehumidifier or ionizer?
– Pumping and knocking
All the dreck from the air so we didn't have to
Breathe history.
Facts lie
In wait behind the scenes and
Thank God! We could finally be
Rip-divulged, hardcore-forensic-rendered
Agape and whistling phew! Or it could finally be
Torn-divulged and for what it was
Rather than is: a kind of material nostaligia
Determinedly reverting
Lives to some prior kind of life.
A kind of conservatism or

414

Nimbyism that required essentialism –
A striptease to arouse not-a-one no fucking one
Save David Cameron,
Who returned in the autumn of the year 3201 as
A cheeky, poorly darned comedy sock-puppet
Embroidered with *Esto Perpetua* and only
Worked on the floor
And without any arm right up it.
Which what we all had a good larf about,
Then went sudden quiet, then
Sobbed and howled and wailed because
David Cameron had RETURNED and
Satire had just died and we were all feeling incredibly
Sad.
Sadness, Dolly.
– I looked more than a little like
David Cameron don't I
– which said nothing, really.
Appearance applied edge-of-trowel, and not bloomed.
I was becoming increasingly, um,
FORGETFUL.
Specifically faces:
Mine and MPs and
Bastards.
– It may have once been a good idea to talk
To my GP about early signs of dementia.
If I'd had a GP.
As I got older, I, um, found that, um, memory
Loss became an,
Um, problem.
Memory was affected by age and
Stress, tiredness and
Certain illnesses and the
Medications addressing said

– All of which I had
Submitted to.
It got annoying when it was occasional, but once it
WAS affecting my daily life and was worrying
ME or someone I knew, I should have sought
Help from my GP
If I'd had a, um, GP, mum.
The, um,
Dementia was a *well*
Common condition that affected something
Like a billion people in the Britain.
My specific rank risk of developing
Dementia photochemically, increased as I got older and
Dementia was a syndrome that you would
Associate with an ongoing
Decline of The Brain
In the third aeon and its
Abilities in the fourth.
This, for me, included problems
With: Memory
Loss,
Thinking speed the speed of,
Mental agile,
Language,
Understanding Judgment.
– I became apathetic,
Uninterested in my usual activities, and had
Problems controlling
My emotions. I also found social situations
Challenging; lost interest in socializing
Beyond animals,
And so the Pathetic Fallacy aspects of
My personality changed.
Addled by toxomoplasmosis made the cat alluring

416

– But only so she could eat me
And the parasites could flourish.
I love the cat.
Anyways: Me-with-dementia lost
Empathy and I may have seen or heard things
That other, um,
People did not.
– Or I may have made false claims or, um,
Statements, such as not like lies for wishes.
The swap, I mean: lies for wishes.
'I built this life', for instance.
And as dementia affected my mental
Abilities, I found planning and organizing really
Really.
Maintaining my independence
Also became a problem.
I often needed the help from whatever
Friends or relatives were still
Barely alive including the help
Who helped with decision-making from a really really
Sick sibling.
My GP would have discussed the possible
Causes of memory loss with my – if I had
Had a GP and including dementia.
They would have relayed the
Other symptoms could have included:
Increased difficulties with tasks and activities, crafts
That require concentration and planning,
Depression,
Changes in personality and mood,
Periods of mental confusion,
Difficulty finding the right words to, too.
Along with most STYLES
Of dementia, mine couldn't be

– But if it had been early there would have
Been ways I could've
Slowed
And maintained the mental.
 Read more about the symptoms of dementia.
 Why is it important to get a diagnosis?
 Click here to donate blood,
 Too.
If we used to consider language a technology,
Then all the logorrhoeic THIS
Simply shored it all up and, um, also
Coated it with that black anti-climb paint we'd all
HEARD SO MUCH ABOUT and also
Filled in every single air hole, stifled the life out.
Horror vacuui congested again
The possibilities
Inaugurated in a kiss. As in, breath
Impractical but
A communication of erotic
Blew with
No blow, importantly.
So submission to what
For the various MEN? Eventually fell
Into global rank and filed off
the edge or just did
Shut up for a few millennia.
Or did shuffled off that mortal etc.
Or boarded loads of little dinghies
Over there, right, and just left
Or whatever.
Just fuck off.
Behind the scenes: Andy Serkis.
Andy Serkis, scuttling about in emerald spandex and
Covered in a kind of digital measles. The crew keeping

Their distance.
A bathing cap and histrionics are the only tools Andy
Serkis needs as he leaps about polystyrene Mordor, or
Waddles through virtual Coconino – with the thrilling
Energy of a man utterly devoted to his craft.
Andy Serkis. Trained in Meisner and Method,
Grotowski's 'poor theatre', Artaud's assaults.
Techniques trailing The Authentic like lousy carica-
tures, anachronisms and ironies.
As it seemed to pioneering Performance Capture actor
Andy Serkis.
Later:
Wrestling Elijah Wood and, err, Sean Astin,
Or, um, James Franco, lovingly, along here.
Or, um, Jamie Bell similarly rigged –
Or, um, Naomi Thingy, the humans
And on a different scale.
Pathos was the only revelation
To materialize
Behind the scenes. Through that curtain there,
Behind the scenes.
Knowledge was punted further out
Of touch, fucker
– Vanished by the shitty draw-distance and
The poignant personage
Of a post- and denuded
Andy Serkis. Somewhere near this bit here.
And also the vast quantities of the dazzling
Green dollar
Green screen celebrant of this economy
Being the sure thing –
Monies on money
Turning avocado, to the oxide
Of chromium, a kind of *terre verte*,

Lurching to phthalocyanine green
Yellow shade or phtholocyanine green lake;
Viridian of the bright green lake
Bloomed algae once a decade,
And the permanent green light – the green ray –
Inducted
Permanent sap and deep cobalt green silent wood,
Shade, vom, wipe, growp.
Thru there, behind the scenes, an exemplary
Revelation is attempted convincing performed and,
As ever, of course,
An IDEOLOGICAL GRIFT
Executed instead,
To placate the faith and the entire
Sensible.
– I literally wanted to be struck dumb
With understanding.
Literally.
I wanted to fucking see
And for that sight to be
The condition
Of truth. Bullshit.
Literally, I wanted
Immanence & The Spectacle
Of divine peach sunlight-focusing
Ochre the faltering soft-capped
And knowledge
And O! The agency and
Even wishing
For that wink to be
Heartfelt, collaborative and in our secret
Lover's accord
– Or to simply mean the pleasurable if temporary
Suspension of disbelief.

– I really didn't want my own
Rort thurst and distraction to be captivated
Aphonic!
– I didn't want to be rendered, Mum.
And all the way back to inside
My own head! Circuitous, like.
This here, then, the extraordinary rendition
Of self
To selfish
– Mollified and scrubbed –
Blasé so that sight would be the condition
Of truth,
And the precondition of
All mortal quiddity –
DIS-APPEARANCE
IS REDACTION.
And this aligned so perfectly with the render
Over there.
Instead of the bloody blubbery
Livestock breadbasket your invisible aspects
– The Politics & The Loves –
Get levelled by spectacular empirical
Hegemony.
– Rendering the captured individual
Brutalizes Nuance and
Vitalizes representation.
– Rendering annuls
Individual
For the infinite refinement of
Appearance.
Your whatever-name is precisely as
Unimportant as your history, your pay, your health,
Codified in your mysterious body, writ
Complicated writhing bingy, brown or black

For lack
Of day, wrenched.
And I could have been your haruspex, sexy:
I could have read omens in your extricated liver. If I'd
been allowed.
I could have maybe ascertained
The surgically thin
Gap between mortal-inevitable capitulation
To representation,
And the wilful-lifelong pursuit
By choice and force.
But whatever.
– Keep your sodding liver.
The fast flyblown, um, obsolete
As Breville or, better, butter
Or complex carbs that tyre-up the
Cross-trained frame & tummy.
Spot-healing clone-stamp the eyedropper
To ensure the facial recognition.
The disabuse is the Merrick to
NO FACE DETECTED.
Did you mean
To break the tech with your face?
Dodge, burn and
Sponge, asshole –
Then come back to me, my love.
This shit costs an absolute fortune
And we are merely sponsees.
Usually this shit is the sole prevail of Hollywood.
Usually this crap is the sole prevail of Andy Serkis.
Your face determines that the trampling'll be
Heavier, the rendering
Slower, more ponderous, less detail, more
Cleanup

As the farm tries to, um, DESCRY arse
From elbow and wringer right thru them
Anyways.
Shagged-out useless with the shittier
Knowledge and intolerably
Pressurized as-such at the Stygian,
To the point where, in the scene, a metal
Bolt pops out of the submarine, um, wall (?) and
Slams into some poor
German's sweaty arm with the force of a
Really bullet.
Or the scene where cava
Bottles are shook-primed makeshift guns.
Under there. The hold.
Or the bit where Russian roulette is
Played and the comedian says something about
Revels – the chocolates – and there's a smattering
Of laughter, though definitely not enough to
Raise the spirits or the weighty
Bods tarrying on their backs
Over there.
Guns that were not loaded with tar and the more
Vicious
Were buried by a snowdrift over there.
This was the place, P.
This whole bit was used.
This whole bit was overused.
This whole bit was expurgated.
This whole bit all along here was redacted
By a big aeroplane.
Or this whole bit right along here was found to be
Unintelligible, useless & pissy:
Got redacted at the big gunpoint.
– Not redacted, simply forgotten & useless.

Or this whole bit along here precisely affirmed useless
& of
Massive value,
So gotten recouped already?
Yes and fucking wolfed.
In the corner of your eye
– Don't know if you can make it out –
Everything was sawn misandrist lens, S.
A vision
Visible to disappear the men inclusive & entire.
Every inch of what we used to call MEN,
Nudged surreptitious into a barrel of ancient brown
Semen. Muted splashing & bawl
Sounds like
The soundtrack
To your well-gratted
Life, E.
Magic words were entirely
The burlesque of the dull ones.
So previously, the eucharist got done,
Parodied, up-camped to some gorgeous,
Spangled & diaphanous
Spell, cast for agency – a sigil
'Hocus Pocus' for 'Hoc est corpus
Meum', scoffed my own body gibberish, magic words
Expressly for my reappearance
And in a puff of theatrical smoke.
That, then, was my amazing body
And I wanted to have it back as I remembered it.
So perversed the transubstantive with some
Neat a-moves to demystify:
To re-render the rich cakes, the booze,
The stronger bread & dark beers, Bobo – to rouse
My body, to

424

Re-conjure its myceleum pleasures and accordingly
Did, among moon and stars and other celestial
Ideas, stuck over the
Beautiful blue gown.
Was a way of satirizing the lot, I reckoned.
As in, when I ate the wafer and, um,
Drunk the wine, did it taste like blood and raw?
– No. Literality is as prone to misuse as figuration, Y.
But Y, could you get drank off blood?
– No. Jesus's blood had no alcohol in it
I don't think.
And
Did you mean?
'It's never failed me yet'.
And also, right,
Was God some kind of wafer?
Was that cracker The very Christ?
If arsenic or other
Poison
Were added to the wine before the, um,
Mass, would it have still been the blood after
The, you know, elevation of the, um,
Host?
And then there was the tiny amount of
Spider and insect
In all wine which just got in it
From the earth
With legs.
– Was that bug juice verily and truly the Blood of
Christ?
Finally,
If a mouse had gotten behind the altar
And ate the wafer-host
Would the resulting mouse droppings have been

God?
Should the priest then go about and
Eat them?
This HAS happened, so it is a serious question.
Right here, metaphor became the real thing
And was held
In material abeyance
As a consequence:
Cause and effect routed the blurt,
As it were.
Hocus Pocus! That thing of
The leg becoming more
'Leg', becoming,
As it got sorer.
BTW
Some of us congregated here. In size order.
Tried to 'line up the harpoon', as they say,
To try to finish the game before bed and otherwise.
I'd've really loved to be able
To retrieve all the pretty human bodies
From the mire of figuration.
A plea made for re-embodiment, Lauren.
Active materialism in perverse relation
To what you, um, tended to think of as
The mystifying effects
Of that so-called digital life;
A corporealism to affirm
Experience against process
– Finitude against the fucking pseudo-infinite;
Proper magic against illusion
– And against ignorance a kind of sensitivity,
Like the sweetheart fruiting body in the wood,
Underwriting the very floor with an Edible & Vamped
Alacrity.

Human bodies and, um, certainly the animal,
Bodies were the first to be spirited away
From their innate contiguousness with the ANIMA
That ANIMATED them
At the insidious metaphoric & demonic
Behest of some shitty ideological consensus
That saves its most virulent, illy shits
To dump right inside the language.
With hushed magic word,
Or the laying on of hands AGAIN,
Fingers the tact-grope & grooming
Warty fingerpoints
And the sweat-sparged, um,
Grip, the swiped Christ gesture
Or the Queen's own alloy sword, staid
From decapitation by royal decree and
Octogenarian decrepitude – blunted by the
Cutting of ribbons outside
Museums, then blunted
In the beatifying of
Slebs: the fountainheaded-inductable...
– And with that
A thousand lovely, mysterious other
Bodies were disappeared
– And corporeal indices were figuratively
Wiped from
All those
Black glass façades and aluminum unibodies
And forgetting, um, losing the line, literally.
And this, um, was another
Perversion of the transubstantive
– A concealing of the declarative hocus:
This, here, is really honestly NOT my body,
My body is precisely NOT here.

And we could say, rather,
That THEIR bodies are precisely not HERE,
Where the 'they' are poor, notwhitenough,
Demonized, disempowered wholesale.
And where secularity might have once
Uncoupled bodily sovereignty from
Christian mysticism,
Relations of that digi-cadenced life
Were RADICALLY re-mystified –
Re-abstracted to a point where bodies seemed
So often to just, um,
Not be there.
Not here.
– Or a ghost in parallel,
Cellophane of shudder, dread wave
Where we lived the living death; a point beyond the
Means and the love and certainly the sketchy arms
Proffered eerie Karloff cuddle, but
The scoop and grisly trudge of
Contracted JCB & yellow & black sans
The legal aid.
A huge moth literally pinballed about the kitchen that
night:
Meanwhile, somewhere in the Mediterranean,
A couple thousand lives
Just got oceanically pwned in the deep drink.
It often felt to me like my, um, body
– Its potential to pronounce itself, to perform and
Embody the possessive singular,
In all its abjectly encumbered ways
– Is not 'this', cannot, surely, be sited
Unto itself.
This, I suppose, might have once been seen as
PRODUCTIVE.

More often than not I wanted bodies rendered
Properly alien
In order to retrieve them,
Welcome them again,
Perform a kind of esoteric
Grace and in a manner sufficient
To dramatically, explicitly re-manifest them,
De-mediate them from whatever excessively
Spurned state
I'd sent them.
So rather than calling it the, um,
'Cloud'
We recited whopping tomes
Of info and with maps, schematics and
The whole sweep
– A novelization of the network
In forensically shaded figuration:
Every molecular, aluminium-scented warm
Breath exhalation chronicled.
So rather than 'wireless' we would say:
'Over there are the wires
In that massive tangle of wires
Over there.'
Or, 'Over there is the terrible skein of
Chuquicamata thins
To stop or incite the world.
Or the whole cul-de-sac deveined
Like that prawn cocktail
Copper and fibre optics
Was for up cutey bondage-black & rubber
Serpentine garroting stash steeped in the pallid
Torrent of
Porn, diverted by a gang of dead-straight canvassing
Men, slowly, to reach the not the licit, um,

Assault and the unambitious answer
To the demand
The supplying apologist
Anonymous skulk, C. Darkened
Living in sort-of abandoned cul-de-sac –
– Abandoned but full of people
Who are living in there without
Classification as homeless,
Classification as humans, citizens.
Again, and worth reiterating,
Citizenry can very much go to hell, where
I might have presumed you should have
HOUSED your mind and despaired not, M.
– The reiterative as important is totally,
Important, despair NOT.
In that hall over there (*)
Faces and anuses
Got cosmetically bleached
Using something like horse or pig, um,
Bile or vom. Or pigs were coerced
Into vomming on people's really really GLAD faces
In this room
And for the hard cash, for the readies
Or credit, 'course.
Remember that scene with everyone lying
Under vomiting pigs in this very room,
Handled rough,
Accompanied by, um, the
Raindrop Prelude?
Shit! *Sooo* good!
Or in this room, like that one,
The police burst
And aimed squarely at the face again,
Targeting reticule locus of the people's

Sensible for chemical peel.
Or in this room some men clamped crocodile
Clips to bits of the body that I felt were [...]
Then made those bits feel more like [...],
Etc.
– All the while acid-washed jeans were fished out
Of the hulking vat over there and hoiked
Onto pigs' hindquarters.
Piggies paraded about like fetishes or, um, nothing
So much as a SOLDIERED, topless Guy.
For sacrificial purposes and the cash,
We sacrificed pigs all the time.
Better him than me.
And sometime over there, under the boughs of a
Proud English oak,
We meted out justice on sad brown piggies
For adjourned guilt or something.
Dispensed and all the while from behind
Our freshly excoriated faces.
– I did a sort of live Instagram thing of it, Stella.
I did a load of Vine things of it.
Shared the fuck out of it.
A better analogy would have been to be
Precisely out of reach of the being knowable:
Tucked in and down
With the marrow, as they said,
But, um, not with the marrow at the core
Or only if the marrow formed around
Everything else
Alike, like a fawn aspic.
Or if marrow were a grammatical device
Or a literary mode,
A tropic aspic, aspicking or suspending
Somehow

The disbelief of a kind of irony
For warding off the dialectic.
Suspended inside: Satsuma segments and
Very readable unfurled
Poor fortunes from crummy cookies and bits
Of police paraphernalia:
Badge, gun, Twinkie,
Black gaffer, cable ties, rubber bullets,
That there body armour, mo-capping
Some of your stationery, some of your
Hair scrunchies,
Fragments of that larger meteorite
That extincted the dinosaurs.
All along here grewed the
Blusher wild roses.
Mums' garden for mums,
Upkept and schtum for the
Dad's inspirations, pseudo-struggled
Honeysuckle & suffocated but actually apparently
The fertilizer
Hosed standing.
And so scent was the herald,
Musk damsel pheromonal non-abeyance
– Though tried to be contra to Biological
Determinism, which
Got harder rather than easier,
In spite THO because of some resurgent
Empirical drive
At the wall, all true and orange and well built
Of *Men's Health* sex tips
How to extrude the correct bits,
Curtail the wronged bits,
Harden the rocks and be rock entire
To stove whatever head needs

Fucking stoving.
Neurological addenda to the psychoanalytic
Skewed by the grey grey cells themselves,
Phrenological neuro-eugenic
Blathers to compound
The difference in a member's club of same-same
But different matte plaster ghouls
– Like me, only more so.
And me too! Corroborative exception
To prove the rule of
Your mustachioed pappy, heavy cudgel
That babby, raised by humans.
And this bit spackled with irises and
Tiny white ones.
Edelweiss, Iris.
And peonies grewed in the hurt
And wound the blossomest apple-blossom
Frothed wild! from the rabid pleasures, thrashed
The ancient bed, clothed
And the awareness of a smile
Beneath the kiss,
A sense of teeth needing baring or grinding or
Clenching
For the grin,
Like a decommissioned rose, clasped
Between teeth
Like your tested rump.
GAWD!
Just over here,
Bowered before it all begun, we held
And without recording it,
For starters.
Tho at the lock-jut jaw, pooling
At what was now

433

Less the 'mouth' of a river and more a, um,
Browned duct enjoined
And pro-steel-tapped by the blues
And reds, piping plumes of the multicoloured
Smoked out the barrel-aged and fining'd
Liquids
That gurgled and black-reeked from
Rock of sorrows or pleasures or ages.
Or excessive sensate, asif the sensate
Was forced in and out by the out
– Like being *outed*
Tears and the blood forcibly
Outed, chemically, ideologically
Fracked tears and it was ok
To cry except when it really totally wasn't.
A huge, fragrant bush
Of rosemary girding sage
Shot up here, literally
Rending the tarmac.
Gunpowder residue evidencing shot;
Petrol rained-bowed asphalt were
Some vehicle or maybe a chain
Sawed or similar; single strands of
Hair, caught on the grate,
Trapped in the gate.
Over here I sawed one of those huge
Caterpillar-treaded
Machines for gouging tracts
Of petered tarmac.
Just there: slouched Yeatsian along,
Nothing following.
Or that over here I saw one of those huge
Caterpillar-treaded
Machines for shutting down

Protesters the fuck up,
And disintegrating houses and lives
Similarly.
I saw one of those huge
Caterpillar-treaded machines for the boom;
Over there, the penetrated and busted
Lives unlived themselves
In a flash-gunned twinkling
Of an eye at the child
Melting point.
Okay: You can just go ahead and tug
The chicken wire armature
From the flames and proceed
With the insertion thru keyhole groin
Rip up that artery there and basically just cauterize
The spastic bits off your timorous heart.
I used to be something else
And other than that
Until I wasn't. Until I got compacted
TEH poor rendering.
Poorly rendered lower the res. and always
The teasing
That basal cell-shaded porch where representation
Cleaved to, um, death, lurked
Under the flaked sill in the cool evening
Blue and awaited pie to cool in the evening blue, etc.
In and of, etc.
The promise of fragged meat and other
Mechanically retrieved misc. pie.
Just over here
Representation was an iteration
Of understanding:
'Getting it' basically akin to being able to draw
A really good horse or being properly good

At doing hands
Or doing a Disney or a Marvel
Super-well or really
Just perfecting the horse, really
Getting good at those backward knee joint bits,
Getting the feathery
Crosshatching around the face-bone bits
Convincing every time.
Platting the mane, maybe –
Crimping the swoshy tail, maybe.
The name of the horse on an antique sort of
Unfurled vellum
Scroll under the mid-trot legs,
In a crumpled-looking gothic type:
'Brambles' or 'Mr. Hooves' or 'Lady' or
'The Long Face'.
And under there right there,
I buried
Some sort of time capsule
Filled with the incredibly perishable, quiet things
Those things that need air, light, love.
A box of little children, eggs, lettuce.
So just went about drawing 'Mr. Hooves'
On everything.
Every card, every book, every day
On the left hand and crappy
With the sickly stink pink biro.
– Till everyone was totally sick of Mr. Hooves
And his perfectible, hard pencil
Pale lack on white ground,
Rider-less, poorly christened and with
You knew, the stinky.
I got it, alright:
The horse looked correct-ish, well-enough

Rendered
To summon the mincer that, um,
Upcycled the fouled animal pants, animals
Splurged into more or less stable, value-added stuff
Like the dash & the surfaces.
Any of that heavy processing of, um,
Animals into more useful stuff.
So full-on render farm or the
Domestic, kitchen scale, or
– Mr. Hooves –
Boiled down and
Screamed: a thickened, tacky reduction
To value-added something at least.
Perhaps some mucilage stuck spritz
To inhale the black carrier bag, lung
Vignetting behind the village pub with
The paltry slack simperers and Julia,
Who was prone right along here ––
– Right along here.
Mr. Hooves was shoved, then, right
At the slaughterhouse
Accompanied by the turned
Restaurant grease-rupple & mank
Butcher trimmings – shavings & brash –
The doubly expired orange-frayed meat
From that Sainsbury's.
The saddener cadavers
Of the euthanized and other sorts
Of assassinated animals from animal
Shelters, zoos and vets. The body gleaned
Could categorically include the fatty tissue,
ALL OF THE BONES,
The awful offal, also entire carcasses
Of those condemned,

Those that have crossed the great divide
And on farms, in transit, as a consequence
Of my dumbfuck, etc.
The most common meat source was my pets.
The rendering simultaneously dried the,
Um, material, Boo
– Separated the fat from the bone and the protein.
A rendering
Process yielded a fat commodity
(Yellow grease, choice white grease, bleachable
Fancy tallow, etc.)
And a protein MEAL (meat and bone meal,
Poultry by-product meal, etc.).
Rendering plants handle
Other materials, such as slaughterhouse
Thick blood, feathers and
Rear end hair, but do so using processes
Distinct from true rendering, which is concerned with,
Predominantly, the look
Of love: my darling sun-freckles, my moles,
That downy whatever coat, teeth from afar,
And the particulars of my singular,
Singular voice.
The occupation of renderer,
Ripper, reconstituting mechanical steel retriever,
Has been deemed one of the 'dirtiest jobs'.
Which is why I took the position.
Eating made me paranoid. And fat, of course.
Or rather, I was a paranoiac eater.
Or rather, I ate things and was paranoid,
Unrelatedly.
An inflected biscuit.
The fucking kale, etc.
I wolfed paranoiac, fatted

With unsolicited advice and the
Trans animal fats and whatever
Those secret fats are called.
Saturated something something.
Or I know that I wasn't supposed to
Eat barely at all, and tho I was so
Very EATEN
By paranoia, trans.
As in, the transference of paranoia was
Not at all osmotic,
Insofar as my concentration was
Not to be counted on,
Nor was the source of the paranoia palpably
More nor less
Paranoiac. As in, paranoia
Circumvented consequence,
Right? Paranoia's contingency was opaque, forever.
And I couldn't nor never recall a time
When I wasn't totally aware of my insufficiency
And how insatiable that lack is.
Or rather, how temporary was its sating
– How, um, immortal were its sating.
Accordingly, this form: this is the
Consensus.
Not just of body but of image, of function,
Culture, tone.
Of sex, size, shape, weight, timbre,
Gesture.
Of QUALITY, asshole – of type, dream, end.
Hair, push, auth, punch.
And if I were me I'd seriously thunk
And hard on the previously figured and
Sometime heart of the matter: performance, all of it,
Always-already captured, recouped

– Enfleshed, in a way – in the worst way – this way
To TEH stab
– Through lopsided economangling, so that
The greased teeth rent
Bits of yours in turn: the internalized
Sound of which something like
Molared grit or the kitty bones or
The elderly carapace or
The distant nose-punch or knuckle over-crack,
Overwhelming the ghastly sad sounds of
The city's night.
That there, coming now,
Was the sound of your very
Very memories ruining.
Here or hereabouts,
There was maybe a picnic.
Or maybe there was some food and it was
On on the floor.
Yeah and also with people
Who were also on the floor. Or
Yes, there were people and things
All kinds of edible and inedible stuff all
Over the floor and it was outside
And it was night and it was properly chucking it down.
Or, right,
People and the food-like and other stuff
And the very floor, indistinguishable in
The post-power dead of dark and then the
Sheets of rain, and then the things and on the ground
And
Quick brown flood sprang and
Roiled and everything tumbling
About in a kind of 'picnic'.
As in, contemporary to all that all

The gussets getting all
Crack-ransacked, in search
Of whatever scintillas of organic
Bath salts were leftover.
Whatever final petrified prurience, however
Porno, gotten up
Processed for coke and oil and fossils
– In a different order.
And that there, Suze, was the Lush apocalypse:
Lavender and Dettox
Sickly failing to obscure the granny
Turds and chewed dicks
And those complicatedly butchered farm animals,
Local.
I, um, went ahead and read
That 'TOTAL POLICING' backwards
Thru the darkening Metropolitan mirror,
If you follow, P.
The materialization of ethereal monomaniac,
Deliberately canvassed
And state-bobbed so basically
It was just confirmed and way too late,
The cowards.
– Often was seen saliva-stucco'd
All over the cute other faces – or embroidered
On loose and/or cropped black tees, the cock
Monogrammed brand affiliation. Filled
Doomed white van
Wolf-slammed sleeper-held and held
Like the all-too-tangible ghosts of
Deer ticks
And those dainty woodland bluets and,
Um, again,
It was right there on the perma-throttling

441

Bulky white and really bad forearm,
Like a totally backdated jail sentence raised
In pale blue,
Heavy ginger-thatched, bled-out
Cursive you don't even need to be
Able to read to get the whole
Puss, filth.
We were pretty well incorporated
By then, Kevin
– Pretty much inured, too.
Even and especially as you turned
A fetching teal and your eyes erupted
Like some semi-perished stress toy.
After all that, like you, I did
The paranoiac auto-critique
Thing and basically all the time.
Busted pataphysical dervish,
Self-harming with every wicked
Revolution double take wha?
Over the shoulder wha?
And just what was that
Climbing the ladder after me?
WHO was that
Making the whole edifice rumble and crumble?
– Like you, we did of ourselves,
As you of yourself.
So we just hads to be para- and
To the brink of screamo-
Wrenching mouth-frother, right?
To the very quivering lip,
The moment where the whole guilt-knackered
Back sundered and all the red stuff
Grabbled onto the cobbles, Dave.
– That red, um,

Stuff should have remained
Inside the back,
As it doesn't really work
When it's not inside the back and further,
Doesn't work when it's outside and even
In roughly the right order,
Even incubated by a crowd and the sun's
Blessing and willing
– We all were – willing
With all our hearts, that we could just
Command-Z the lot.
The repatriation of the schizoid
Happened over there, beside a huge
Dome of buddleia and
With a pretty amazing procession
Complete with floats
And a brass band and
Refreshments. We drank
A kind of cordial and talked, maybe sang,
I think, about
Girding the planet with
Love.
Or we talked about turning the planet into
A radioactive desert for
The mummichog,
Cockroach,
Lingula and
Tardigrade:
A terrible post-apocalyptic pappyshow
Of 'The Town Musicians of Bremen', scuttling
(Or whatever apposite horror adverb)
Though living out their eternal days
Inside an oil drum.
Or we talked and sang a little about

Girding the planet with love – how the global's manoeuvers
Might be better retooled as a way
Of spreading love
About the planet.
Meanwhile, the surviving beings,
To stay warm, had formed a kind of
Parasitic turducken:
Tardigrade inside cockroach;
Tardigrade and cockroach inside lingula;
Tardigrade, cockroach and lingula up against
It and for no one to eat
In the post-apocalyptic here,
All across there.
I'm basically a totally baroque conceit.
The ghost of a universe
Of really big fleas.
I'm tropical, certainly, and crammed
With the ghoulish bits of actual people, literally.
As in, I'm engaged.
Not like your fiancée but like a toilet.
More or less
Temporary occupancy for the exorcizing
Of shit-headed demons,
If only for a mo, out of sight of the moon,
Behind a weird mask I found in a charity shop that
Looked like rare dog breed but still
Sort of cute.
Then you
Rolled your eyes right back
And observed
The flinching brain, restrained against the
Grey occipital back wall by those paraphreniac,
Liver-spotted mitts.

And that thin shaft of dwindling daylight
Picked out the pathetic
Hackles, the poorly wretches, the perspiration;
Illuminated cast bleak
Thru blown trepanation.
Picture it, Hannah.
And the narrative, aesthetic full-frontal
– The total blues,
Policing thru
Jargon backed up
With the hard, polished turd kit, butt
Straight up the sun-blush bods,
All them bombed quasi-bods
And those well dear extensions of the
Banging bods
Weensy plumbing the world:
Sinew-optic lashed, rebuffing your tight,
Chamfered cable wish.
Glossy insinuation
Up the the high road, via the
Disputed permafrost, bloody
Melt water and seal club, materializing,
Asif by magic,
As a pretty convincing pneumatic
West. Not a hair out of place.
So go certain renderings of life, Sharon:
Eye, blubber, icicle shiv.
The stakes of, um,
Vérité were so massively stacked
In favour of dead human being
Persons: shambling and explicit
– Super-allegorical even as they retarded
The possibility
Of their inference by the overwhelming

445

Spectacle of their follicular fidelity;
The queasy purpling around that head trauma
I could MAKE OUT;
The sense of gravitational CONVICTION
Where the arm was hanging by a
Filament of gristle;
The slow-matting glisten of
The piebald, scalloped tongue
And the unfortunate, sort of
Seeing eyes.
Contemporary verisimilitude was dead.
Literally, figuratively.
And vandalized allegory: zombies
Stalked coherence, stalked
The sensed – hunted down intelligibility and,
PFFFF, shamed it.
And this was also how I looked and
How I didn't look also:
Also was my forever hidden bits
– Not hidden for demure shrinking
Violets, but buried in everyone else's,
To the hilt and figured holy, a striking
ENFILADE of every possible body,
Even and especially the gone
Ones – even those who were not yet
And over there and space-time whatever.
It was always like this:
Hegemony looked like this, Sally.
Like me.
O! and also,
My proper name is,
Um death.
I suppose I just wanted to see
What all the fuss was about;

I just wanted to see
What the inside looked like.
Over here was inside:
And here was outside.
Here was inside again.
Likes include:
Self-harm
According to how totally massively
I failed you;
Redundant bums
About the High Street, electioneered
For the only tru party and
4 eva the rimmer,
Anus of the city, crusted at either end:
Shit-blown or Zwarovski
Netsuke darling puppy or seal-pups
Studded and dawdled
From oversize Lanvin handbag zippers:
I loved them.
I loved to see them, Fran
– To be dazzled by them.
The, um, freshly prepared, the engorged:
The world elevated, ideologically, up from
Whatever livid basement.
Elevated world, enlightened-up.
I really really liked
The amount of control I had
Over what people thought of me.
– I just had to, um,
Sand off every prominence, ensure
Every unaccounted for was censored for
And before the others got wind
Of the ripe corporal fetor.
I really really liked the,

Um, blush frisson
That emanated from near the
Sort of hinge bit
Of the laptop
Every time I posted something tight & bleurgh or
When I retweeted something collapsible
With not too much meat and white or
When I posted something akin to
Kitten purse or swatch
Or fungible bluestone, something
Handsome stirred.
And so eyes – I imagined – would pivot
My way
And in just a way
That made for perfect
Unanimity & accord: the kind of solidarity
Contingent on total avoidance
Of telescopic superannuation
Clauses force-writ and blind-read
Between
Useable language
But never ever expository, like.
And I liked it when I could
Retweet or happy Favourite
Something that affirmed
My APPAL
Or my INHERENCE to some
Extra-political rad
Or my disgust,
My support for those over there and without;
The rally. The appreciable
– Though worn hem – real-world
Return; clarion
'WAKE UP' to the grey scabs

4 4 8

Affixed barnacle mirrored
Their grey digital selves.
*
SONG
*
Over there, before the Temple of Ceres,
There was a fountain, separated from
The temple by a wall and
There was an oracle,
Very truthful – super truthful –
Truth and not for all events, but for the sick
Only.
The sick person let down
A mirror suspended by a thread
Till its base touched
The surface of the water, having first
Prayed to the goddess and
Offered some, um, incense.
Then, looking in the mirror, she would
See the presage of death or recovery,
According and
As the face appeared fresh and healthy, or
Of a ghastly aspect.
– Another divinatory method involved
Holding that cheap hand mirror
At the back of a kid's head
After tight-bandaging their eyes real
Off, then asking something of
The dimming head
– As if apart from the kid – and asked
Just sort of thru the mirror,
Which angled just so
To glimpse your lips,
The lips now appearing sad and made up,

Sort of isolated and on some bleak
Ground, all blued and chapped;
The future of your lips and reversed to
Grim articulate the grim futures
Or no, and all this had to be bounced
Off the kid's
Bonce skull-back
And blindfolded in order
For the prophesy to have any validity.
The kid's bonce might have pulsated
– And although the cause of that
Wasn't, um, for sure,
It'd been guessed at
And was pretty consistent: normal
Perfectly normal and seemed
To echo the kid's wheeching heartbeat
– Perhaps via the, um, arterial pulse
Within the very brain vasculature,
Or in the, um, 'meninges'.
There were no mirrors left, Mark.
Only the concept of reflection, which
Lived on in the unreflective puddles made
Spilled milk & sour beer, curdled
And the entire occlude the damned
Floor when it rained searing
Little bits of real pain, Mark. No
Children, either.
Just this,
Just me – the sole
Image and blotted out
Even eventually the stars, the moon. The sun.
Or at least its effect
– The effect that afforded vision,
Right?

So this – that – me – was – is – are,
The spectacle(sss),
Right here, Harry:
This the spectacle wat
Jammed and totaled.
Like a car, obviously.
Specifically a silvered
Daihatsu Sirion wrapped around,
Um, bollard
With Manchester gilt bee emblem and
The perp in the driver's
Seat obscured, enveloped
By absurd airbag but the perp
In the passenger seat not
Actually in the passenger seat but up
Against that nearby & hard
Wall and unrecognizable, literally
– Tho so incredibly visible. A revelation:
So much of her revealed, tho not
For what she was-is, but what
She was
Rendered, behind-the-scenes;
Just what the symbolic meant abutted
In a manner literalized and to have
Wracked the whole and
She was forced to cohere, to make sense,
According to the lacquered
& hard-boiled
Language of walls and cars
And bollards and,
You know,
Images
All rendered evidential: forensic
Rendering at 50, 60 mph.

– Really, Sarah, she should have been
Permitted the really good grace:
Incoherence practiced proper:
The ethic. She should have been
Left suspended, perpetually adjourned and
According to her own, personal,
Occult geometry, physics for
Self and self-to-self and,
And, and, and integrity to have
Spun pirouette diamond pinwheeled
And not squarely at the death and
His super-cogent
& HOT
Mangle-reveal.
This, then, me
Literally totaled the society as
The whole 'we'.
Sooo sad.
This used to be a, um,
Tesco, mum.
Or, like, a castle or a garage or a bank or something.
Or a gallery sort of thing. Perhaps something
Public, something that does not engage the
Operational 'revelatory' because it is
Open and, um, public and by constitution.
Everything used to.
Or, of course, the erosion of the
Public sphere (an image of a silvery
Medicine ball or Mars
Or the dear lunar) bankrupts
The language and hides the keys. And outside,
The performance rages and fucking rages.

AFTERWORD

'Endlessly I sustain the discourse of the beloved's absence; actually a preposterous situation; the other is absent as referent, present as allocutory. This singular distortion generates a kind of insupportable present; I am wedged between two tenses, that of the reference and that of the allocution: you have gone (which I lament), you are here (since I am addressing you). Whereupon I know what the present, that difficult tense, is: a pure portion of anxiety.'
—— Roland Barthes

'Life is a punch in the stomach.'
—— Clarice Lispector

What makes writing fill up on contact with the lost or dead? What makes it flounder or distend in relation to its objects? Is the language of excess always compensatory, or is it sometimes only inadequately violent, smeared over longing like sobriety on a shady weeknight evening? How is writing the body, and the writing of the body, still possible in an era like ours – one in which bodies are so routinely and seamlessly evaporated, collapsed, flat-packed and disappeared? Or rather, what is writing's task in the face of this situation, what is the urgency with which corporeality needs to be insisted upon in writing, and the relationship between writing and the body be made freshly vigorous, committed, beautiful and messy? Or has the insistence on 'the' body itself become anachronistic, as if, in any case, there were a single mould or model from which we could derive all the essential elements of a defence of the form? It seems to me that Ed Atkins' writing addresses itself, without the grandeur or security of oratory, to these kinds of questions. It does so falteringly and gingerly, but sincerely and expansively: sustaining the discourse of the beloved *and* its absence, or flitting back and forth between them, offering as a site of corporeal resistance the very bodies perpetually at risk of becoming corporate or virtual junk. The writing speaks through these bodies; appropriates them, recognizes them, represents them, desires them. And it does so in forms that are tantalizingly invented for the task. Part prose-poetry, part theatrical direction, part script-work, part dream-work, Atkins' texts present something as fantastic and commonplace as the record of a creation, the diary of a writer glued to the screen of their own production, an elegiac, erotic *Frankenstein* for the twenty-first century. What are they like, and what is the experience of reading

them like?

The first thing to register about Atkins' writing is how much of it there is. It gets everywhere. In defense of corporeality it is relentlessly and corporeally expansive, logorrheic like only bodies can be, pushing and tonguing itself into every seam and juncture. Whatever the matter at hand, the language in all of the texts collected here is determined to over-produce itself as a condition of discovering expression. Anxiously these texts unfold in restless, perpetual motion, sniffing out the limits of their discursive space, overflowing internally, haemorrhaging externally. The logic of their accumulation is always excess, always superfluity, as if to claim the protection of super-erudition against the blank and deathless paucity of over-representation – of what Hito Steyerl calls, in the context of our ubiquitous digital surveillance, being 'represented to pieces'. It is true that the body of work in this volume is divided into various constituent parts to represent its different and particular compositional contexts and energies. These parts are titled according to a traditional publishing logic of authorial presentation. But whatever titular, thematic or conceptual lines are drawn in the inky sand between each of the texts, such lines nevertheless dissolve on contact as the writing proceeds; the texts are constantly invading each other's personal space, swapping and repeating lines and phrasal arrangements. Thus the work maintains a kind of fallible, practically alchemical relation to being read. Dip in at any point and the trace of corporeal abstraction is reinforced with fatty, material emphasis. The writing *baits* itself, vocabulary breeding jargon or deadpan exegesis, extruding itself through dialogue either solipsistic or actual. Its copiousness is its own reward. If to

'speak amorously is to expend without an end in sight, without a *crisis*,' as Barthes suggests, then Atkins' texts are supremely amorous. They practice and comment upon, as Barthes continues, 'a relation without orgasm.' To the extent that Atkins' texts read as commentary on such a relation, they seem both to seek out and to shy away from readerly encounter, offering a dialogue or transcript of sorts, or an overheard epistolary, or apology. The form that each takes is superfluid to its content, which roves around like a set of objects discovering their relations for the very first time. The same logic engenders form at the level of individual sentences: omophagic vowels and testing, teasing clauses do not so much beckon a subject as constantly re-animate one. The ventriloquism of tone in the writing is obsessive and pathological. It cannot stop doing things in different voices; it cannot stop putting things in its mouth. It is writing with one foot in the oral stage, as childish as it is denuded, as infantile in its gorgeous, gorging openness as it is mature in its skepticism of the contemporary, merely grown-up moment. In this sense it resembles a kind of symphonic tantrum.

To insist in writing on the exhaustive, excessive materiality of embodied experience in the midst of its appropriation by what Atkins calls 'these trainee murderers, these bastard representationalists,' is to practice something like an elegy for the contemporary itself, for its ever-replicable skein of catastrophe and sacrifice. It is therefore also to imagine, albeit fleetingly, some moment outside or beyond the contemporary, some scene of life beyond its accelerated, perfectible immiseration: perhaps even a different kind of futurity (or infinity) to the one often implicated by Atkins' trademark 'etceteras.' But if the mode is elegiac, then

what precisely is the relation of Atkins' writing to loss? It is difficult to discern. At times the writing feels tenderly melancholic, at others belligerently scarified; at others again grossly or ghoulishly jovial, like a wasted, uncomfortable uncle. One aspect of this relation is certain. The truth is that this writing *hurts*, and that it continues to hurt as long as it lasts, not because it is masochistic or senile, but because pain is a necessary correlate of mourning: the mood of mourning is a painful one. The kinds of exhaustion and excess I have tried to describe above are not benign or simply technically virtuosic, but rampant, discomforting, nauseous and upsetting. In the long poem 'Performance Capture', the endless iterations of the anti-emphatic interjection 'um' feel like miniature asphyxiations; they clot the lines with gulping incertitude, blank misgivings as physical as they are epistemological. The poem wants to remember and possess its objects. It is at once gripped fast by this desire and simultaneously suspicious, to the point of paranoia, of its concomitant need for re-presentation, and it thus ensures through the formal distensions and distractions of its unfolding that no object is held within its mutable catalogue unless sabotaged – grammatically, tonally – by a dizzying process of verbal attack and delay. The poem remains in this pure portion of anxiety throughout its fifty-four pages and one thousand eight hundred and thirty-three lines. Like a school bully, the left margin of 'Performance Capture' exists sometimes to torment the writing, and sometimes to make it come alive, to eroticize it. Lines are tripped up and galvanized, turned on, in turn. I want to resist quoting a portion of the poem to prove these conjectures, because what I am trying to write about here is tone. It is as difficult a thing to describe as the text's relation to loss because,

like that relation, it is produced so incalculably in the medium *writing*; the effect of tone is so all-encompassing that it determines the affective comportment of a text almost before you've noticed it. And Atkins' texts bleed tonality, just as they sustain and materialize absence.

It is perhaps this quality that makes them such compelling accompaniments to Atkins' growing body of video work. Whether spoken or sung, when part of the musical-visual collage of Atkins' films the texts become libretti. They seep into the image with the density of colour. Heard on-screen, the texts are often spoken through the bodies of stock, downloadable CGI avatars, digital representatives of precisely that form of representation which 'Performance Capture' is concerned to interrogate and de-stabilize. In the mouths of these interlocutors the texts achieve another layer of tonal ambiguity, as the shifts in register and vocab become plastered over by the honeyed larynx of Atkins' real voice, even as sarcasm and pathos make cameo appearances where one might least expect them. But it is worth considering what these texts might *lose* in such a context. Writing on the page such as this, like the most extraordinary contemporary poetry or prose, requires an effort of encounter to enliven and make richly complex its superficial verbosity and weirdness. Witnessed aurally in a gallery or at a reading, a different kind of attention is required, but one that threatens to evaporate from the writing its peculiar kind of clinging, its verbal mechanics of obsessive introjection. You need eyes for this. A scopophilic relation to the text is the necessary correlate to its own logorrheic tendencies: it wants a desiring body in front of it. 'Performance Capture' is, in one sense, the drama of this exchange. It contains passages of pastiche essayistic argument,

line-broken into prosodic reflection, that flesh out such an encounter: 'Bodies were the first to be spirited away / From their innate contiguousness with the ANIMA / That ANIMATED them / At the insidious metaphoric & demonic / Behest of some shitty ideological consensus / That saves its most virulent, illy shits / To dump right inside the language.' 'Performance Capture' knows very well that language is not food or shelter, or knows at least that its food is spiked and its shelter is bleakly figurative. And it knows, too, that the denigration of idealism in writing is almost always the flipside to the boring insistence that writing censure its own excesses in the name of what exists, and how best to overcome it. But no-one writes like this; no-one loves like this. Even a basic human body knows better. 'I enwrap the other in my words, I caress, brush against, talk up this contact, I extend myself to make the commentary to which I submit the relation endure' (Barthes). Language will not save the body from becoming fleshy decorum, but it will be a skin with which to endure; this, in Atkins' words, is writing's 'Proper magic against illusion.' Writing is never a way out but is always a way out of not wanting to get out of not wanting.

Something to hold on to, at least.

Joe Luna, July 2016

References:

Hito Steyerl, *The Wretched of the Screen*
(Berlin: Sternberg Press, 2012).
Roland Barthes, *A Lover's Discourse: Fragments*
(New York: Hill and Wang, 1978).
Sigmund Freud, *'Mourning and Melancholia*,' in *The Standard Edition
of the Complete Psychological Works of Sigmund Freud*, vol. 14
(London: Vintage, 2001).

References

Appendix

Several of these texts have appeared in some form or other elsewhere, almost all were written on the occasion of an exhibition, a new film, a commission. 'An introduction to the work' was plastered to the walls at the entrance of the Kunsthalle Zürich in January 2014. 'Razor', the earliest thing here, was handed out in brown envelopes at The Slade in 2008. 'A Tumour (In English)' was a free takeaway during a show of the same name at Tate Britain in 2010. Subsequently metastasized into 'Ein Tumour (Auf Deutsch)' for the Bonner Kunstverein in 2011, and 'Guz (po angielsku)' at the Centre for Contemporary Art Ujazdowski Castle in 2015. 'Intrusion' was written for Michael Dean, in a book accompanying his exhibition at Kunstverein Freiburg in 2011. 'Material Witness OR A Liquid Cop' was written for the initial stages of 'Tomorrow Never Knows', the first Jerwood/FVU Award. 'A Primer for Cadavers' appeared first as the narration in a video of the same name, made for a weekend of fecund mourning at the ICA called 'A Dying Artist', organized with Siôn Parkinson in 2011. 'Air for Concrete' was chopped up to form the core of 'Delivery to the following recipient failed permanently', a video commissioned by Frieze Film, also in 2011. 'Depression' started life as a text to be performed, albeit re-mediated through digital whatevers, firstly as part of 'Weighted Words' at the Zabludowicz Collection, then at the 'Memory Marathon' at The Serpentine, both in 2012. 'Warm, Warm, Warm Spring Mouths' was written for the second part of 'Tomorrow Never Knows', in early 2013, and features Gilbert Sorrentino's poem of 1971, 'The Morning Roundup', rehearsed over and over. 'Us Dead Talk Love' was given away for free as portable accompaniment to the video of the same name at The Chisenhale in 2012. 'Maple Syrup and Cigarettes' was written for Helen Marten's monograph, published by JRP Ringer in 2013. 'Somebody's Baby Boy' started life as part of an exercise given by Natasha

Soobramanien and Luke Williams in a cottage in Wales with the marvellous LUX Associate Artist Programme in 2012. 'The Trick Brain' was written for Isabella Bortolozzi's magical show, 'The Inexplicable Paravent Illusion', also in 2012, accompanying archive footage of André Breton's apartment before everything in it was sold in discrete lots by Calmels Cohen. 'Even Pricks' was written for the 2013 Lyon Biennial, then pulped and translated into a video of the same name that premiered there. 'Or tears, of course' was written for an exhibition at Temple Bar in Dublin in 2013. There was once a video of the same name – though no more. 'Hammering the bars' fed a video suite named 'Ribbons', and was first printed in a monograph published by JRP Ringier in 2014. '80072745' is just the beginning: the first two letters of a decade-or-so-long correspondence project for the Serpentine 'Extinction Marathon' in 2014. They are love letters (sign up at 80072745.net). 'A Seer Reader' was printed by Koenig Books to accompany an exhibition at The Serpentine Sackler, with an original design abetted wonderfully by The Zak Group. 'Performance Capture' was written for a project of the same name that somehow, miraculously, transpired over the course of the Manchester International Festival in 2015.